WICKLOW BOUND

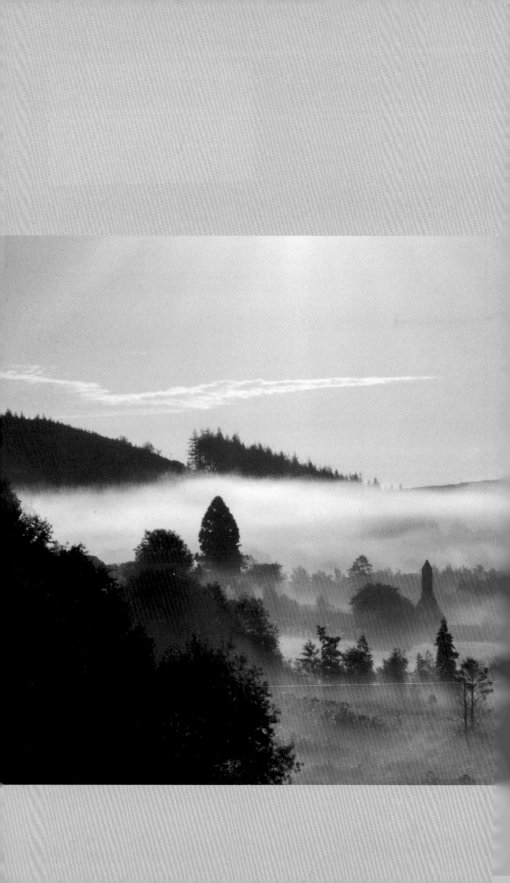

Wicklow bound

A seasonal guide

Seán Ó Súilleabháin

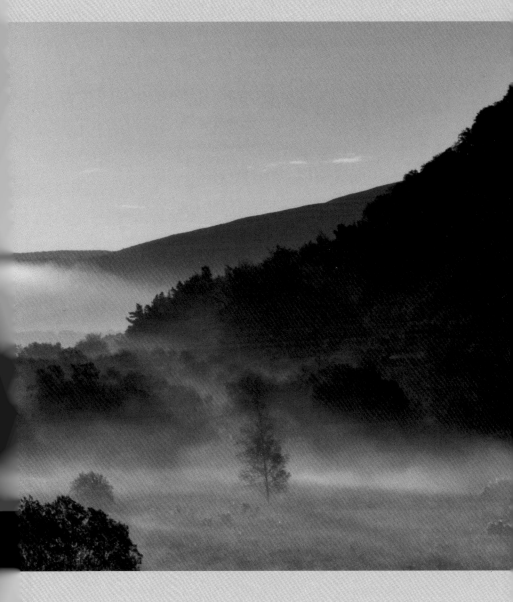

Wordwell

Copyright for typesetting, layout, editing, design:
Wordwell Ltd

ISBN: 978-0-9933518-6-0

British Library Cataloguing-in-Publication Data
A catalogue record for this book is available from the British Library.

Front cover illustration:
The Lower Lake at Glendalough by Chris Corlett

Other cover illustrations:
The Strawberry Path, Kilcoole by Seán Ó Súilleabháin
Cuckoo by Shay Connolly

Photos:
Shay Connolly: www.flickr.com/photos/shayc
Chris Corlett
John C. Murphy: www.flickr.com/photos/jcmurphy
Seán Ó Súilleabháin

Typeset in Ireland by Alicia McAuley Publishing Services: www.aliciamcauley.com
Copy-editing: Alicia McAuley
Book design: Alicia McAuley
Cover design: Ger Garland

Printed by Turners, Longford

Great care has been taken in the preparation and publication of the contents of this book. However, the information contained herein is of a condensed and general nature only and is intended as a secondary resource. Both the publisher and author recommend that anyone considering exploring the areas mentioned should check weather conditions in advance and ensure they have appropriate clothing, footwear and equipment, including maps. As a courtesy, all visitors to lands in private ownership should request permission from the landowner.

Contents

Acknowledgements vii
Introduction ix

Chapter 1 January 1
Chapter 2 February 19
Chapter 3 March 35
Chapter 4 April 51
Chapter 5 May 69
Chapter 6 June 83
Chapter 7 July 99
Chapter 8 August 115
Chapter 9 September 131
Chapter 10 October 147
Chapter 11 November 163
Chapter 12 December 179

Appendix I Suggested itinerary: a five-day tour of east and 197
 south Wicklow
Appendix II Suggested itinerary: a family day out using public 199
 transport (Bray, Greystones and Kilcoole)
Appendix III Selected walks and places of interest 201

Bibliography 215
Index 219

To my wonderful parents,
for always taking the time to stop and point.

To my beautiful wife, Emma,
for always being with me along the way.

Acknowledgements

This book would not have been possible without the support of many people. Thanks are due to the wonderful team at Wordwell, including Nick Maxwell for putting his trust in this project, Alicia McAuley for her eagle-eyed copy-editing and Caoimhe Fox for her continuous encouragement and support.

I would also like to thank those who generously gave their time and expertise and who advised, corrected and instructed me throughout the writing of this book – Niall Hatch and the team at BirdWatch Ireland, Stan O'Reilly, Deirdre Kelleghan, Seamus O'Brien, Bill O'Dea, Brian Nally and Brian White. Chris Corlett, Shay Connolly and John Murphy, meanwhile, provided beautiful illustrations.

Thanks also go to all the staff in Coláiste Chraobh Abhann, especially my friends Donal Evoy, Terry Halpin, Éamonn Dunne, Martin Healy, Ruairí Farrell, Conor Kennedy and Karl Rice, who accompanied me on many a walk in the Wicklow Hills, making a long road short – and, occasionally, a short road long.

I have been lucky enough to have had some wonderful teachers in my life, but I would like to offer special thanks to my English teacher, Máire Ní Anagáin, who greatly encouraged my writing from an early age, and to Caitlín Nic Shiachas, whom I still hold as an exemplar for the very best in the teaching profession.

Thank you to all my friends from Tallaght and to my family in the US and the UK, especially Joan, Mags, my godmother Barbara, my sister Dee and my brother Dan, who have always been so supportive.

Special thanks, too, to my amazing parents, who instilled within me curiosity and a love for both words and nature. Anything I have achieved in my life is built on the foundations of what they sacrificed for me.

Finally, I wish to thank my beautiful wife, Emma, who not only put up with me during the writing of the book, but also accompanied me on many a walk, before undertaking the unenviable task of reading and correcting numerous drafts. Her love, support and patience are immeasurable.

Introduction

When I first moved to Wicklow in 2005, I had no plans to stay here permanently. I saw it as a gap-filler before I packed my bags again and headed off to explore other places and cultures. That was the plan, anyway. However, as soon as I began to walk Wicklow's coast, or go hiking in the Wicklow Hills, I soon realised that the *other* was suddenly losing its magnetic pull. I have often heard it said that the place where a person feels happiest is a place that mirrors something within themselves. For some, that can mean the clamour of the city; for others, it is the vastness of the outback or the symmetry of the desert. For me, it is the land and seascapes of Wicklow that have firmly anchored me and that I now call home.

This book is my attempt to capture the natural beauty of this wonderful county over the space of one year. It is by no means an exhaustive account of the walks, gardens and scenic spots that can be visited, nor does it attempt to cover all of the area's local history. It is simply a personal response to some of my own favourite places, to which I love to return again and again in order to observe the changes that each new season brings. Some of the places are well known; others are perhaps a little less so, being off the well-trodden track. I hope I have managed to portray at least some of the deep attachment I feel for this place, and perhaps even to encourage others to go out and explore the Garden County.

Seán Ó Súilleabháin
July 2016

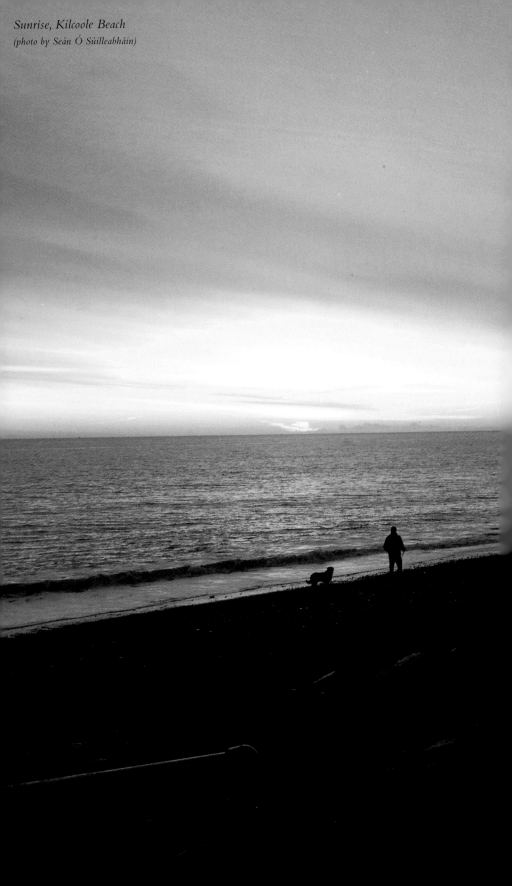

Sunrise, Kilcoole Beach
(photo by Seán Ó Súilleabháin)

January

Looking forward, looking back.
— Seán Ó Súilleabháin

One thousand, two hundred and twenty-three — a number I still remember from my days in school. It was not some kind of constant we had to memorise for maths class, or even a significant date from history, when some ancient battle took place, perhaps. If that had been the case, I am quite sure it would have evaporated into the mist of forgetfulness before the lunch bell rang. No — it was in the relatively numberless world of our English class where we were first introduced to this magic number. I can still hear our brilliant English teacher announcing it with such clarity, such pride:

'One thousand, two hundred and twenty-three. Imagine that!'

She would pause for dramatic effect so we could anticipate what was coming next.

'That is the number of characters Shakespeare created in his plays. Ponder that great number, boys and girls, before telling me that you can't come up with one single character for your homework.'

Thinking back, I do not remember anyone ever questioning her on this. Had she actually gone to the trouble of counting Shakespeare's characters? Nobody dared ask. It was simply a given — a fact to be remembered. And remember it we did. Even now, many years later, I still have not verified my old teacher's nugget of information and I probably never will. I have seen a lot of Shakespeare's plays over the years, although I have not counted the characters. Among all the characters I have come across, there is none more corrupt and depraved than the ensign Iago, who appears in *Othello*. From the

very opening of the play we see how morally bankrupt this duplicitous man really is, weaving a web of lies and deceit that eventually results in pitiful and heartbreaking destruction for all those involved. And the worst of it is that he never gives a satisfactory motive for his depraved actions. He is simply evil for evil's sake. In Act 1 Scene 2, when we see Iago standing by Othello's side, advising and counselling the very same man he earlier proclaimed to hate, it becomes clear how vulnerable Othello truly is. In the same scene, Iago swears by the Roman god Janus. It is a line that could be easily overlooked but — as is often the case with Shakespeare — there is more to it than meets the eye:

> By Janus, I think not.

Janus, of course, is the Roman god of doors and gates, endings and beginnings. He was often depicted as a god with two faces — one looking back, the other looking forward. So what better god for Iago to swear by than Janus, the two-faced god?

Before Julius Caesar reformed the calendar in 46 BC, there were only ten months in the year, with the year ending in December and beginning again in March. The winter days remained nameless and uncounted, until two new

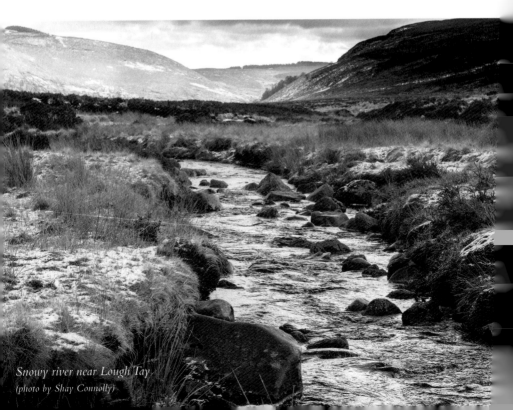

Snowy river near Lough Tay
(photo by Shay Connolly)

months, Ianuarius (January) and Februarias (February), were introduced. The month of Ianuarius is thought to have been named after the same two-faced Roman god by whom Iago swears — and, it has to be said, it does seem to be an apt choice. Consider how, in January, we look back on the year that has been, before looking forward in hope towards the new year and what it might bring.

New-year's resolutions are one way in which we turn Janus's key on last year's mistakes and previous failures, before setting out again to, in the words of Samuel Beckett, 'Try again. Fail again. Fail better.'

When I moved to north Wicklow ten years ago, I knew I had found a place I would call home for the rest of my life. The unspoilt beauty of its woodland walks, mountain hikes and coastal paths compel me to go and lose myself. The open trails lead me both wayward and homeward. There is a force of attraction that calls me to return, again and again, to this magical county — similarly, perhaps, to the migratory birds who make their seasonal journeys, both wayward and homeward, over land and sea. Unlike Jutland in Seamus Heaney's poem 'The Tollund Man', this is a place where I feel happy and at home. After years of enjoying the unique colours and sounds of each season, I have decided to record my personal reflections on the seasonal changes of Wicklow over the course of one full year.

Recording dates and celebrating a year's end is a very human custom that has been with us since prehistoric times. There seems to be an ingrained impulse in the human mind to put order on the cycle of our world, a deep-rooted desire to record our place and time while we're still here, before passing our brief experiences on to the next generation in the great progression of life becoming history. But nature is oblivious to such fanfare. It ignores the momentous occasions in our lives. It continues on its own journey with a detachment that is almost enviable. The sun rises as it did the previous dawn, a signal for the fox and the badger to retrace their ancient tracks back underground. In the distance, the constant rhythm of the sea ebbs and flows like the breathing of a heavy-bellied doe grazing on the hillside. And yet it remains, waiting to be walked, waiting to be explored. I now look back one last time on the year that has passed, before facing forward to see what the new year will bring.

Everyone has their own New Year's Day ritual, and a brisk walk on a cold Kilcoole Beach is as good a place as any to open the account. There are the usual sights to be seen — dog-owners running after unbound canine companions, followed by parents chasing wayward children, who in turn

pursue well-intentioned but slightly nervous joggers. Couples stroll hand in hand, past birdwatchers observing, their binoculars around their necks. And then there are the walkers. There are as many species of saunterer on Kilcoole Beach as there are birds here. You have the common speed-walker, the solitary rambler, the 'out for a quick breath of air before making a quick dash back to the car' rover. All can be spotted venturing out on a New Year's Day as a sharp breeze comes fresh off the grey sea, blowing away the previous night's celebrations and soothing sore, groggy heads.

Looking north along the coast, Greystones Harbour can be seen through mist and rain and, further on, Bray emerges with its protruding head bowing in reverence to the majestic sea. Stephen Dedalus famously described it as the 'snout of a sleeping whale' in the opening episode of *Ulysses*. It was pointed out to me recently by a knowledgeable (if somewhat pedantic) reader that this must have actually been Killiney, since Bray Head lies hidden from view from the top of the Martello Tower in Sandymount. But sure who are we to contradict James Joyce?

Looking south, the coast sweeps slowly down and around to the very tip of Wicklow Head, with its winking lighthouse signalling back across the bay towards Howth and out into the Irish Sea. The albicant January sky is brightened by a watery sun, dipping beyond the Wicklow Hills in the west. The sandy soil is solid and easy to walk on, as long as you can avoid the occasional calling-card of an overfed dog. Beyond the railway, the marshes become an orchestra of sound that travels across the open wetlands, with the distinctive calls of the waders, whooper swans and ducks filling the air. Overhead, a V-shaped squadron of brent geese can be seen, their barking calls not dissimilar to those of the narky little terrier snapping at the jogger's heels. When they fly low overhead, you get a close-up view of their strength and grace, before they glide down to land on the muddy runway. But, once earthbound, they quickly lose their graceful nobility, proceeding to waddle around, pecking the soil like shawled old women at a country market. It is an iconic sound of the estuary in winter. The ex-Manchester United manager Alex Ferguson said that, whenever he wanted to demonstrate the importance of teamwork, he would tell his players about the V-shaped flight pattern that geese use when migrating and about how they would constantly rotate the position of lead bird. In that way, when one bird grew tired, there would always be another one to take its place.

This part of the coast that runs from the wetlands of Kilcoole all the way to Wicklow Harbour is called the Murrough. It is home to an abundance of

The Breaches, Kilcoole
(photo by Seán Ó Súilleabháin)

wildlife throughout the year but now, during the winter months, the brent and greylag geese are the star attractions. The brent geese have made the long journey from Baffin Island in Canada, while the greylag geese have migrated south from Iceland. These are just two of the incredible journeys undertaken by our diverse wildlife that can be seen along the coast. The key species from Greenland and Svalbard are the barnacle geese, but they are infrequent visitors to the eastern shores of Ireland. Once the geese arrive, they immediately begin to graze. One sentry stands alert, watching for any unwelcome visitor and, if alarmed, signals the approaching danger with a terrier bark. Indeed, it is said that when the Gauls were sacking Rome in 390 BC it was the sacred geese of Juno on the Capitoline Hill that alerted Marcus Furius Camillus of the invaders' imminent attack. Here on the wetlands, it is not the stealthy approach of the Gallic leader Brennus that provokes their warning calls, but rather, more often than not, the lurking presence of a hungry fox.

Watching these gregarious birds strutting across the marshy fields, I try to imagine the barren ice landscape from where they have made the long trip south. Throughout the summer months their calls will have echoed across lonely, uninhabited mountain ranges, accompanied only by the wind and the occasional groan of a glacier. The treacherous flight they make across the north Atlantic before arriving on our shores in October is over 2,500 kilometres. Up on the vast breeding grounds of Greenland, from where the

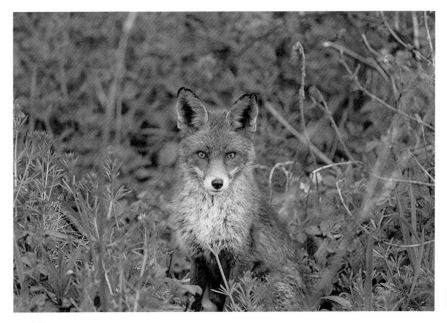

Red fox (photo by Shay Connolly)

barnacle geese migrate, it is the Arctic fox who lies in wait. Smaller than its cousin the red fox, the adult wears a thick white fur that is perfect camouflage for hunting nutritious birds' eggs, which must form an essential part of its diet if it has any hope of surviving one of the harshest climates on earth.

In Ireland, we rarely experience such snowy conditions. When we do, even the ordinary becomes wondrous. One such moment was the snowfall of 2010, when a simple walk down to the beach was like stepping into a Guinness ad. Camera in hand, I eagerly snapped the ebony horse in the field beside my house. Its burnished coat shone brightly against the covering of fresh snow, creating a perfect picture postcard with every click. Beside it, an opportunistic lapwing tilted its distinctive punk-styled head, hoping to find some loose grains in a cattle trough. The beauty of a winter landscape can make you forget that natural life is really struggling in times like these, and that finding a small meal can be the difference between life and death.

Down by the bank, the rare union of sand and snow lies lightly strewn across broken shells and stones. Across the estuary, everything seems calm and still. The ditches and trees that divide the fields stand like charcoal silhouettes against a bleached January skyline. Suddenly, through a small gap in the hedge, a small fox's head pokes out from the darkness of the trees. He sniffs the cold air cautiously, before lightly hopping over the iridescent carpet.

A fox is not a rare sight these days for either country or city dweller, but at this specific moment his ochre coat floods the barren countryside with the warm richness of an open fire. I do not photograph him. I do not know why. Maybe I feel that the fleeting moment will be lost in the time it will take to put eye to camera and focus the lens. I simply watch him making his way through the snow. Almost as soon as he has appeared, he is gone. He slips through a fence and is swallowed up in the shadows of the motionless fir trees. But that simple memory of a fox scurrying across a snowy field on a cold January morning remains with me.

One of the attractions of the coastal walk between Greystones and Wicklow town is how the skyline of the Wicklow Hills sweeps down into the woodland, which in turn gives way to the fertile wetlands that are home to a great abundance of wildlife. At the mouth of the estuary, the fresh water of the marsh flows into the salt water of the sea, creating a rich and diverse habitat for mammals, insects, fish and birds. The union of land, sea and river offers the observant walker a wonderful opportunity to see something new with each visit. At this time of year, cold light illuminates the mist that runs down from the hills and, when it snows, the sky appears so low that it seems you could reach up and touch it. In the novel *Far from the madding crowd*, Thomas Hardy describes such a landscape, with the dark cavern of sky sinking to meet the earth beneath. He describes an apocalyptic vision of sky and land fusing to choke out the 'intervening stratum of air'. But for me, this landscape is anything but claustrophobic. I love the mystery of looking out across a white field and not knowing where the earth rises and where the sky falls.

The beginning of a new year often brings with it the resolution to lead a healthier lifestyle and a morning winter walk before work is one of my favourite ways to begin the day. A winter dawn is a magical time, when the sky is precariously poised between those two ancient foes, night and morning light. It is that otherworldly moment when Horus, the Egyptian god of daylight, finally overpowers Seth, the god of night. The two are locked in a continuous, cyclical battle for supremacy. On a clear winter morning the western sky is stained cerulean, the last bastion of a defiant night that is slowly succumbing to inevitable defeat. Despite its best efforts, it is being overpowered. Before long, the flood of the morning has washed away the last of the quickly submerging island of deep blue and suddenly the light of the winter dawn stands victorious. In less than five minutes, the half-moon of the previous night has become little more than a faint watermark on a pale blue card. For a few moments the rising sun and the fading moon appear

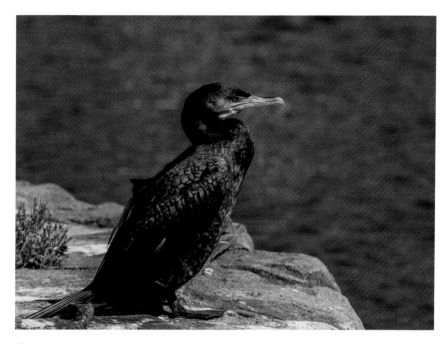

Cormorant (photo by Shay Connolly)

simultaneously, framed by a streak of salmon pink that seeps into honeyed yellow.

The rising sun in January is not one of those baby-carrot suns that Monet loved to paint; it is more like a gentle, whitish glow, promising a clear but cool winter morning. I particularly love walking along the coast after a stormy night, when the wind and sea have blown themselves out and calmness is restored. Waves gently break over strewn seaweed and shingles, while herring gulls scavenge for their breakfast offshore. On still mornings, cormorants can be seen flying fast and low above the water, with their shiny slick bodies gliding effortlessly across the horizon. The Irish name for the cormorant is *broigheall*, but Deirdre Brennan refers to them in her poem 'An t-oileán' as *cailleacha dubha*, or black witches. When you watch them flying with their long, broomstick necks stretched out, it's easy to see why. The cormorant is difficult to distinguish from the shag, both being of similar shape and colour. Small white patches on the chin and the flank of the cormorant are one of the noticeable differences up close. According to Niall Hatch from BirdWatch Ireland, the shag has a slimmer bill and shows a more abrupt junction between the bill and the forehead. But, to my untrained eye, telling them apart is always a challenge.

When walking the cliff between Bray and Greystones, the cormorants and shags will often be seen stretching their wings out, batlike, as they dry off in the heat of the sun. Both are excellent fishermen. Shags dive down to the seabed in search of sand eels, while cormorants are so proficient at catching fish that they are used in traditional Chinese fishing methods. A coil is tied around each bird's neck so that when it dives to catch a fish it is unable to swallow. When it resurfaces, the fisherman grabs it by the neck, squeezing the still-live fish out of its throat and into a bucket. Once the bird-slave has

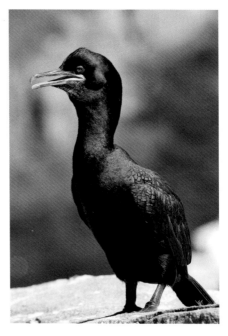

Shag (photo by Shay Connolly)

reached a certain quota, the coil is removed and it is finally given one of the smaller fish as a reward for its work. When John Lennon penned the lyrics for 'Free as a bird', he certainly was not thinking of the lot of the poor Chinese cormorant.

Down by the estuary in January, flocks of whooper swans may also be seen, grazing on the wetlands. These swans are identifiable even without binoculars, simply from the sound they make. Goose-like in their honking, these yellow-beaked birds are easily heard across the morning marsh. I have heard some people romantically describe their call as a song — but, to my ears, the sound they make is a little closer to a squeaky wheelbarrow. In Irish the whooper swan is called *eala ghlórach* — the noisy swan — as opposed to its more common, more taciturn cousin, *eala bhalbh* — the mute swan. An adult male whooper swan can reach up to five feet in length and its wing span can reach an impressive eight feet. When not feeding, swans are often seen in an act of what looks like feather-preening. What they are actually doing, though, is spreading oil from a gland at the base of their tail and rubbing it over their body to keep their feathers waterproof. The whooper swan is a migratory bird, arriving on Irish shores in October from Iceland. It signals its arrival with a celebratory display of wing-slapping and high-pitched whooping, which

resembles an out-of-tune brass band. Its smaller cousin, the Bewick's swan, has become a very rare sight in Ireland nowadays, with very few reaching our shores in the last few years. The Bewick's swan migrates from Siberia. It is thought that the increasing temperature of our planet has made a trip so far west unnecessary, as food can now be found closer to home.

Any time I observe swans, whether swimming serenely on a lake or spreading their wings in flight, I am always reminded of the Irish mythological story 'Clann Lir', which my dad used to tell us as children. Of all the Irish myths I know, I find this to be the most heartbreaking. It tells of the tragic tale of Lir and his four children, Fionnuala, Aodh, Fiachra and Conn. When Lir's wife, Aoibh, dies, he marries her younger sister, Aoife, who becomes madly jealous of Lir's love for his children. Driven by this jealousy, she brings the children to Loch Dairbhreach (Lough Derravarragh) in County Westmeath and, as they swim in the lake, she casts a wicked spell on them, transforming them all into swans. The spell commits them to spend 300 years on Loch Dairbhreach, 300 years on Sruth na Maoile (the Sea of Moyle) on the North Sea between Ulster and Scotland and 300 years on Irrus Domnann (Sruwaddacon Bay) and Inis Gluaire (Inishglora) in County Mayo. The only thing the children are left with is a beautiful singing voice. From the day of their transformation, their despairing father, Lir, sits by the lake and listens to the sweet, sad music of his swan-children.

I often thought of this myth when my dad was diagnosed with Alzheimer's disease. If the two-headed Janus is the god of gates and doors, Alzheimer's is the guardian of a particular door through which, once you enter, you can never go back. Slowly the illness transformed my dad from a kind, intelligent man who had a deeply passionate love for learning into a fragile, broken shadow of himself, sitting blankly by a third-storey window in a Dublin nursing ward. Our family situation was a bit like the 'Clann Lir' tragedy in reverse. My 11-year-old brother and 13-year-old sister would get the 77A bus from Tallaght to Heytesbury Street and sit on his hospital bed, recounting to him whatever they had learned in school that day. Watching him struggle to find the right words hurt us all deeply. Our attempts to communicate often faded into a sad silence, broken only by the sound of the persistently loud TV coming from the next room. A breakthrough came, however, when we realised the magical power that singing had on him. My dad had always had a great love for the Irish language and, when we were growing up, we would often hear him singing songs like 'Oró sé do bheatha 'bhaile' and 'An poc ar buile' to anyone who cared to listen. If not, he would sing away to himself, regardless.

So, when we began singing these old Irish songs, he would suddenly lift his eyes in recognition of the familiar airs, which somehow contained a key to his forgotten door. As we sang, he would slowly begin to tap his fingers on his lap, before smiling and joining in with us. The words of the songs flooded out in a torrent, bursting through the blocked dam of his memory. The irony was that he remembered the words of these songs much better than we ever could. Once the Irish songs were over, we decided to branch further afield. We began to go through his entire repertoire, from 'If I were a rich man' to 'I hear you calling me' and even 'Yes, sir, that's my baby.' To anyone listening from the hall, we must have sounded like a family of wandering minstrels singing for our supper. What we were actually singing for was something much greater. Our half-sung songs had the strange power to find his lost boat and pull it back in to shore for the briefest of moments, before the thick fog inevitably returned and he was lost in the sea of forgetfulness once more.

With each passing year, the storms became more brutal. His sentences split and splintered into single words. Gradually, the words became brittle. Each letter was washed away in the deluge of this terrible illness. In the end, even the songs struggled to reach him. A musical lighthouse scanned the open water and, on good days, it found him and guided him back to the shore. On bad days, the search would be called off with no sighting at all. By the end, our words simply became meaningless, and the only way to communicate was through snatches of old songs that I remembered him

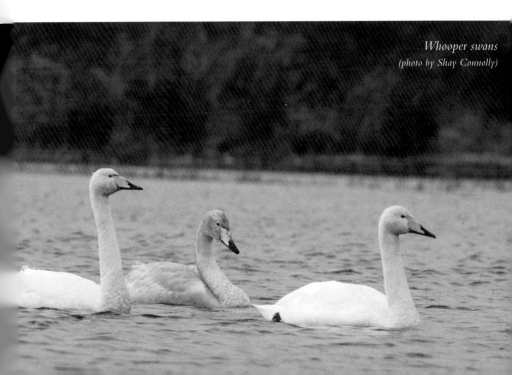

Whooper swans
(photo by Shay Connolly)

singing as I watched him shave as a young lad. An eclectic musical assortment became the soundtrack to the last few years with our dad — a troubadour's miscellany, led by Count John McCormack, Etta Jones and a Jewish man called Tevye, who played his fiddle on a roof.

And what becomes of the cruel Aoife who turns the Children of Lir into swans? Well, she in turn is turned into a *cailleach na spéire*, a 'witch of the skies'. She is doomed to fly above land and sea, never to find peace or rest. Perhaps she is somewhere far away now, a coil around her neck, working the sand-bank rivers for a Chinese fisherman.

For the last few weeks, the bank down by Kilcoole Beach has been frozen. When walked upon, the brittle spikes of grass crunch deliciously underfoot. It is a meteorological paradox that in early January the earth is closer to the sun than on any other time of the year. Five million kilometres closer. Looking out over the wetlands, where the tall rushes are firmly anchored in frozen pools, one would be forgiven for wondering how this could be true. But the reason for the cold weather is not down to the distance of the earth to the sun, but the axis on which the earth lies. The earth's tilt means that, in January, the northern hemisphere is facing away from the sun, with the southern hemisphere tilting towards it. Despite the cold and seeming lack of wildlife, if you look hard enough there will always be something to see, even if it is only a moment of shifting light reflected on a polished sea.

I witnessed one such moment of extraordinary beauty down by the Breaches one evening, when a small, distant dot appeared in the purple twilight. At first, disorientated by the sheer vastness of colour in the sky, I thought my eyes were playing tricks on me, but then another dark dot appeared, and another. They were coming down the coast from Greystones and heading south towards Wicklow Head. As they approached, I could eventually make out that what I was looking at was a flock (or, more correctly, a parliament) of common rooks. Compared to little egrets or lapwings, rooks might be easily dismissed as dull, unexciting birds, the farmer's nuisance. But the sheer number of them was striking. They appeared like a feathered tsunami in the sky. I tried to count them as they flew across the breaking waves, but I lost focus after the first 70. And still they arrived — sometimes in waves of 10 or 12; sometimes in groups of 100 or more, flying directly overhead. There was something trancelike in their flight. No cawing could be heard. The only sound was the soft whisper of wingbeats. And, just when I thought the show was over, another wave appeared, like a lost float in a Saint Patrick's Day parade. I tried to keep focus on the very last bird as it disappeared down the coast and, as I watched it

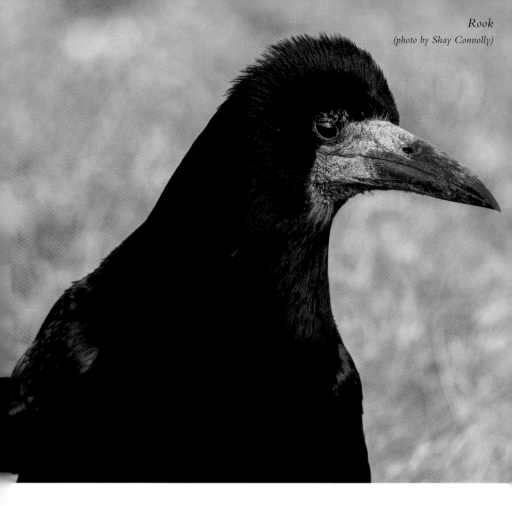

dissolve into the approaching night, a soliloquy from *Macbeth*, Act 3 Scene 2, came to mind. In this pivotal speech, Macbeth looks out on a murder of crows returning to roost before night falls. The collective noun 'murder' is all too appropriate — this is the night when the killing of Banquo takes place:

> Light thickens, and the crow
> Makes wing to th' rooky wood.
> Good things of day begin to droop and drowse;
> Whiles night's black agents to their preys do rouse.

The purple sky was inked black. I was left alone. I do not know whether it was the mesmerising rooks flying down the coast or the troubled lines from *Macbeth* rattling in my head, but I came to the conclusion that it was time to leave the night to its own devices and make my own journey home.

Throughout mid-January, I always try to keep our garden bird-table stocked up with as much food as possible, especially in the mornings. It is a

difficult time of year for wildlife to survive, and a morning visit to the bird-table can be the difference between death and survival. At this time of year, our table is inundated with feathered visitors, all eager to refuel after the freezing night. Chaffinches, great tits, blackbirds and starlings are our most common customers, but we are sometimes visited by song thrushes, wrens and an occasional long-tailed tit. It is a nice way to enjoy the wildlife from the comfort of your kitchen window as you wash the dishes.

Another feature of Wicklow, and indeed Ireland, during the early months of the year is increasingly heavy downpours. A weekend of continuous rain is not unusual and, when it ceases, the wetlands down by the Murrough are sometimes utterly transformed. On one occasion, after the rivers burst their banks, the Breaches looked more like an isthmus, with the Irish Sea to the left and a newly formed lake to the right, where marshland once stood. Rivers themselves have long been seen as a metaphor for the journey of the year and, indeed, of life itself. When the Florentine navigator Amerigo Vespucci was exploring the coast of Argentina and Brazil, he came across what he thought was an estuary to a mighty river on 1 January 1500, and incorrectly named it Rio de Janeiro, or 'river of January'. What he had in fact discovered was a new continent, which he named the New World. It was later termed South America in Vespucci's honour. Unlike the rivers of Brazil, the rivers of January across Ireland are now in full flow. The melt of the high mountain snow raises the level of the water as it meanders its way from mountain source to coastal estuary, providing dependent wildlife with a diverse source of nutrients. The returning salmon and sea trout make their way down the rivers and lakes of Ireland, continuing the cycle of their ancient epic journey out to sea. January is the earliest month in which the fishing season opens. Anglers have been off the water systems since the season closed at the end of September, so the first day of the new fishing season is a red-letter day for them — the real beginning of the new year. The springer salmon is the holy grail of the fishing community and, whenever the season reopens, anglers will be seen by banks and lakes waiting to cast just as the light breaks, hoping that this year they will be the lucky one who will catch the first fish of the season.

By the end of January, the evening light stretches out until half past five before the winter darkness appears. Now we see a noticeable stretch in the evenings and the Irish spring finally begins to stir.

January is a month I also associate with the great wildlife filmmaker and Gaeilgeoir Éamon de Buitléir, whose 1960s nature programme *Amuigh faoin spéir* was the first Irish wildlife programme that reached a mass national

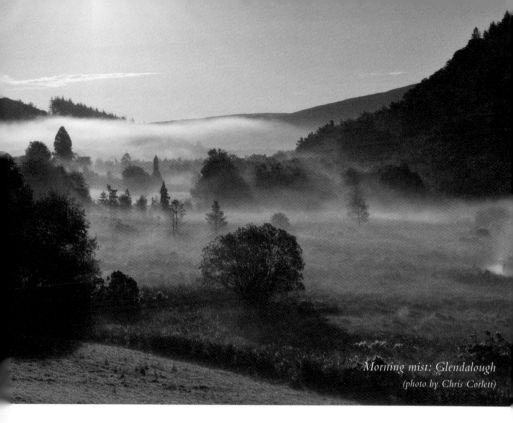

Morning mist: Glendalough
(photo by Chris Corlett)

audience and inspired young nature enthusiasts. I met Éamon on many an occasion, walking along the Murrough with Cara, his obedient labrador. One of the memories I have of him was when I was down by the Breaches one morning, watching some curlews feeding. I heard a man in a khaki-coloured fly-fishing hat call over to me. He was pointing towards something that was moving far off in the distance.

'*An bhfaca tú madraí uisce riamh?*' he asked me. 'Have you ever seen otters?'

He pointed his finger in the direction where I was to look. At first I could not find them through my binoculars, but eventually I had them. A family of otters. The mother was lying languidly on the grassy bank, keeping a watchful eye on her two cubs as they swam and played by the water's edge. An opportunistic grey heron stood close by, hoping the otters might offer up a tasty fish snack. It was a wonderful sight, and when I complimented Éamon on his eyesight he turned and smiled.

'*Bhuel, bhíos ag breathnú ar na hainmhithe seo mo shaol uilig. Tá taithí maith agam, bíodh a fhios agat.*' ('I've been watching these animals my entire life. I have a bit of experience, you know.')

When I heard of Éamon's passing in late January 2013, I instantly thought of the last time I had met him. It was the previous June. Along with Cara, he had a young labrador pup with him, who ran energetically ahead of them both.

'Ar chuala tú an nuacht? Scuab an taoide na huibheacha uilig.' ('Have you heard the news? The tide has swept away all the eggs.')

He was referring to the eggs of the little terns, who return each year to the very same spot on Kilcoole Beach to lay. This is the largest colony of little terns in Ireland, with over 150 pairs. During the summer months the sky is filled with these diving missiles, shooting down into the waves in search of fish. As its name suggests, the little tern is the smallest of the tern family and its arrival from sub-Saharan Africa in May is an important time in the birdwatcher's calendar. Dedicated members of BirdWatch Ireland spend entire summers living in a caravan by the shore, monitoring, protecting and studying the terns. The area where the birds lay their eggs is sectioned off, to prevent walkers from accidentally treading on the precious eggs that are nestled amongst the stones.

Unfortunately, this particular year, despite the great efforts of the BirdWatch Ireland monitors, two full moons in the one month caused very high tides to sweep away all the terns' eggs, not to mention the work and time put in by the dedicated wardens. When the first summer tide hit, there was hope that the terns could lay again and all would not be lost, but when the second came just a week later it destroyed the second batch of freshly laid eggs too. There was nothing more that could be done.

It made me think how fragile the line is between success and failure in the natural world, and how even small changes in our climate can dramatically affect our wildlife's habitat and breeding cycle. Éamon was clearly upset that day by the loss of the terns' eggs, and I didn't realise that that would be the last time I would ever meet him walking along the Murrough. Perhaps he knew that this was his last opportunity to witness this great event and was hoping for one last breeding success; which, in hindsight, made the destruction of the terns' eggs even more poignant. I remember him walking slowly on towards Newcastle, occasionally lifting his binoculars out to sea, the sun warming his back and his dutiful old friend Cara strolling by his side.

The following year my final encounter with Éamon came back to me when I was teaching Philip Larkin's poem 'The explosion' to my senior English class. In this poem, Larkin gives a tragic account of a coal-mining explosion, before and after the event. At the end of the poem the miners' wives are listening to the priest's sermon, when suddenly they have a collective vision of their husbands walking towards them, immortalised.

Larger than in life they managed —
Gold as on a coin, or walking
Somehow from the sun towards them.

One showing the eggs unbroken.

Vartry Reservoir
(photo by Chris Corlett)

February

The real spring had come.
— Leo Tolstoy, *Anna Karenina*

In Leo Tolstoy's novel *Anna Karenina*, he describes the arrival of spring as a reawakening of the natural world. Larks burst into song, bees hum, lambs begin to play under the watchful eyes of their bleating mothers and the snow dissolves into iced rivers, which in turn crack and foam into torrents. Down on the Murrough on 1 February, there is a real sense of the abundance of life that Tolstoy illuminates in his great novel. A flock of lapwing make a rhythmic dance across the clear morning sky. At first a wave of black is all that can be seen, but suddenly they turn in unison like an automated billboard, showing how their lustrous feathers reflect the sunlight with a polished mirror's brilliance. Their dance swoops and swirls, rising higher and higher in a momentous wave of perfect symmetry. What a wonderful choreographed exhibition, and what an enchanting chorus to accompany it. The other name for the lapwing is the peewit, derived from its distinctive high-pitched call, which can be heard quite clearly above all the other sounds on the wetlands as day breaks. The piercing cry rises high into the morning air, before the bird returns down to feed on an open field.

In a little over a month, these birds will begin to lay their first batch of eggs on the farmland, making their young very vulnerable to a keen-eyed kestrel or rook. The male will make a small inlet in the earth with its breast, scraping away the topsoil with its feet, before the female chooses the most suitable scrape to lay her eggs in. When the chicks hatch, she will remain sitting on them to keep them warm and protected — a hard job in

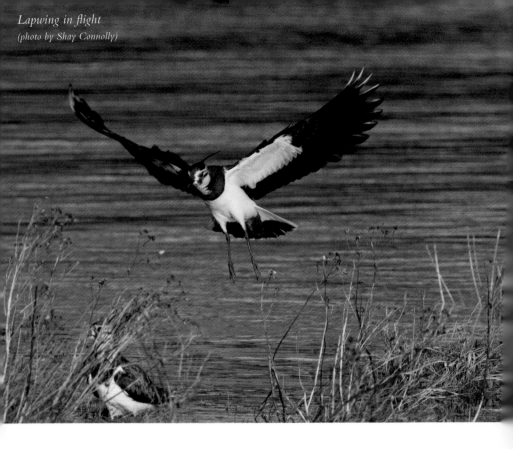

conditions that can only be described as Baltic in these early days of spring.

Spring in Ireland traditionally arrives on 1 February, which is known as Saint Brigid's Day. For centuries, making a Saint Brigid's cross was a traditional ritual all over Ireland to welcome the arrival of new life. Rushes were pulled from the river beds, then woven together and hung on the entrance of doors as protection against fires or disasters. In primary school I remember our teacher bringing in bundles of reeds for us to make these crosses and, years later, when I was beginning my own teaching career in Tallaght, I happened to mention to my supervising inspector that my teaching class was called Rang Bhríd. When this softly spoken old Connemara Gaeilgeoir arrived, he presented the class with a wonderfully crafted Saint Brigid's cross, which he had made that morning on his train journey from Galway to Dublin. That old man's skill and benevolence in crafting the cross was a simple but very insightful way of putting me at my ease, and I went on to teach a fairly good lesson. It was an act of kindness that I often think of, especially at this time of year, when the reed-beds rustle in the cold February wind.

February is also the month when our migrant waders pack their bags and move into the departure lounge. Down on the mudflats when the tide is out, there is a hive of activity where the wading birds gather. The redshank, the

bar-tailed godwit, the knot, the curlew, the sanderling and the dunlin are all feeding as much as they can to bulk up for their long journey north. One of the most distinctive differences between the waders is the size of their bill. The curlew, with its long, curved bill, is the largest of them, and its haunting call travels loud across the Kilcoole wetlands, being one of the most recognisable bird sounds on the marshes. It announces its arrival with a shrill 'coooor-lee', which, like the peewit, constantly reminds us of its name. The curlew's Irish name is *crotach*, meaning 'curled' or 'curved', which is the bird's most distinguishable feature when in flight. I love watching curlews flying in squadrons low overhead, silhouetted perfectly against the dipping sun, with their melancholic call echoing across empty fields. This is the call that inspired W.B. Yeats to pen the poem 'He reproves the curlew':

> O curlew, cry no more in the air,
> Or only to the water in the west,
> Because your crying brings to my mind
> Passion-dimmed eyes and long heavy hair
> That was shaken out over my breast:
> There is enough evil in the crying of wind.

Not to be outdone, the redshank, too, has a characteristic call — a shrill whistle that the bird often emits when startled, before taking to the air. In Irish the redshank is called *cosdeargán*, meaning 'red-legged one', and his red legs and long bright beak make him fairly easy to spot when feeding.

The reason all these wading birds are able to feed in the same area and not be in competition with one another is because they do not feed on the same type of food. The waders with short bills, like the knot, feed along the surface of the mud and sand, whereas the larger-billed waders, such as the curlew and the bar-tailed godwit, go further down to feed on worms and shellfish. On a still morning in early February, the estuary reminds me of a local supermarket, with each bird busily stocking up its trolley with all its favourite products.

Looking out across the Breaches, I cannot help but think of the incredibly long journey these birds make every year. Some of the redshanks that are feeding here have migrated from Iceland, a distance of over 1,500 kilometres. The smaller dunlin arrives from Russia and the ringed plover comes from Greenland. The bar-tailed godwit leaves for its breeding grounds in northern Scandinavia and Russia in April, but returns again in early July — a round trip of 6,000 kilometres. These great distances are even more amazing considering

how small some of these wading birds are. The reason they make such long trips is the change in climate, as well as the availability of food. The Arctic winters are too severe for these birds, so they fly to warmer climates to feed. During the summer months they return north to breed, where the wild, unpopulated areas of Greenland, Iceland, Russia and the Arctic give their young a greater chance of survival. Many people see these birds flying across the fields, or feeding on open mudflats around Ireland, but not everyone stops to appreciate the unimaginably long distances these small birds have travelled to get here. Some stay here to winter, while others use Ireland as an important refuelling stop on their journey further south.

A couple of years ago a number of redwings wintered among the long grass of the sand dunes on Kilcoole Beach. The redwing is a thrush from Scandinavia with a glorious red patch under its wing, which is very conspicuous when in flight. That particular winter was very harsh, and many of the redwings fell victim to the cold. I have not seen a redwing wintering on Kilcoole Beach since. Perhaps they have moved further inland, or perhaps the weather conditions have altered their migratory locations. Aristotle believed that the redwing was actually a summer robin. He documented that the redwing could be seen in winter, but as summer approached it would suddenly disappear. His conclusion was that it somehow went into a quiescent state, like a caterpillar, only to re-emerge as a red-breasted robin. He was not alone in his theory of birds hibernating. Swallows were also believed to hibernate in cliffs or mud swamps, which explained why they disappeared in the winter months. The eighteenth-century Welsh poet Iolo Morganwg (Edward Williams) wrote the line:

And sleep the swallows in their cavern'd rocks.

This shows how the idea of birds migrating to far-off shores seems neither logical nor possible, even for the greatest of minds.

One creature that does spend the winter underground and now begins to resurface after a long, subterranean sleep is the common frog. Male frogs may have used the pond as their wintering quarters. Once they have surfaced, they begin to jostle and clamber for the best position in eager anticipation of the arrival of a fertile female. Frogs are usually silent throughout the year, except during the mating season, when their distinctive frog belch can be heard far and wide, signalling to the female her destination. The female is already heavy with eggs and her journey can often be a difficult one, with many dangerous

obstacles along the way. Herons and large fish are just some of the predators she needs to avoid, as well as the perils of new roads or paths that cut across old breeding routes. If a female does manage to reach her destination and take a fateful leap into the pond, the awaiting males are instantly worked up into a frenzy. If an observer is anticipating a graceful courtship ritual — maybe something along the lines of the intimate displays of affection the emperor penguins perform to one another after their long winter apart — well, he or she will not find it in the bottom-of-the-garden pond in February. This is no place for playing it cool and wooing the lady with a wink from afar. This is every frog for himself, with each bullfrog desperate to mate. The poor female inevitably ends up at the bottom of a sprawling rugby scrum. Finally, one male will manage to latch on to the correct position for fertilisation to take place. Then, when the two seconds of magic are over, the female releases her eggs as frogspawn and the job is done.

Wicklow has one of the largest numbers of frogs in the country. The spawning pools range from sea level all the way up to the top of the Wicklow Mountains, with the wet weather providing perfect conditions for the common frog to thrive. Nowadays, I am delighted to see frogs appearing at the bottom of my own garden as they make their way to and from the stream. But, I have

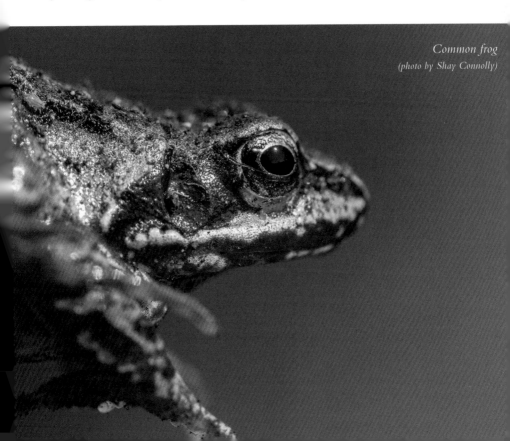

Common frog
(photo by Shay Connolly)

to admit, I do not think I was always so thrilled to see them. The life cycle of the frog (along with that of the butterfly) is something children learn about from a young age, and I remember my own parents showing me the jelly-like frogspawn on the banks of a stream or pond on our Sunday walks in Glencree. I think I felt a mixture of wonder and horror at seeing this strange substance for the first time. And my horror did not abate when I was told that the larger tadpoles sometimes ate their smaller brothers and sisters if they needed extra food. In Seamus Heaney's poem 'Death of a naturalist', he too describes this initial wonder and excitement, as his child-self scoops up the frogspawn in a jam-jar to show his teacher, Miss Walls; and later, his change of attitude when the bullfrogs invaded the flax-dam in their hundreds, filling the air with 'a bass chorus' and filling the boy with a sense of utter dread when confronted with the mating rituals of the 'slime kings' for the first time.

The frog is just one of the creatures that return to the surface when winter comes to an end and the seasons slowly begin to change. The cycles of the sun and the moon, along with the rise in the temperature, have a direct influence on the life cycle of many of our hibernating animals. The hedgehog also returns after its long slumber underground to go foraging for food and, if you are up early enough, you just might see one scurrying surprisingly quickly across your garden lawn under the light of the moon. Traditionally, a full moon was seen as a harbinger of doom. That is a myth that most people would dismiss today as superstitious but, in the natural world at least, there may be a modicum of truth to it. Nocturnal animals are inclined to hunt during full moonlight, which gives them a better opportunity to see their prey, but this of course means that they are vulnerable to being seen and predated themselves. Badgers can be also influenced by the waxing and waning of the moon, often choosing the cover of darkness during a new moon as the best time to mate.

One of the great advantages of living in Wicklow is the lack of light pollution compared to Dublin, which gives you a great opportunity to observe the night sky in all its unspoilt splendour. Looking at our shifting moon through a telescope is a humbling reminder of the incredible diversity of life that exists on our planet. All life that has ever been (as far as we know) is sitting on a moving ball of rock that is travelling through space at 110,000 kilometres per hour. There is a primal wonder that sets humans apart from all other life on earth. It's a wonder that compels us to look up at the infinite blackness dotted with celestial light and pose questions about our very existence. Perhaps it is the same primal impulse that draws us back to the sea's edge, where we listen

to the heartbeat of the earth's rhythmic tide as it whispers the mystery of our origins.

In James Knowlson's memoir on Samuel Beckett, the theatre critic Ruby Cohn recounts how Beckett once told him that Casper David Friedrich's painting *Two men contemplating the moon*, which he first saw when visiting the Alte Nationalgalerie in Berlin, was the original inspiration for his play *Waiting for Godot*. In the Friedrich painting, of which there are several versions, two figures stand by a dead tree and peer at the rising moon over a desolate landscape. The similarities between these paintings and Beckett's play are clearly obvious. The hopelessness of the tramps Vladimir and Estragon is there for all to see, with the unescapable bleakness of their surroundings punctuated by their constant longing to look up, observe and contemplate something meaningful and great, like the silver light of the moon, which illuminates the inner darkness of their own private existence.

It is easy to forget, with our fast, busy lives, that we are a very rare, if not unique, form of life, living on a very vulnerable piece of rock in a galaxy of perhaps 400 billion stars. Indeed, many of us have forgotten — or have never been taught — the importance of looking up at the night sky. Einstein famously said, 'Look at the stars and from them learn.' The stars answer some

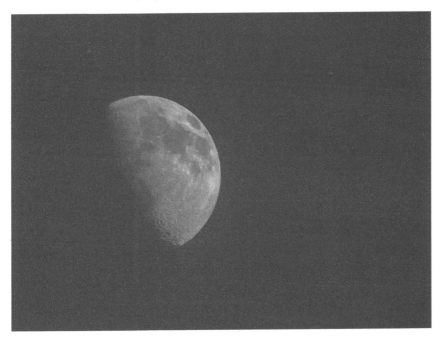

Waxing gibbous moon or winter moon (photo by John C. Murphy)

of the fundamental questions about the mystery of life on this planet and life here is connected with everything else in the universe. It is easy to forget that we are just a small planet with a wafer-thin atmosphere, orbiting an average-sized star that is halfway through its lifespan. Our daily preoccupations can distract us from taking a moment to contemplate the majesty and complexity of our universe and our place within it. But I think it is important to take a moment to look up in wonder.

Children in primary school are taught about seasonal changes and their effects, be it the changing colours of leaves in October to the newborn lambs in March. They react with an innocent sense of wonder, which is often lost when we 'grow up'. We often forget that the 23.5-degree tilt of the earth is the reason we have seasons in the first place. Without the tilt, our world would be a vastly different place, where we would experience very hot summers and very cold winters. And the cause of the earth's tilt? Well, the answer is sitting above our heads. When our infant earth was still a ball of molten lava in the Hadean Eon, over four billion years ago, so the hypothesis goes, a planet called Theia collided with us. As well as causing our planet's tilt, the colossal impact spewed chunks of molten rock out into space, which cooled and fell into orbit around the earth. These smaller pieces of rock gradually formed one large rock we now refer to simply as the moon. When we look out to sea, it is easy to forget that it is the gravitational pull of the moon that causes high and low tides. It literally pulls the huge mass of water away from the shore. The movement of the tide and the seasonal changes are events we accept as part of our world, without really thinking about how they came to be. Only when we have rare cosmic occurrences like an eclipse or a close-passing asteroid do we stop to take note.

If we look back in history, we see that our ancestors had a much better innate understanding about the wonders of the sky than we do today. Our knowledge of the universe is vastly superior to anything the Egyptians or the Incas contemplated, but on a day-to-day basis astronomy played a greater role in their lives. Of course, they would not have called it astronomy. Mostly it was religious worship. Many ancient civilisations looked up at the sky in awe and wonder and celebrated this wonder by building spectacular structures around the light of the stars. From the Mexico to Peru, from the city of Kairouan in Tunisia to ancient Egypt, from Newgrange to Stonehenge, we can still see the evidence of how in tune our ancestors were to the changes in their natural environment and the light that came down from above. Their survival most likely depended on it. Their curiosity was often based on a religious belief that

the sun was a god and a giver of life. Today there are very few people who would believe the sun to be a god, but nobody can be in doubt that it is our source of life.

So, when I look out at the waders feeding on the Breaches and I think of the far-off countries that these migratory birds have flown from and will in a few months return to for breeding, I think about the inevitable question: how do they know where and when to go? The answer to this is not fully understood, but it is strongly believed that the position of the sun and the stars and the amount of daylight available have an important role to play. Even the young, who have never made the journey before, can find their way back to their breeding grounds. The key to their navigational ability seems to be that they know instinctively where the sun is in relation to themselves, whether they are travelling from north to south or from south to north. They can also tell where the sun should be at a certain time of the day. If a swallow is travelling north, it will keep the sun behind it to its right in the morning and behind it to its left in the afternoon. And yet, some birds often travel by night, like the redwing, who leaves Scandinavia as the sun sets. This suggests that it is not simply the sun that birds use for guidance, but star constellations too.

This ability to use the sun and stars as a guide to direct their path is remarkably similar to how sailors used astronomy to keep them on course before the use of detailed maps and satellites. The Phoenicians were a seafaring people based in the Fertile Crescent, off the eastern Mediterranean coast, around 1150–300 BC. They were blue-sea sailors who went out in search of distant trading ports across the Aegean Sea. The Phoenicians were a highly industrious people and the most famous gift they gave to the world is something that is used prolifically to this day. Before them, writing was done through symbols like Egyptian hieroglyphics. But, with a revolutionary new invention, writing abstract thought was possible. Today, we call it the alphabet.

These bronze-age coast-dwellers were obviously keen observers. They believed the Pole Star to be static in the night sky. This star, also called Polaris, is the point in the northern hemisphere around which all other star constellations seem to rotate. Using this star as a marking point when they were sailing out on the open seas in their horse-headed boats, the Phoenicians were able to navigate their open-sea journeys with great accuracy. This was a brilliant piece of astronomical observation that opened up the bronze age to a world of cross-channel trading. But, as brilliant as the seafaring Phoenicians were, it would seem that migratory birds had already been using the same technique for millions of years.

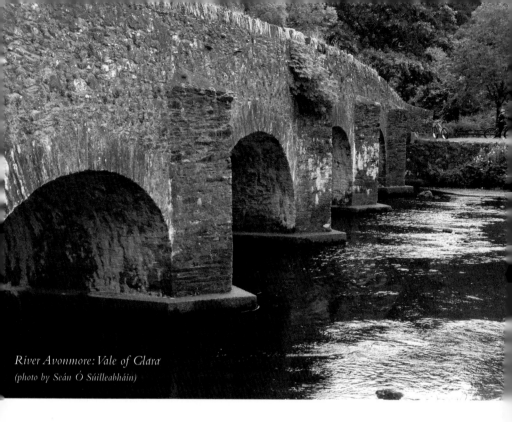

River Avonmore: Vale of Clara
(photo by Seán Ó Súilleabháin)

In fact, it is also believed that birds have an even greater ability. They can sense the earth's magnetic field and use it in flight — like an avian GPS system, minus the robotic voice. The homing pigeon is perhaps the most famous example of a bird that uses magnetoreception, but it is not only birds that have this ability. Bats, insects and even bacteria have shown evidence that they too respond to the earth's magnetic field. How they manage this was until recently a biological mystery that left even the greatest scientists scratching their heads. However, one bird eventually helped shed light on this mysterious phenomenon. This was a creature you might see feeding on your garden bird-table — the homely, unassuming robin.

Professor Henrik Mouritsen from the University of Oldenburg investigated the theory that robins navigate using the earth's magnetic field. He placed a robin in a cone-shaped capsule lined with scratch-sensitive paper, which he placed in turn in a purpose-built magnetic birdcage. When he changed the artificial magnetic field, he could see how the robin responded by the scratches left on the paper. When the professor covered the robin's eyes, the magnetic compass was cut off, suggesting that the robin was sensing the weak force of the earth's magnetic field through its eyes. He found that a chemical reaction was triggered by the light particles in the robin's eye, creating a strange phenomenon called quantum entanglement. Light protons created

entangled electrons that were mysteriously connected. Tiny variations in the earth's magnetic field changed the way the electrons in the robin's eyes were entangled, forming the robin's compass.

From the most massive objects in our night sky to the infinitesimal world of quantum physics, nature responds to the world around it in the most amazing ways. In my own back garden there is a resident male robin who is a regular visitor to the bird-table, and every morning he defends his territory fiercely when challenged by other intruders. When I look out at him feeding on the table or perched on a branch, I find it incredible to think that such complex physics is taking place behind his dark, mysterious eyes.

As February passes to March, birds like the robin have to face a new challenge. Just like in Friedrich's painting of the moon, the month of February offers a glimmer of hope. The barren landscape we see in his painting could have been taken from any woodland walk around Wicklow at this time of year, with its dark, overhanging, leafless branches. February can sometimes resemble a jailer, unwilling to loosen the chains and set spring free. But, just like the illusion of our silent and unmoving universe, we know that last year's winter must eventually give way to this year's new beginning. Nothing is constant. The seeming lifelessness of winter is like everything else — a slave to time. February may look and feel like winter, but things are already beginning to stir. It may be out of sight for now but, under the surface of the dark earth, or in the belly of doe or ewe, or bursting through seed and egg, new life will soon be here once more.

One of the places I love visiting at this time of year is the quaint hamlet of Clara, situated halfway between Rathdrum and Laragh, just off the R755. I enjoy walking these woods at any time of the year, but I always make a special effort to return in February, just as the bare winter trees are beginning to show the new-year's life once again. This small hamlet consists of a couple of cottages, a narrow stone bridge that crosses the Avonmore River and the picturesque Saint Patrick's and Saint Killian's Church, which was built on the banks of the river in 1799. Any tourist that visits here will think that he or she had just stepped onto the set of *The quiet man* and will be impressed by the quaint, unspoilt beauty and picture-postcard setting. Saint Patrick's and Saint Killian's is a very popular church for weddings, and my own grandparents stopped here in February 1943 during their cycling honeymoon to Cork. I think this would have been a very romantic place to bring your new spouse (even if cycling 70 miles on an old Raleigh over rough terrain might not be the ideal honeymoon for some people nowadays).

It is interesting that we use the phases of the moon to quantify the sweet beginning of our journey into married life. In some traditions the word 'honeymoon' (or *mí na meala* in Irish) is thought to have derived from the drinking of mead in celebration of the first month of marriage, which would hopefully result in the newly married couple being blessed with a child before the first year had passed. Samuel Johnson, on the other hand, had a much more cynical understanding of the word, stating that the first month of marriage is always the sweetest, before love begins to wane, just as the moon does. Well, mead or no mead, my grandparents had a very happy life together, raising four children. The Vale of Clara was one of the resting places along their journey.

Just a little further up the hill, to the right, is the Vale of Clara Nature Reserve, with its various looped walks that run through an ancient sessile-oak wood along the banks of the Avonmore River. This wood has been designated a Special Area of Conservation under the EU's Habitats Directive because it is one of the most extensive oak woods outside of Killarney National Park. Clara is one of the glaciated valleys of Wicklow and, along with native oak, holly, birch and hazel also line the steep river valley. It is the solitude of these woodland walks that attracts me, with the constant murmuring of the river flowing over shale and sandstone the only sound to be heard along the way. Startled deer sometimes appear on the woodland track, before quickly plunging into the thick bracken. Jays, dippers, wagtails and blackcaps can also be seen along the river path, and the surrounding oak woods are home to kingfishers, long-eared owls and treecreepers.

Back by the church, there is a memorial stone carved in memory of the men who left here in 1914 to fight and die in the Great War. It is hard to imagine a greater contrast between this beautiful setting, which exudes the peace of natural beauty, and the deadly killing fields of Flanders. The three men who are commemorated on the stone are Patrick Cross, Christopher Meegan and William Murray, all of whom were in their early twenties when they were killed in action. Reading their names aloud, I wonder what drove these men to leave the safety of their homes in this heavenly valley, to die an inglorious death in the trenches, or to be cut down in no-man's land, or to be stretchered off to die in blind agony in a makeshift field hospital. I wonder whether, in their moments of despair, they thought of the narrow stone bridge by the river, or the small white chapel with its bell calling them home. I wonder whether any other young men from this area survived to return and look down upon the cold, flowing river once more. And, if so, did the beauty of the Wicklow landscape help to cleanse them of their inward

horror, or had their experiences coloured the brown water of Avonmore an irrevocable crimson?

Another woodland walk that is well worth a visit is the Devil's Glen, situated about three kilometres above Ashford. This wood is located in a valley that was carved out by the meltwater of a glacier two million years ago and, if you take the top path, you are offered impressive views of the entire ancient valley. From this path, the sea is just a faint blue ribbon in the morning mist, where you can follow the meandering journey of the Vartry River over field and hill, until it eventually reaches its end at Wicklow town.

Along the walk an arboreal tunnel of birch and oak covers the leaf-sodden path on either side but, at this time of year, the bare branches are powerless to block the morning sun that occasionally bathes the undergrowth in shafts of light. On the opposite side of the valley, fir trees stand tall and straight like Irish Guards, rigid against the stubborn mosaic patches of snow, the last bastions of winter. Tree trunks lie sprawled across parts of the woodland way, having fallen victim to a night winter gale, where only the blackbird and the badger stood witness to their dramatic end. Along the path, unobtrusive wood carvings and sculptures appear unexpectedly from the trees. At one

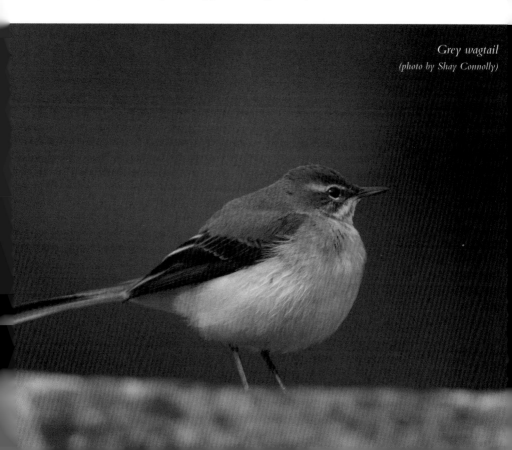

Grey wagtail
(photo by Shay Connolly)

point you can stop and look through an empty window frame that hangs from a low branch. The picture it frames depends on the season, the light, the weather and even the viewer's position, meaning that each view is unique to that moment. It also entices the passer-by to stop and look back at the vista of this glacial carved valley. And what a view it makes, even in colourless February. The secluded wooden sculptures that are to be found along the trail add a sense of childhood fun as you stumble upon a new engraving or spot a hidden carving amongst the rocks. This is an open-air art gallery of the very best kind. Many of the sculptures have been broken over time — blown down by the wind or knocked over by a falling tree. Some are stained with moss or fungus; others have cracked and split. Nature has reshaped and recoloured them like an old master putting the finishing touches to an apprentice's work. When we visit an art gallery, we are usually looking at a creative process that is complete. We see the final outcome but are not privy to the actual process. But here, the work has an unfinished quality that makes each visit that little bit different. I think of the amount of time and thought each artist must have taken to carve out and polish these wonderful sculptures, knowing that over time nature would inevitably claim ownership once again.

Following the path down a slope to the right, you arrive at the bank of the river, where dippers might be seen bobbing from one rock to the next. Grey wagtails are also common visitors here. They often perch on a branch or a stone, their long tails fanned open with all the elegance of a Japanese Noh actor. It is at this point in the walk that you can hear the end of the path before you see it. Seamus Heaney describes the waterfall as a 'helter-skelter of muslin and glass' as the water spills and crashes on the rocks below. Is this the waterfall he was describing when he wrote that poem? Probably not. In that poem he is looking over and downwards, creating a sense of vertigo as he watches the violent crash of the breaking water. But at the Devil's Glen Waterfall your eyes rise up to the rocky opening where the River Vartry explodes into the valley.

Any time I come here I get a sudden surge of energy as I watch the billions of droplets plummeting downwards in the violent white spray. I stand and observe from the safety of the path — cautious, but enthralled, as if observing a majestic wild animal that could attack at any moment. At this time of year, the melting snow increases the intensity of the flow, which echoes ceaselessly through the otherwise silent valley. This is the source of the great, endless roar of the river.

As well as the wooden sculptures, some lines of poetry that can be found carved amongst the rocks. Some are lines taken from Seamus Heaney's work,

written in his creative sanctuary down the road in Glanmore. Others are simple observations — the broken thoughts and conversations of visitors as they walked through the valley. One of my favourites is, 'Look at the dog run here. At home he seems so old.' But the one that has stuck with me above all others is this carving by the waterfall, which simply reads, 'When I find the ring I'll propose.'

On a beautiful February morning I did find the ring and I kept my promise. And, echoing Molly Bloom amongst the rhododendrons up on Howth Head, she too said 'yes I will Yes'.

Bray Head
(photo by Seán Ó Súilleabháin)

March

The earth invalid, dropsied, bruised, wheeled
Out into the sun,
After the frightful operation.
She lies back, wounds undressed to the sun,
To be healed ...
— Ted Hughes, 'March morning unlike others'

In Ted Hughes's poem 'March morning unlike others', nature is a convalescent recovering from winter's 'frightful operation', with open wounds being soothed by the balm of spring. Larkin also celebrates this cycle of rebirth in his poem 'The trees', with each spring returning 'afresh, afresh, afresh'. Tolstoy may have described February as the 'real spring' but, in Ireland at least, it is only with the arrival of March that we can visibly mark nascent life reawakening from its cold, deep slumber, with the budding of the golden daffodil leading the charge. We now enter the season that embodies nature's eternal promise of hope — the hope of longer days; the hope of emerging green buds on bare branches; the hope of fragile life being protected inside the shell of a sky-coloured egg. And yet, looking out my window on a wet, misty morning, branches and bushes sagging heavy with last night's rain, well, nature's promise of hope still seems a long way away.

March is the most unpredictable of months and any type of weather is possible — not just in the one month, but often in the same afternoon. Hail, rain and sunshine can all appear, one after the other, and sometimes it's a strange confusion of all three at once, which makes picking suitable clothing a game of roulette. Later on in the month, the evenings will noticeably retreat,

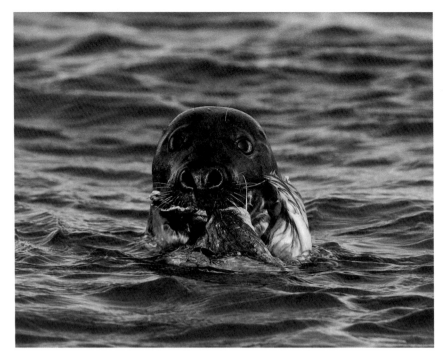

Seal (photo by Shay Connolly)

until we finally share an equal amount of both light and darkness with the arrival of the spring equinox on 20 March. From then on, the darkness of winter will finally begin to give way to bright summer evenings. But for now, March begins with the all-too-familiar greeting of a frosty coldness that is as harsh as any winter's day.

Walking the coastal path from Kilcoole to Greystones can turn into a real test of endurance on a windy morning in March. It has the ability to lull you into a false sense of security. What began as a pleasant stroll can spiral suddenly into a bitterly cold trek by the shore. On such a day, when snow spits sideways into your face and the black-backed gulls struggle for mastery over the upwards gusts of wind, you would be forgiven for cutting the walk short and returning home. It is a clear sign that times are bad when our largest gull is forced to fly inland to escape the harsh conditions of the open sea. In moments like this, I often accept defeat and make my hasty retreat. But even the retreat is not easy. The fierce wind makes it almost impossible to walk upright, confounded by boots sinking into the moist sand. Even the gulls' desperate cries are vanquished by the roar of the insatiable waves, the leviathan call of the sea as it swallows a mouthful of shingles with every

break. It drags them down like drowned sailors into its bottomless gut, before spewing them out again in a violent crash of froth and spray. The only other brave souls to be seen on days like this are the determined dog-walkers. I admire the dedication of these people, who give their pet a run out no matter what the weather. However, I cannot help but think that both human and dog would be somewhat happier in the comfort of their home.

The parenting skills of any early breeding birds will be severely tested in such inclement March winds. What a time to be born into. The only creatures that seem to be enjoying themselves are the resident seals that bob up and down amongst the swell. They're at home out there, with their smiling, hairy, moon faces beaming towards the shore, safely wrapped up in their warm blubber, contentedly riding the rollercoaster waves.

Along with the cold, March also brings the rain. Even the water-loving alder tree at the bottom of our garden seems miserable in the biblical downpours that this month brings. The pattern of extreme weather we have seen in recent years, with freezing winters and record hot summers, does seem to suggest that global weather patterns are shifting. I know some people become exasperated when our localised bad weather is confused with climate. Has weather such as this not been with us forever? Has it not, indeed, been the backdrop to some of literature's tragic scenes? King Lear knew the effect of such weather when, in Act 3 Scene 2, he screamed onto the stormy heath:

Blow, winds, and crack your cheeks! rage! blow!
You cataracts and hurricanoes, spout
Till you have drench'd our steeples, drown'd the cocks!

And in Thomas Hardy's novel *The return of the native*, Eustacia feels the driving rain on her face as she attempts to flee under the darkness of a wild stormy night. The doomed heroine's chaotic mind mirrors the destructive weather as she stumbles over furze-roots and pools in her desperation to escape her unhappy marriage:

It was a night which led the traveller's thoughts instinctively to dwell on nocturnal scenes of disaster in the chronicles of the world.

And yet, the question remains. Are our seasons becoming more dramatic? Are our once-clement winters becoming colder? Are our springs becoming

wetter and our summers warmer? If we look at how weather records have been repeatedly broken in the last few years, it does seem that this may be the case. If this heavy rain continues indefinitely, there will be serious problems for crop growth, which in turn will affect farmers putting their cattle out to graze. From a wildlife point of view, it will mean that flowers will not be pollinated in time, which will create a shortage of food later on in the year. It reminds us once again how dependent and vulnerable we all are to even the smallest of changes in our natural climate.

Whenever there is a brief respite in such conditions, one of the first places I return to is the cliff walk from Greystones to Bray. The original walk began by the Beach House pub and wound its way around the North Beach, leading to dramatic viewpoints at the top of Bray Head. However, in the last few years, the eroded walkway has become too dangerous, so the council has moved the trail back a few hundred yards from the coast. The views may not be as spectacular as they were from the original path, but this precaution was definitely necessary. The reshaping of the cliff face is a stark reminder that the island we live on is being constantly moulded and crafted by the elements. We think of these geological changes as being gradual, extending over extremely long periods of time — but, according to Richard Nairn in his book *Ireland's coastline*, the erosion of the cliffs in Greystones is occurring at two metres per year, often with sudden and dramatic consequences.

An example of such a geological reshaping of the coast can be seen on the now-abandoned Greystones cliff path. An old fence that once protected walkers from the unexpected drop off the cliff's edge has itself fallen victim to the continuous pressure of erosion. The fence still remains attached at both ends of the protruding landmass, but for about ten feet it sways in mid-air like a forgotten clothesline. The soft, sandy soil of the cliff has crumbled away over time, leaving the fence hanging there, a humiliating reminder of our futile attempts to control the effects of time.

In Rebecca Solnit's walking book *Wanderlust*, she looks upon a walking trail in the same way Heraclitus looked upon a river, never being able to step on the same path twice. The act of walking for Solnit is an entirely different type of movement from travelling by car, bus or aeroplane. These mechanical modes of transport cut time into sections of disconnected space, in which the body is stationary and confined. But the act of walking does the opposite. When you set out to walk along the coast, or climb up a mountain trail, you become part of that movement that occupies space and time. You become part of the immediate present; your thoughts and movements combine to

create not just a physical landscape but a mental one too. I suppose that is what Solnit means when she says that, each time you walk a well-travelled path, the experience will always be unique. From a physical point of view, the light is constantly changing; the selection of people you meet along the way makes each experience different from the last; and, of course, there's a great dichotomy between walking with somebody and choosing to make the journey alone. All of these physical circumstances influence how we experience the space around us and at the slow pace of walking we learn to observe our surroundings in great detail. But, even more than the physical stimulation, it is the mercurial nature of our mental processes that never lets us travel the same path twice. Our thoughts are inspired by what we see along the way, by something someone says to us, by whether we are happy or sad, relaxed or stressed. Body and mind find an equal, complementary pace when walking, which often helps to clarify our ideas and solve our problems.

The cliff walk has been altered, with a new harbour and marina being built in Greystones that will eventually have capacity for 230 berths for visitors who are travelling around the scenic eastern coast of Ireland. A new town square is planned to connect with a boardwalk lined with cafés, shops and private residences, which will in turn link up with the Greystones to Bray cliff walk. The old Victorian pier was badly in need of restoration and it has now

Kestrel
(photo by Shay Connolly)

been replaced with a southern and northern pier, along with club houses for sea scouts, divers and anglers. It is on this old pier that Krapp experiences his revelation in Samuel Beckett's play *Krapp's last tape*, with 'the wind-gauge spinning like a propeller'.

Similar to Krapp's wind-gauge, many local residents criticised the new construction as a vanity project that had spun out of control, with their concern exacerbated by Ireland's economic crash, which resulted in the project ceasing entirely. For a while it looked like it was never going to be completed — but, as a result of new investment, construction has resumed once more and it is planned that it should be completed by 2020.

Because of the construction taking place, the beginning of the cliff walk at Greystones is not my favourite part of the walk, but the track heading up to the cliffs does have its own charm. In summer, the white gramophone-shaped flowers of the hedge bindweed fuse with the poker-shaped flowers of the purple loosestrife, while in autumn the brambles become full with dark blackberries. Once you reach the path that cuts through a barley field, you begin rising up towards the cliffs. In March, when the weather is mild and the sea is calm, sailing boats bob lazily around the coast, while above a clearing in the trees a hovering kestrel might be spotted, searching for any movement in the undergrowth. The kestrel used to be one of our more common raptors, but has suffered a decline in the last few years. Gerard Manley Hopkins described this beautiful bird as a 'dapple-dawn-drawn Falcon' in his poem 'The windhover', because of its ochre-spotted back. Kestrels can be sometimes seen along roadsides and are relatively easy to identify. The name of the kestrel in Irish is *pocaire gaoithe*, which translates directly as 'wind romper', which gives us an idea about the kestrel's unique method of hunting. It is the only bird of prey that can remain motionless in mid-air for minutes on end. The kestrel faces its head into the wind and moderates its wing strokes to match the wind's speed, keeping its head completely still so it can remain focused on potential prey.

One of the main features of this walk is the railway track that seems to be precariously built on the cliff edge. The single-rail track was first built between the years 1854 and 1856 under the instruction and guidance of the great civil engineer Isambard Kingdom Brunel. It is remarkable that the railway-builders were able to tunnel through the shale and quartzite rock, the oldest of which dates back to the Cambrian Period, 500 million years ago. When the line was completed in 1856, Greystones was finally connected to Bray by rail. Nevertheless, some people caustically referred to the line as 'Brunel's folly', owing to the constant maintenance it needed.

Kittiwake (photo by Shay Connolly)

Although the original track has been moved back since its first construction, the views out to sea and down the coast remain as spectacular as ever. The railway journey only takes ten minutes, but the sensation that you are speeding over the sea makes this a train ride to remember. Despite its proximity to the cliff edge, there has thankfully been only one major accident on this line. In 1867, subsidence of loose rocks caused the collapse of a bridge known as the Ram's Scalp Bridge by the Brandywell Viaduct, which resulted in a passenger train derailing. Two people were killed and twenty-five were injured. Before the construction of the railway, there was also a huge cave called Brandy's Hole, which was often used as a landing depot for smugglers who were bringing in tea, silks, wine and gin under cover of darkness so as to avoid paying customs tax.

In March, small pockets of yellow gorse begin to sprout across the rising cliff face, and by early summer the entire hillside will be ablaze with its amber flowers, filling the salt sea air with the faintest whiff of coconut. Down by the rocks, cormorants perch with their wings spread wide to dry in the morning sun. Some bob up to the surface before diving down in search of fish, while others use their ungainly method of running on the sea to gain momentum before taking flight.

One of the most distinctive calls of the cliffs comes from the nesting kittiwake, which can be seen nestled in among the steep, precarious ledges so as to avoid disturbance from animal predators and humans. With its soft, white plumage and pool-black eyes, this seabird looks almost teddy-bear cuddly. In Victorian times, kittiwake eggs were eaten as a delicacy and the kittiwake's feathers were used by Victorian milliners to make expensive hats. The kittiwake is unusual as it remains on the nest the entire time, even when approached. This made the bird a very easy target for poachers if the nest was easily accessible. However, despite appearances, it does have one unique defence mechanism. It has the surprising ability to spew out vomit from its stomach, which will either startle and scare off an unwelcome intruder or damage the feathers of a would-be attacker. Apparently the projectile vomit smells quite bad, too. The female calls constantly to the male, 'kittiway-ee-ke', to remind him of his duties. Once the job is done, this pelagic bird will return out to the open seas and will not be seen again until next year's breeding season.

Further along the walk, as you near the Bray side, you will see Lord Meath's Lodge on your left. This was the border between the land owned by the Railway Company and Lord Meath's estate. Back then, if you wanted to continue walking, you had to pay a penny as an entry fee at the toll gate. Following the steps beside the toll house, you would arrive at Killruddery House, where Lord Meath built a carriage walk so that his guests could enjoy the views from the top of Bray Head. Whenever I pass by, I try to remember to leave a coin on the dilapidated wall — a token in honour of the old custom.

In the next few months these cliffs will become the home of thousands of birds like razorbills, guillemots, gannets, Manx shearwaters and fulmars, as well as some of the resident common gulls and cormorants. All these birds will compete for nesting ledges and food for their young. In some places, the rock face will look like the white cliffs of Dover, with bird droppings covering the rocks and precipices. The cliffs will be a constant hive of activity with a glorious cacophony of cawing, screeching and wailing that will carry on into late August. Just as the waders are preparing to leave, our new noisy seabirds will be preparing to unpack their bags. For me, the call of the cliffs is one of the great sounds of summer, but there is one seabird in particular that makes a distinctive sound which can be quite disturbing if heard late at night. Richard Dawkins tells the story in his book *The God delusion* of a group of friends who thought they heard the devil speak to them one night when they were camping by a cliff face in the Highlands of Scotland. Only after telling some local

Killruddery House
(photo by Chris Corlett)

of their horrific experience did they realise that what sounded like the devil screaming was in fact the call of the Manx shearwater. This black-and-white pelagic bird arrives in the spring and burrows into the cliff face. If disturbed, it makes a most alarming call, which can only be described as a cross between radio static and an angry, asthmatic witch.

One sound that is not heard any more on the eastern coast is the iconic call of the corncrake. Once a frequent summer visitor to our shores, its breeding population has spiralled into a serious decline in recent years and is now in critical condition in Ireland. One of the main reasons for this bird's alarming decrease in numbers is how farming practices have changed over the last century. The corncrake is a ground-nesting bird that lays its eggs in hay fields between May to August, but many of these nests are destroyed by early mowing and mechanical hay-making machines. This has resulted in the corncrake abandoning traditional nesting grounds. It is sad to think of the male corncrake singing out in his rusty-fishing-reel call through the night, and no female there to respond. Corncrakes are very shy, secretive birds and are usually only noticed when singing. Their light-brown plumage disguises their location amongst the tall grass, which can also be a problem for farmers, who fail to see them when working the land. Corncrakes have a funny little walk, a kind of scurrying run, with head bowed in a subservient manner, as if playing

a continuous game of hide and seek. Despite their serious decline throughout the country, conservation measures have ensured their survival in Counties Mayo and Donegal, with between 120 and 150 pairs still nesting in Ireland.

Back down by the wetlands of Kilcoole and Newcastle, this is a good time to see the geese flying in formation towards the sea. These may be the first departures setting off on their long journey back to Iceland and Arctic Canada, or they may be test runs, intended simply to practise flight patterns and strengthen wings. As March draws to a close, the sound of the marshes begins to change again, with some waders having already departed. Black-tailed godwits use Kilcoole as a resting spot as they venture up the coast towards their northern nesting sites in Iceland. The last week of March and the first few weeks of April are an in-between period, where our winter visitors are just leaving and our early summer visitors are arriving. It is around now when the first sandwich terns will be spotted feeding off the coast. These are the first arrivals who perhaps caught a tailwind that helped them on their way from sub-Saharan Africa to wet and windy Wicklow.

As inconvenient as this wet weather is for outdoor enthusiasts, it can be a matter of life and death for the struggling wildlife. If temperatures drop too low, nesting birds may not be able to find enough food to keep warm and may even be forced to abandon their eggs. Also, with rivers bursting their banks, many ground-nesting birds will have their eggs swept away in spring floods or high tides. In places like the Murrough, the Shannon Estuary or Bull Island, salt water flows into the estuary, carrying silt and organic matter, while the river carries the debris from the land down to the sea. Where these two waters meet, mudflats are formed. It is here that all the rich and nutritious food gathers, explaining why the mudflats are such a popular habitat for local wildlife. This habitat entices some rare birdlife like the little tern to our shores, and the success of a relatively small nesting colony in this area can have a huge impact on the European population numbers as a whole. It is not only birds that thrive in this unique environment. Mammals like the otter and the fox also benefit from these rich conditions. But when the weather is as challenging as it is this month, both birds and mammals are forced to adapt in the best way they can if they hope to survive.

Underneath the sand marshes lies another unseen world teaming with life, vital for the sustenance of this rich natural habitat. Ragworm and lugworm are the staple diet for many of the waders, while shrimp and the young fish that swim into the estuary supply birds like the grey heron, the little egret and the kingfisher with their favourite meals. Unfortunately, however, in the last few

years, this food chain has come under strain. Local fishermen say there has been a noticeable decrease in the size and species of fish being caught along the beach. Twenty years ago, Kilcoole Beach was noted for its abundance of codling, plaice, dab, ray, pollock, mackerel, coalfish and dogfish. It attracted anglers from all over Ireland and further afield and angling championships were held here each year. This is not the case any more, since many of these fish do not visit the north-Wicklow coasts in the way they used to. The impact of unregulated whelk-fishing and mussel-dredging is damaging the marine food chain in this area and the fall in numbers has affected the numbers across the eastern coast.

The Vartry River also plays an important role in the health and number of our river fish. Brown trout, sea trout and salmon all use this river as a breeding ground and are sensitive to the run-off pollution, especially at the stretch of the river where a sewage-treatment plant was built. Thankfully the river has now been designated an EU-protected salmonid river, which begins at source, high up in the Sally Gap, before it makes its way into the Vartry Reservoir at Roundwood. The lower reservoir was built between the years 1862 and 1866, with the upper reservoir being built in 1923. The Vartry scheme supplied a clean source of water to the people of Dublin and the surrounding suburbs,

Sunset over Vartry Reservoir
(photo by Chris Corlett)

who until then had been forced to drink the unclean water from the canals, which spread cholera and typhus among the population of the city. The new water supply, which was piped from Stillorgan, made a huge difference to the health and well-being of the capital. James Joyce honours it in a number of references to 'fresh Vartry water' in *Ulysses*. Even though it is an artificial lake, nature and time have moulded this place into a scenic sanctuary of natural beauty and it is home to an abundance of wildlife, including the stunning great crested grebe.

Flowing on from the reservoir, the Vartry plunges over the Devil's Glen Waterfall and then under the protected Nun's Cross Bridge, before meandering through the beautiful gardens of Mount Usher, past Hunter's Hotel, then turning south along the coast and into Broad Lough, which is a favourite area for birdwatchers. This intertidal lough is the home of a great variety of wildlife, including water rails, reed warblers, curlews, golden plovers and even the occasional otter. Finally, the Vartry River comes to its end at Inverdea, where the mouth of the river meets up with the Irish Sea at Wicklow Harbour.

Around this time of year, if you take the scenic-route walk along the Murrough from Wicklow Harbour to Greystones, you might be lucky enough to spot some unexpected creatures along the way. As March draws to a close, our native reptiles, the common lizard and the smooth newt, wake up from their long winter sleep. On a warm day, a lizard might be seen lounging along

Common lizard (photo by Shay Connolly)

the coastal rocks, warming up, or a newt swimming in a pond or hiding by the bank. Some people may find it surprising that we have lizards and newts in Ireland at all. Luckily we do, though they are so small that, unless you are really looking for them and know where to look, you can easily miss them. The lizard has a nice little trick of shedding its tail to avoid predation, and its colour can vary from brown to olive green and even black. Its name, *Zootoca vivipara*, tells us that it is viviparous, meaning it gives birth to live baby lizards rather than laying eggs like other lizards do. This is an important strategy for its survival in cooler northern regions.

The smooth newt is rarer. As soon as it emerges from hibernation, it heads for fresh water to breed. It has a lovely orange-coloured belly at this time of the year, with bright spots on its back. The female lays up to twelve eggs per day between the months of March and June. She wraps each egg individually in leaves. The egg hatches after three weeks, developing into a tadpole. The tadpole then develops into a newt with feathery gills; as it matures, it first grows front legs, then back legs. After about ten weeks it develops lungs in place of its gills. This prompts the smooth newt to leave the water and make its way onto land.

In Ireland the newt is protected under the Wildlife (Amendment) Act 2000 and it is an offence to capture a newt without a licence. We do not have any native snakes on this island, unlike Great Britain, which has grass snakes, smooth snakes and adders, but unfortunately they never made it as far as Ireland, with the credit for this being usually attributed to good old Saint Patrick. Of course, the real reason we do not have creatures such as the grass snake or the adder is the ice sheets that existed during the glacial period about two million years ago. The ice sheets in the northern hemisphere lowered the sea level so much that Ireland was connected to the mainland. As the temperatures rose, animals and plants migrated from the south to more northern territories. Some animals reached our shores before the ice melted and sea levels rose, but some did not. One animal that never made it in time was the snake.

Traditionally, snakes have suffered a very negative press in this part of the world, being linked with the devil, who took the form of a snake to tempt Adam in the Garden of Eden. In Gaelic the snake is given the ominous title of *nathair nimhe*, or poisonous serpent, and in English this negative viewpoint is revealed by phrases such as 'a real snake in the grass', referring to anyone who cannot be trusted. In Ireland, we also tend to reinforce this negative image through statues of Saint Patrick, which often depict him as a tall, bearded man,

crozier in hand, standing defiantly on the body of a dead snake. Saint Patrick is credited with banishing the snakes from Ireland, but of course this is simply a symbolic representation of the old pagan beliefs being replaced by the new religion of Christianity. Saint Patrick's Day is one of the most celebrated national holidays in the world, where many countries 'go green' for the day, both in the colour of their clothes at the start of the day and the colour of their faces by the end of it. But Saint Patrick was not always welcomed here with such open arms.

In Wicklow, there is a story of how Saint Patrick and his holy clerics landed on a small beach close to Inverdea at the mouth of the River Vartry in AD 432, in his attempt to bring Christianity to the people of Ireland. This was once an ancient port that was a popular trading destination for mariners from both Britain and Gaul but, when the pagans of Wicklow first saw these foreign men arriving with their message of God, they failed to give them a traditional Irish welcome. In fact, the pagans' resistance to these new arrivals is immortalised in the Gaelic version of the name of Wicklow, Cill Mhantáin, which translates as 'the chapel of Mantán'. The story goes that the locals gathered on the beach and flung rocks at Saint Patrick and his followers as their boats neared the shore. One of Saint Patrick's companions was struck by a rock, which knocked the poor man's teeth out. The party beat a hasty retreat back to sea, eventually landing further north, near Malahide in County Dublin. The man whose teeth had been knocked out, though, was not put off by this initial hostile response and later returned to Wicklow to build the area's first church. He was given the sobriquet Mantán (or 'toothless one'), which we still use to this day.

There is a lovely irony in the fact that, five days after we finish wetting the shamrock for our patron saint who banished our reptile friends from our shores, over in another part of the world they are gathering in their thousands to celebrate a snake's arrival. Chichén Itzá is one of the most famous ancient cities in Mexico and it is here, when the sun rises on the morning of the spring equinox, that a very spectacular event takes place. Crowds of locals and tourists congregate around the iconic Temple of Kukulkan, which was built in honour of the Mayan feathered serpent-god. As dawn breaks, rays of light create a distinctive shadow that runs along the steep steps of the pyramid — in the form of a giant serpent.

The reason we visit such historical monuments in the first place is to feel a connection with our past. But, as impressive as historical man-made structures are, nature is the greatest timekeeper of all. As March draws to a close, an early

morning walk along the south beach in Greystones offers an opportunity to pause and reflect on the beauty of the sea. On a still, calm morning before the business of the day begins, it is mesmerising to stand by the water's edge and look out to the point where the horizon blends with the faintest brushstrokes of a watercolour sky in shifting hues of shade and light. For me, the sea has an enticing power that always holds me transfixed. It connects us to our ancestral past in the same way a flickering campfire can conjure up images of prehistoric humans sitting in a flame-lit cave. But the sea can bring us even further back in time. Back to 400 million years ago, when some segmented organisms crawled out of the water for the first time. Or back further again, to almost four billion years ago, when life began as single-celled structures in ancient thermal vents. For are we not all part of the same natural journey of evolution? Looking out towards the mother sea on a fine March morning, I cannot help but feel that I am staring back into the womb of life.

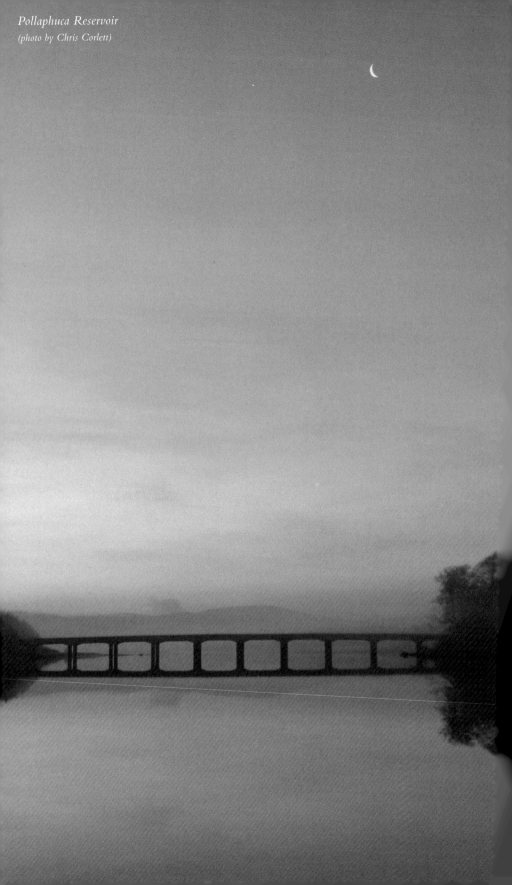
Pollaphuca Reservoir
(photo by Chris Corlett)

April

Panting and snorting like a mad battle steed that has lost its rider,
the masterless ocean overruns the globe.
— Herman Melville, *Moby-Dick*

I n the late 1990s there was a famous black-and-white Guinness ad featuring surfers waiting in anticipation for the perfect wave to arrive. A rhythmic drum-beat rises with the intensity of their heartbeat, as an enormous wall of water towers over their heads. Then, just before it breaks, it dramatically transforms into a herd of wild horses, their legs reared in gallop, before the surfers masterfully ride the raw power of the crashing foam. This advert came to mind while I was reading the novel *Moby-Dick*. Stopping at the line quoted above, I decided to search for it on YouTube, and I was pleasantly surprised to see that my suspicions were correct. That iconic moment when the wave turns into white horses is indeed a nod to Melville's masterpiece, with Captain Ahab even being mentioned in the voiceover. The director also mentioned a painting by Walter Crane called *Neptune's horses*, which was painted in 1892, as an inspiration for one of the best commercials ever made.

During the first few weeks of April, the white horses can be seen kicking wildly once more, as they collide against the rocks around Wicklow Head. From the top of the cliffs the observer is given a bird's-eye view of the battle, as the violent waves spew into the air like a war horse frothing at the bit.

Further up on Dunbur Head, the two old Wicklow lighthouses can still be seen. Their construction was begun in the same year, 1774, and they were first lit on 1 September 1781. Twenty large candles powered these lighthouses, which guided mariners to safety as they entered the coast between Hook

Head and Howth Head. During the 1798 Rebellion, United Irishmen raided the lighthouses and temporarily extinguished the candles, enabling them to transport their arms under the cover of darkness. The octagonal lighthouse that is further inland has now been converted into private living accommodation that can be rented out to visitors. There are two bedrooms, a living room and a kitchen on the very top floor, giving lucky occupants a panoramic view of the entire Wicklow coast.

Whenever I visit this foreboding edifice on the cliff edge, I try to imagine what life must have been like for the lighthouse-keepers who sat alone at the top of these old towers. I wonder who the men were who manned lighthouses such as this night after night, year after year, through the centuries — sitting up there in their solitary beacons, backs bent in reverence to the flickering ember that illuminated all before them. In their scarred hands I see a half-carved boat emerging out of dark wood, the chippings falling silently around their steadfast boots.

These men are the forgotten, nameless faces of our history — nameless, but ever-present. The lighthouse itself stands testament to their being. It gives substance to their brief existence. It stands out strong and bold like the embodiment of the land's last word. The eight-sided feet are stamped defiantly in clay, refusing to retreat from the relentless crashing waves. But, eventually, this land too will be forced to bow and reluctantly give way to the all-conquering sea.

When not filled by the laughter and giddy excitement of a family on a summer retreat, I wonder what can be heard in this stone chamber. When the echo of the locked door dissolves and the sound of the car driving down the lane fades away, how long does it take for the resident noises of the lighthouse to return? Do sounds appear like weary mice or spiders, peeping out through crack and crevice? How long does it take before the deep, plangent moan of the sea begins to seep once more through the thick stone walls? Or, from somewhere within its structural bones, do the window frames add an occasional creak to this maritime symphony? I imagine how the light of the day rises and fades unnoticed in every room, accompanied by the salted breath that lingers in musty air. At night, I imagine how moonlight shines in through darkened panes, illuminating empty rooms in its ghostly hue. Come dawn, does sweet birdsong pour down through this great tubular bell, filling the lighthouse with a waterfall of unheard chamber music?

In the second part of Virginia Woolf's novel *To the lighthouse*, entitled 'Time passes', we are given a description of an old, empty house by the sea after the

inhabitants have either left or died. Nature slowly reclaims each room through a shadow cast on the wall by a tree, or the 'soft spot flutter' of a passing bird. The inhabitants have departed, but their presence is still felt by the stillness of the objects that are left behind. A pair of tattered shoes, a worn cap, a chipped cup on a dresser. Everyday objects that were once the props of someone's life take on a greater significance when at rest. Now, in the stillness of time, they cry out to the future, 'we remain'.

The gulf between the transience of our own lives and the eternal cycle of the seasons is one of the reasons why I am so drawn by the power of nature. It offers me a solid and reliable consistency that I feel acts as a counterbalance against the excess that can potentially rule our lives. By simply taking the time to pause and look at the natural world that surrounds us, we are not simply admiring the unique beauty of a tree or a lake. We are tapping into an inner calmness within ourselves which helps us maintain a healthy mindfulness. Most people have a favourite place they love to visit; a place where we feel part of something greater; a little piece of heaven we feel is our very own. For me, I find this sanctuary amongst the hills and coastal walks of Wicklow.

But calling it 'ours' is a mistake. We do not own this beauty. Of course we can smell, taste, feel, and touch these places. We can replicate them in song, in word or in paint. But we no more own them than visitors to an art gallery own the paintings that hang upon the exhibition walls. We are more like passing travellers who can choose to stop and look at these wonderful free gifts that are there for us to admire and enjoy, or we can simply ignore them and go on our way unmoved. The hills of Wicklow were walked long before I ever stepped foot on them and, when my footprints have long since faded, some other person will stand and witness the beauty of this special place. Long after I am gone, the kittiwake will still nest on Bray Head's cliffs and, down below, the white horses will continue to rear up in stormy weather or nestle softly against rocks on lazy summer evenings, when nothing stirs but the glow of the setting sun, safely lighting someone else's journey home.

There is one flower that blossoms at this time of year and, for me, captures the essence of this permanent transience more than any other. It is one of the little gifts that April offers each year, and its arrival is awaited with great anticipation. With the first sight of the beautiful pink and white flowers, we know that the last of the dark winter will be replaced, at least for a little while, by the exotic, oriental colours of the cherry blossom. Pockets of pink clouds suddenly burst out over garden walls and fences, dotting our roads and paths with pale-pink petals. It is the fragility of this simple flower that I

suspect makes it such a favourite with so many people. In Japanese art, the flower symbolises the transience of life, being both beautiful and ephemeral. In Japan this concept is called *mono no aware*. The great Japanese film director Yasujiro Ozu used this theme as the cornerstone for many of his films such as *Late spring* and *Tokyo story*. *Mono no aware* is a Buddhist concept that seems to defy translation, being more of a feeling than a phrase, but it can be perhaps best described as the effulgent feeling one might get when looking at a sunset, or what a parent might feel when looking at their sleeping child tucked up in bed. It is a moment of still beauty, when life's heavy panting slows right down, exhales and slips into a deep calmness. It is one of those 'ahh' moments in life, where a deep, satisfying happiness is felt, resulting in an inner calmness. Some people get it from simply being in nature. However, it is a happiness that is also tinged with a certain sad acceptance that such pure moments are fleeting. The evening will inevitably fade and darken, the child will grow up and leave the nest and the cherry blossom will be scattered by an April wind. These fleeting moments of beauty are all the more precious because we know they can never last.

A wonderful place to see the cherry blossom in its full beauty is the stunning Japanese Garden in Powerscourt Estate during springtime. Here, you will not only see the cherry blossom, but also magnificent azaleas and magnolias, covering the dark paths, which wind around stone lanterns, bridges and pagodas, with their delicate petals. The Japanese Garden was built in 1908 by the eighth Viscount Powerscourt, but other parts of the gardens date much further back. The grotto next to the Japanese Garden was built in the 1740s, while the Italian Grounds, with their iconic view of the Great Sugar Loaf, were designed by the architect Daniel Robertson in the 1840s. The vast variety of trees like the giant sequoias, the red cedars and the dawn redwoods were planted by the seventh viscount during the nineteenth century, while the River Walk was laid in 1868. It is here, by the banks of the River Dargle, that you will see the tallest tree in Ireland, a Douglas fir that stands at 61.5 metres tall. Strolling through these grounds, you can trace the historical journey that was undertaken to create the splendour of what we see today. Each addition and development was passed down from one generation to the next, creating a living palimpsest of all the previous owners, who each left their own unique mark on this exquisite estate.

April is also a recommended time to pay a visit to the National Botanic Gardens, Kilmacurragh. A monastic community was established at Kilmacurragh in the early seventh century, with the construction of an abbey

likely to have been built on the grounds several centuries later. The Kilmacurragh estate was privately owned by the Acton family from the seventeenth century, when Oliver Cromwell granted the land to Thomas Acton I in lieu of payment for his military services in 1649. Kilmacurragh House was built a quarter of a century later by Thomas Acton II, with the stones of the old abbey being used for its construction. In the early nineteenth century William Acton introduced exotic trees into the garden, some of which can still be seen today. When his children,

The National Botanic Gardens, Kilmacurragh
(photo by Seán Ó Súilleabháin)

Thomas and Janet Acton, took over the estate in 1854, they began to sweep away some of the older features of the eighteenth-century garden. Under the advice and guidance of David Moore, curator of the Royal Botanic Gardens in Glasnevin, the Actons introduced many new features to the garden, along with rare and exotic plants that had been gathered by Victorian plant-hunters. The acidic soil of Kilmacurragh made this an ideal nursery for plants that would not be suitable to the alkaline soil of the Glasnevin gardens. One of the features that was built in the 1860s is the impressive Broad Walk, which is lined with yew trees, the crimson rhododendron 'Altaclarensis' and the white-flowering rhododendron 'Cunningham's white'. Similarly to Powerscourt Gardens with their cherry blossom and azaleas, if you visit the Kilmacurragh gardens in April you will also see fallen petals covering the pathway in an exquisite display of vibrant colour. The scattered petals are now seen as a symbol for the tragic history of the gardens.

When Thomas Acton died in 1908, the estate came into the hands of Captain Charles Annesley Ball-Acton, who was killed on the French front in

1915. He was followed less than a year later by his brother Reginald Thomas Ball-Acton, killed in action in Ypres in 1916. Many of the gardening staff also went off to fight in the Great War and never returned. This resulted in the estate falling into debt and disarray after the war. The Acton family eventually had to sell it in 1944. The state bought the grounds in the 1970s and in 1996 it became part of the National Botanic Gardens. Ten years of hard work changed the then-overgrown garden of cherry laurel, sycamore and the invasive *Rhododendron x superponticum* (a man-made hybrid of the well-behaved *Rhododendron ponticum*) into a garden that is now home to some of the rarest plants and trees from all over the world, including China, Chile and the Himalayas.

In Oscar Wilde's story 'The selfish giant', the giant's garden becomes a place of eternal winter after he banishes the children from playing in it. But when he realises his mistake, he knocks down the wall and calls for the children to come back and play; with their return, spring covers his garden in beautiful white blossoms once more. The history of the Kilmacurragh Gardens reminds me a little of this children's story. These gardens also suffered a prolonged winter for over 50 years, but now, with dedication and investment, visitors can enjoy this hidden treasure once more.

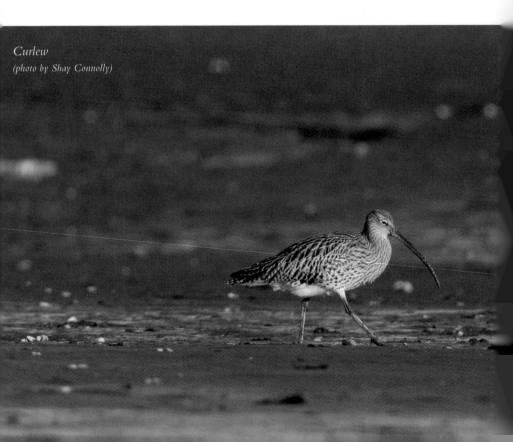

Curlew
(photo by Shay Connolly)

Just a few kilometres south of Kilmacurragh Gardens lies the small village of Redcross. It was here, to Kilpatrick House guesthouse, that one of the twentieth century's most famous philosophers, Ludwig Wittgenstein, retreated when completing his *Philosophical investigations*. The isolated solitude of Redcross must have suited the Austrian philosopher well, with the conditions being in stark contrast to those under which he had written the notes for his first philosophical masterpiece, the *Tractatus logico-philosophicus*, while serving as an officer and then lieutenant in the Austro-Hungarian army during World War I. Interestingly, a plaque in the Botanic Gardens of Dublin also marks the place where the philosopher sat, thought and wrote under the shadow of the statue of Socrates. Wittgenstein remained in Ireland until April 1948, before returning to Cambridge, where he died three years later, on 29 April, aged 62. Wittgenstein had a sad and troubled life, encompassing moments of great despair, which included three of his four brothers committing suicide. And yet, a remarkable change happened to him towards the end of his days. Following the death of sister in 1951 and his own diagnosis with prostate cancer, he believed that his capacity for philosophy had left him. But a month before he died, he wrote to his friend Norman Malcolm that the curtain on his brain 'had gone up' and he was writing once more. This change of form during his final days makes his reported final words all the more moving: 'Tell them I've had a wonderful life.'

Another type of change is occurring down by the coast during the last days of April. Many of our avian winter visitors have already migrated back to their breeding areas in Scotland and Iceland, and some will already have hatched successfully. The unsuccessful birds will return to Ireland and their lonely call will be heard once more during the long summer evenings. Down on the Breaches over the last few weeks, I have noticed that the call of the curlew has gone silent. During winter, the curlew may be seen along the mudflats and estuaries of our coast, but there has been an alarming decline in our breeding curlews in the last few years. The reason for the dramatic decline in our largest wading bird is believed to be at least partly due to the change in our farming techniques, with many of our marshy habitats being drained for agricultural reasons. The curlew is now a red-listed species in Ireland, with a fall of 60 per cent in the number of breeding curlews in Ireland since the previous estimate in 1987.

Other visitors that are set to leave any day now are the brent and greylag geese. Every time I see them grazing on the marshes I think it will be my last sighting until the winter. On the other side of the county, in west Wicklow, the

Pollaphuca Reservoir (also known as Blessington) is one of the best places in Wicklow to spot greylag geese where they spend the winter. The lake is of such importance that it has been made a protected area by the National Parks and Wildlife Service to ensure that the habitat remains suitable for these migratory birds. What is remarkable about the lake is that it is man made, created by the ESB when they dammed the Pollaphuca Waterfall in the 1940s to create a hydroelectric plant as well as supplying water to the greater-Dublin area. There are some stunning walks around this large body of water, which covers 5,000 acres of what was once farmland. On a summer's day, when the water levels are low, the occasional church spire can be seen piercing the surface, revealing the old, lost village that now lies at the bottom of the lake. Small country roads can also be seen running down into the water at some places, which to my mind adds a sense of mystery and perhaps even melancholy to this location. I remember coming here as a child and being fascinated by the fact that there were old cottages, roads and farms frozen in time under these still, dark waters, submerged forever in the silence of a lacustrine tomb.

One of the downsides of the reservoir is that the Pollaphuca Waterfall is no longer the impressive cascade it once was. The name Pollaphuca translates as 'the hole of the *púca*', perhaps a reference to the once-violent flow of water that was supposed to plummet into the rocky depths of a demon's lair. In the 1827 edition of G.N. Wright's *A guide to the county of Wicklow*, he describes the waterfall as 'an extraordinary and terrific object', where the Liffey flows over a 150-foot drop 'with the utmost impetuosity into a circular basin of stone, worn perfectly smooth, the form of which imparts to the water a rotatory motion, which Seward compares to the eddy on the coast of Norway, called the Navel of the Sea, a vortex whose power of ingulfing is so great that no vessel dares approach it'.

No wonder nineteenth-century tourists would make a day's round trip from Dublin just to picnic at the falls and marvel at its majestic power. In 'Circe', Episode 15 of *Ulysses*, when Bloom visits Nighttown, he hears the sound of a waterfall in one of his many hallucinations, which brings him back to a childhood memory of a school trip to the Pollaphuca Waterfall when he was 16. The yew trees accuse the young Leopold of profaning their 'silent shade' when he followed Lotty Clarke into the trees. Joyce has great fun in morphing the sound of 'Pollaphuca' into the suggestive repetition of 'Phoucaphouca Phoucaphouca', with the guilt-ridden Bloom comically blaming the demon of the waterfall for corrupting his mind: 'A saint couldn't resist it. The demon possessed me. Besides, who saw?'

Today the waterfall is but a trickle of what Wright describes in his book, or what Joyce would have remembered when writing *Ulysses* in Zurich and Paris years later. A pity, perhaps, but sometimes scenery must be sacrificed for practicality. The damming of the Liffey at this juncture has another benefit too. During these heavy-rain-filled days, when rivers across the country burst their banks and flood streets, shops and homes, the one river that keeps a regulated flow is the winding 'recirculating' constant of Anna Livia Plurabelle.

By the time mid-April has arrived, Wicklow enters a period of transition. Traditionally, rainy days are broken by the occasional 'pet day', as my mother calls them, where we get a brief glimpse of what summer might bring. These soft spring days are our first reminder that winter's fingers are gradually releasing their cold grip, allowing sunlight to seep through its cracked fingertips. However, in recent years, 'pet days' have tended to be simply wet days. If April brings near-constant heavy rain, the result is a lack of growth, which means that farmers can struggle to feed their cattle — as happened a few years ago, when the country was faced with a national fodder crisis. It is not only the wildlife that is affected by the sudden changes in our seasons, but also those who depend on the land to make a living.

But, even in these harsh wet conditions, spring brings hope. Eventually April shakes its wet, sleepy head and, from the undergrowth, tiny pink-and-white herb-robert flowers begin to peep out along the road banks and

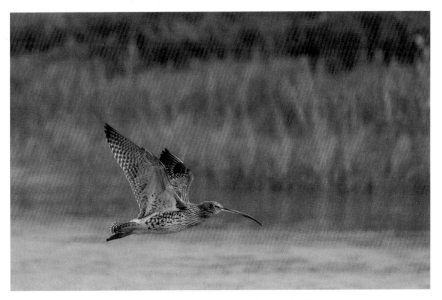

Curlew in flight (photo by Shay Connolly)

hedgerows. They are followed by the sun kisses of the lesser celandine and the common field speedwell. Along the waterlogged meadows, however, there is still very little sign of new growth, and the old, sloped Wicklow Mountains remain a misty blue under a cold, liquid sky.

The mountains are the one constant in this shifting landscape. They are able to maintain their majestic presence whatever the weather. These ancient kings remind us that our stay on this earth is fleeting — nothing but an insect's wingbeat when compared to their dominant reign. Some of our oldest rocks, found in Kilmore Quay in County Wexford, are an unimaginable 2,000 million years old. The Wicklow Mountains were formed in the Caledonian orogeny, the first phase of mountain-building that took place over 400 million years ago. Two plates pushed together, one from the north-west and one from the south-east, forming the Caledonian mountain ranges. Along these foldings, subterranean earthquakes caused cracks to occur. These cracks were so far down below the crust that lava did not flow to the surface and erupt in volcanoes. Instead, the molten rock that flowed into the cracks hardened, forming crystal quartz and mica, which can be seen today in the granite rocks of the Wicklow Mountains. These mountains have been eroded over millions of years, and today we are only seeing the stumps of their once-great size. The Great Sugar Loaf stands highest amongst its neighbours, owing to its makeup of quartzite rock, which is much more resistant to erosion than the surrounding granite. I was once told that, looking west from the top of Bray Head, the Great Sugar Loaf, combined with its smaller companion, the Lesser Sugar Loaf, has (from a certain angle) an uncanny similarity to a lady's chest. I know the Blasket Islands can sometimes look like a sleeping giant but, I have to admit, I've never seen perked breasts above the Glen of the Downs, no matter how hard I've tried. In the end, I dismissed it as heresy. Imagine my surprise, then, when I learned that the Great Sugar Loaf is officially classified as a Marilyn. This geological term refers to a hill that is at least 150 metres higher than its surroundings. The term was apparently coined to contrast with the term Munro, referring to a Scottish mountain with a height of 3,000 feet or more. So I suppose we can say that there are two Hollywoods situated among our Wicklow Mountains.

One of the reasons why I love living in Wicklow is that, after a long day's work, there are so many lovely walks on your doorstep in which you can just escape and clear your head. One such place is the fen walk in Newcastle. The circular fen walk takes about an hour if you start and finish at the Newcastle station and, on a cold day, you can warm up afterwards with a

hot bowl of homemade soup in the Castle Inn. The fen walk was opened by BirdWatch Ireland in 2009 and is officially called the East Coast Nature Reserve. It has several bird-hides where you can look out over the estuary and, depending on the time of year, see a great variety of geese, ducks and waders without disturbing them in their natural habitat. To reach the fen you follow the grassy path that leads around the cow field. Along the way, meadow pipits rise like fleas from the tall grass, as if being belched into the air by a subterranean monster. These ground-nesting birds lay their eggs among the reeds and grasses, hoping their speckled feathers will be sufficient camouflage from any lurking predators. A stonechat is also a familiar sight along this walk. The call of the stonechat is similar to the sound of two pebbles being tapped together, and its Irish name, *caislín cloch*, translates as 'small stone castle', suggesting the preference these passerine birds have for perching along abandoned ruins and old stone walls. Continuing along the grassy verge, the walk veers to the right, where a built wooden pathway invites you to enter a rare and ancient habitat. Swamped by tall stalks of sedge on either side, it creates a glorious green tunnel that leads into the mysterious world of the ancient, secret fen.

The fen is located in Blackditch Wood and is a type of wetland that used to cover most of Ireland millions of years ago. Now, very few of these habitats still exist in Ireland, with most having turned into bog land long ago. A fen differs from a bog in that it has a higher nutrient level and is less acidic, receiving its water from underground water supplies, whereas a bog receives its water through rainfall alone. The groundwater deposits calcium from the bedrock and the blending of the nutrient-rich alkaline water with the acidic soil creates a rich, diverse habitat for flora and fauna alike. During the summer months, the fens will come alive with the arrival of colourful butterflies, wildflowers and mellifluous birdsong, but there are still many things to observe on an evening stroll in April. Whenever I step into this ancient habitat, I suddenly become aware of the rich diversity of life that is lurking all around me. It is like stepping back in time — back into a long-lost world. At the entrance, the creaking of some old trees can be heard from deep inside the fen — a warning, perhaps, informing the rest of the unseen inhabitants that an outsider is arriving. As you enter, the diversity of the wildlife of the fen is not always immediately visible but, if you stop to listen, you will soon realise how alive this place really is. Somewhere out amongst the sedge, a soft splash breaks the still water. An outlaw frog, perhaps, ruminating on the glorious eon when his ancestors ruled this domain, his motionless head semi-submerged in green

Horses, Delgany
(photo by Seán Ó Súilleabháin)

algae, suspiciously observing every movement. If you bend down and stir the thick black pools that surround the boardwalk, it is like trying to penetrate an opaque window that seeps down into this ancient land's beginning. Movement in the treetops above might be the stirring of a wood pigeon taking flight and, down by the stream, you might see a disgruntled grey heron leave its favourite fishing-bank at the sound of approaching footsteps.

On reaching the other side of the fen, you arrive at a farm gate, where horses graze in the open field during the summer months. From here the gentle brush-sweep sound of the waves can be heard over the swaying of the treetops. As you follow the trail around the field, seven gregarious Kerry bog ponies sometimes appear from amongst the gorse. These friendly creatures with their long, rustic manes are always very appreciative when you produce a tasty apple or carrot, but even a soft word and a scratch behind the ear is welcomed, before they eventually turn their hirsute backs and saunter lazily to their cool spot beneath the trees. Leaving the ponies behind, the trail leads through a row of trees and shrubs before arriving back on the coast at Five Mile Point. At the bottom of the *bóithrín* stand some old fishing cottages with their whitewashed walls and brightly painted doors, where a resident pheasant's call cuts the air like an electric saw as you pass. On a calm evening, when the sun is dipping low beyond the western hills and the evening's failing light casts the land in long shadows, there is, to my mind, nowhere more beautiful.

By mid-April many new arrivals have begun to appear, having made the arduous journey from sub-Saharan Africa. Attempting to distinguish house martins, swallows and sand martins from each other can sometimes cause a little confusion. Often, the place where you see a particular bird is the key to telling one from the other. Down by the Bray pier, for example, house martins or *gabhláin binne* flutter over the water, feasting on swarms of evening flies. Their plump, white rumps can often be seen tinted with a slight amber colour when reflected in the artificial street-light. These birds will often build their mud nests in the eaves of the old Georgian houses that line the seafront, or down under the old pier, where the mute swans gather. On the bridge by the lonely Breaches, the red-faced swallows swoop down acrobatically to take a quiet drink on the wing, before spiralling back up into the dusky sky, their long, forked tails silhouetted in the setting sun. The sand martins or *gabhláin gainimh* are the first visitors to arrive and can be seen amongst the cliffs of the north beach in Greystones. The cliff face is pock-marked by the small nesting holes to which they return each year. A brown band around the neck distinguishes them from their cousins the house martins if seen up close. By mid-July, they will begin making their way back down the Irish coast, before facing into the long flight back to the African Sahel, an area of semi-arid climate that forms a transition between the Sahara Desert to the north and the Sudanian Savannahs in the south. Severe droughts can often hit this region, causing a significant decrease in the numbers of martins and swallows that are found here during the summer months.

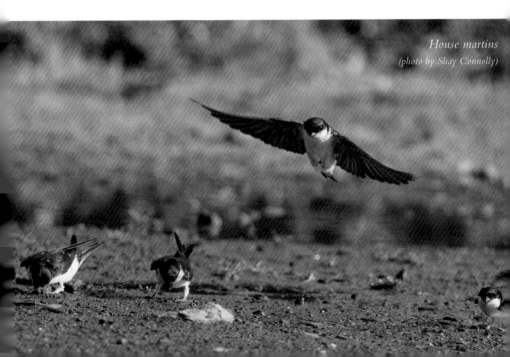

House martins
(photo by Shay Connolly)

The swift, however, is not part of the same family at all, despite superficial similarities. The swift has a beautifully alliterative Irish name, *gabhlán gaoithe*, which translates as 'forked wind', and it is the last of these four birds to arrive to our shores. Its dark underbelly, crescent-shaped wingspan and angular body may be seen gliding over farmland, open countryside, towns and villages. But for me it is the high-pitched screeching that first signals the arrival of the swifts. They can feed, sleep and even mate high up there in the sky; indeed, they are only ever grounded when nesting. Their Latin name, *Apus apus*, means 'without feet', suggesting how rare it is to actually see them land, with their distinctive calls filling the skies by mid-May. In the month of August the Bray Air Display boasts the incredible stunts of the Red Arrows, but the swift's mastery of the skies can never be equalled by man or machine. The skies are their domain.

As April draws to a close, the bright evenings are filled with joyful birdsong, giving us a joyful sense that things are beginning to stir. On Kilcoole Beach, the little terns will soon arrive once more, and feed manically along the sea's edge. Once they mate, their precious eggs will be laid amongst the stones on this small stretch of coast, under the watchful eye of BirdWatch Ireland. Up on the hills, the gorse comes into full bloom, carpeting the landscape with a golden filigree that brings a summer warmth to even the wettest days of April. Down in the ancient woodlands of Tomnafinnoge, bluebells begin to nod their sapphire curls, as if agreeing solemnly amongst themselves that now is indeed the time for spring's arrival. But spring is also stirring, deep down, under the cover of earthy darkness.

In dusky badger setts, restless cubs begin to emerge from their musty tunnels, poking their noses out for the first time to smell out fat, juicy worms. Around this time of year I set off on some evening strolls in the hope of spotting some of our more reclusive, nocturnal wildlife. In the Delgany Woods, the soporific cooing of a collared dove lulls the day to sleep, while bats zigzag across the inky blue sky, ravenously feeding on a feast of invisible flies. From the top of a hill, I look back down on the reflection of a sliver of moon dangling by a silver thread above the sea and, for a brief moment, all grows dark when its pallid face is scarfed by a burqa of cloud. But, as soon as the cloud drifts by, the fields are bathed in full moonlight once more, illuminating the reclusive creatures of the night. Things take on an entirely new appearance after dark. The sounds of the nocturnal animals are magnified in the echo-chamber of a silent wood. Our senses become more attuned to our surroundings, especially to some of the sounds of nature that can easily

Venus, from the Great Sugar Loaf
(photo by John C. Murphy)

go unheard in the loud haze of daytime traffic. The unsettling cry of the fox across the farmland is distinctive, but the shy badger can also produce a terrifyingly eerie scream if disturbed.

The best way to see a live badger is to locate its sett during the day. The entrance to the badger's sett is much larger than to the fox's den. Each sett is passed down from generation to generation and the underground tunnels can go on for miles, with new ones being constantly dug and old ones being restored. Beside the tunnels' entrances you will usually find lots of badger dung, often in a nearby hole, where the badger very civilly leaves its droppings. The main diet for the badger is worms, but they also eat fallen fruit, insects, small mammals and birds' eggs. During the winter months, maybe even the odd fieldfare or redwing could appear on the menu. Once you have located a sett, the best thing to do is to return just before dusk and place yourself where you have a good view, but are far enough away that you will not be smelt. The badger's sense of sight and hearing is not very good, but its sense of smell is extremely keen.

This may be the best way to see a live badger, but the sad reality is that, more often than not, our native badger is usually spotted as roadkill, their crushed bodies often marking places where old family foraging roots are located. Unfortunately, a road being built through old badger territory will inevitably result in roadkill, as they will attempt to travel from one side of their territory to the other. One such place is the Glen of the Downs, where a dead badger or fox is unfortunately a very common sight for drivers on the N11. In some countries, nature tunnels have been built above motorways where these old roots lie. These are grass bridges that connect the land that has been

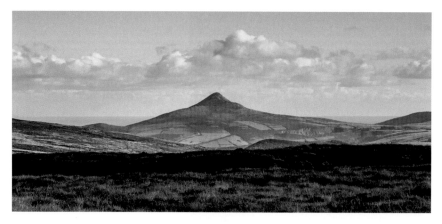

The Great Sugar Loaf (photo by John C. Murphy)

divided by the road and allow the animals to pass over safely from one side to the other. To my mind, this is planning at its most advanced, with modern progress and environmental protection both being catered for.

One evening a few years ago I had the privilege of spotting a badger in a field in Newcastle. I had set out that night to do so some stargazing and I was looking down towards a line of trees at the bottom of the hill. Orion's belt sat in the eastern sky and, to the west, the crown of Cassiopeia shone.

'I ofen looked up at the sky an' assed meself the question — what is the stars, what is the stars?' Captain Boyle says to Joxer in Seán O'Casey's *The plough and the stars.*

'Ah that's the question, that's the question — what is the stars?' he replies.

This same question came to my mind that night as I sat drinking my hot cup of soup by the walls of the abandoned castle. Suddenly, some movement at the bottom of the field caught my eye and, a few moments later, a solitary badger emerged from the undergrowth and began making its way across the field. Its bristled back shone silver in the celestial light, before it stopped, smelt the air and turned back on the trail from whence it came. Seeing this nocturnal visitor was a special treat for me and it made me stop and think. Did the ancestors of this particular badger also wander this same patch of land when these castle ruins were last occupied? In the stillness of the clear night, I was transported back to a time when tapestries lined great banquet halls, telling tales of courageous battles; back to a time when the lady of the manor could be seen through the candlelight of the bower window, combing her hair for bed. All human history seemed woven together and passed down through the ages, like the tunnels of an ancient badger's sett. But,

above the ebb and flow of human tide, the night light of the firmament had travelled unperturbed through time and space, until that very moment, when it finally reached its destination — to illuminate for the briefest of moments a foraging badger crossing a field in Wicklow.

Foxgloves
(photo by John C. Murphy)

May

Sweet April showers
Do spring May flowers.
— Thomas Tusser, *Five hundred points of good husbandry*

After the heavy days of April rain, May bursts into life, bringing with it all the delights of summer. Now is the time when the gardener's winter toil pays off, when cocooned spring buds that lay buried under winter earth emerge once more to taste light and rain. Down forest tracks, roadside ditches and mountain trails, forgotten seeds awaken from their cold, sleepy darkness to taste sweet, sweet air. But these wildflowers need no special care from an attentive gardener. They are the true independent survivors of our countryside, and at this time of the year their hidden faces are revealed to the world once more. Walking down a country lane, or strolling through a meadow, you cannot help but notice the ubiquitous presence of the wildflowers. A dull ditch in winter is suddenly transformed into a floral kaleidoscope, announcing to the world that summer is here.

If wildflowers are summer's stimulus for the eye, the dawn chorus is summer's music for the ear. Just before daylight, the day is greeted with a symphony of orchestral birdsong that calls out to the morning sun, 'I'm still here! This is still my spot!' But the dawn chorus is also an avian version of Tinder, with each song hoping to attract a suitable mate: 'Feathered, red-breasted male, enjoys feeding and singing, looking for friendship and perhaps ... a little more.'

The first Sunday in every May is International Dawn Chorus Day, where people are encouraged to wake up early (or perhaps go to bed late) and head

Wild poppy
(photo by Shay Connolly)

out and listen to nature's free open-air concert. It surprises me how deaf we've become to the natural sounds that surround us every day. The smartphone or MP3 player often carries the preferred soundtrack for walkers or joggers these days, and the chirping of the blackbird or the warble of a song thrush simply goes unheard.

BirdWatch Ireland's East Coast Nature Reserve is just one of the many places you can visit if you want to hear the morning song of the birds at this time of year, and it is one of my favourites. Sitting on a wooden bench surrounded by trees and tall sedge, I sit back and wait for the show to begin. At first, all is still and perfectly silent but, after a few minutes, the faintest melody can be heard rising into the air, just as a thin ribbon of light unravels above the horizon. The song increases in tempo and is soon accompanied by that of another bird, responding to its neighbour's call. Two blackbirds are in competition for the role of lead vocal, each attempting to drown out the other. The shrill song of the blackbird is closely followed by the wavering aria of the robin and, before long, a chorus of birdsong is bellowing out in full voice to welcome in a bright May aurora. Some birdwatchers use recording equipment to help them identify each individual song; to my untrained ear only the more common calls are recognisable. But even without recognising the singer of the song, the dawn chorus is something anyone can appreciate. The delicate music that we hear with each new morning is made up of the same melodies that have been sung since time immemorial.

To the east, the rhythmic pulse of the sea beats out in time with the song of the birds, the constant hum of this ancient land that transports us to a place where past and present unite. Further up the grassy path that runs along the railway track lie the mysteries of the secret fen, where life is stirring out of sight. I think of the fen's deep, wet earth with its cold 'black butter', as Heaney describes the dark peat in his poem 'Bogland'. The youth-preserving balm of the Irish bog earth has revealed some of the oldest and best-preserved bog bodies found anywhere in the world. Whenever I pass the National History Museum in Dublin and have ten minutes to spare, I enter and pay my respects at the glass tomb of the Clonycavan Man and the Old Croghan Man. At first glance, these leathered bodies seem otherworldly. It is easy to forget that you are in the presence of a human that walked this land thousands of years before you existed. But then, looking a little closer, you begin to notice the small, human features that are so very familiar to us all — like the trimmed fingernails on the bent fingers, or the five o'clock stubble bristling on the chin. These are the undeniably human characteristics that remind me that I am not simply looking at a jewel-studded brooch or a golden chalice. No matter how well crafted and rare such artefacts are, they can never compare with the mesmeric fascination the bog bodies exert. They bring us face to face with our shared ancient past and it humbles me to be in their presence. Listening to the birds welcoming another sunrise on a May morning, I think on our peat fathers, who went before us. I try to recreate the intricate peaks and valleys of their shell-like ears in my mind. Did their minute hammer and anvil vibrate to record the vibration of some early birdsong calling out for a mate? And did the success of such song allow me to enjoy, thousands of years later, the same eternal music of the dawn?

T.S. Eliot saw April as the cruellest month, but for me this accolade falls on May. It is always around this time in the academic year that I notice a slight change coming over my students. It is quite subtle at first, with perhaps just one or two suddenly looking up from their books and taking a forlorn peek out the window. Then another looks up, and another, until, halfway through May, the class resembles a colony of meerkats, all gazing in the one direction, longing for that last bell to unlock the gates to summer's freedom. Senior students are especially vulnerable to such daydreaming, knowing that the final stretch of study is counting down before the overhanging guillotine snaps in the form of the merciless Leaving Certificate. I remember my own time, looking out on an inviting sunny morning and wishing to be anywhere else but the confines of the chalky classroom. The April rains can make you feel

almost grateful for the shelter offered by the maths class; but come soft May, with its tapping of warm sunlight on the window pane as you slog over your French grammar, well … *c'est un mois cruel.*

Making the most of the improved weather, my May walks always include an at-least-weekly visit to the nesting site of the little terns on Kilcoole Beach. By this time of year, a cloud of white can be seen on the edge of the shore, as these small, agile birds nosedive into the white surf in a frenzy of feeding that will help them build up the energy to ensure a successful breeding season. Another recommended walk in May is a stroll in Tomnafinnoge Wood, situated just outside Shillelagh village. Tomnafinnoge Wood is an ancient forest of old oak trees. It is said that Trinity College, Dublin, King's College, Cambridge and even Westminster Abbey were built with wood from this great forest. Parking at Tinnahely railway trail, you can follow an old, disused rail track that connects to the forest trail. This particular piece of rail was laid in 1865 to transport passengers from Woodenbridge to Shillelagh, but it eventually fell into disrepair and was finally abandoned altogether by the 1940s. Over the years, the shrubs and trees reclaimed the land for themselves, burying the old lines under a carpet of wild vegetation, but in 2005 the people of Tinnahely, with the support of County Wicklow Partnership and the local landowners, decided to develop this abandoned four-kilometre stretch of land into the beautiful nature trail that it is today. Following on along the wooden trail, you can pause on the bridge over the River Derry in the hope of spotting a flash of kingfisher blue. By May, the female should be sitting upon the nest that's hidden away under the cover of the reeds; however, later on in the year, the fledglings might well be seen sitting on an overhanging branch, honing the masterly fishing techniques their parents have taught them.

Further on into the wood, another shade of blue catches the eye. By May there will be an abundance of bluebells or *cloigíní gorma*, nodding their delicate bell-heads in the light breeze. Tennyson compared these flowers to an expanse of sky resting on the earth's bed, and it is easy to see why. They bring so much colour to the woodland trail, enticing bees and butterflies to dance their way through to the sweet nectar, filling the woodland with the hum of summer life. Another wild spring flower that washes over this woodland walk is the little lilac cuckooflower, which grows down by the riverbank. Its pale, rosette-shaped flowers become the rented property of the orange-tip butterfly, one of the first butterflies to be seen when spring arrives. The female is actually a marble white, with only the male sporting orange wingtips. Despite the male's diaphanous wingtip looking like it has just been dipped in treacle, do not be

fooled. It is anything but sweet. The bright orange colour warns predators that it has a bitter mustard flavour and hence is best avoided. The absence of the orange tip on the female is because she relies on secrecy and stealth when flying from one flower to the next, not wanting to attract the attention of potential prey. Her camouflage is aided by a marbled green-and-white underwing, making her very difficult to spot amongst the foliage. When laying her eggs, the female lands on a flower and tastes it with her feet. If it proves suitable, she lays one egg on the stem of the cuckooflower or garlic mustard plant. The reason for laying just one egg on each flower is the butterfly's sibling rivalry. The first hatched caterpillar would eat its smaller brothers and sisters for a tasty lunch, so keeping them apart makes sense. Once the caterpillar has eaten its fill, it forms the chrysalis from which metamorphosis into the butterfly takes place.

The first few minutes after the butterfly has broken out of its cocoon are the most dangerous. Its wings are soft and wet and it is unable to fly, leaving it defenceless against all kinds of hungry predators. But, once the wings have dried out and are pumped with blood, the butterfly is ready to expand its wings and take to the air. When visiting Tomnafinnoge Wood in May, you will most likely see their translucent wings skirting across your path as you walk by, before pausing to rest under the protective shade of this ancient woodland.

Bluebells, Clara Woods
(photo by Chris Corlett)

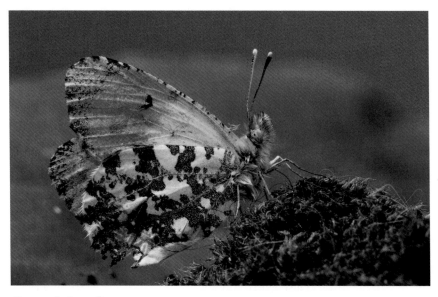

Orange-tip butterfly (photo by Shay Connolly)

In comparison to the life cycle of the orange-tip butterfly, the great oak trees live out their lives on a much grander scale. Like wise old gentlemen, their presence demands respect. Some of the trees have been growing here for hundreds of years, with their venerable branches wider than some of the younger trees' trunks. Up close, the knobbly, scaled bark reveals deep scars, like the wounds on an old bull elephant's hide. Whenever I visit here, I like to stop at the trunk of such trees and trace the thick roots that have sprung up through hallowed earth. How far down do they travel? How far down and how far back? In early summer hanging catkins droop from the wide branches like yellow tinsel, while in autumn acorns litter the forest floor with their green fairy caps, tiny seeds within compacting the mystery of an unborn giant.

Another reason this wood has such a special status — not only in Wicklow, but throughout the entire country — is the presence of a bird that, until relatively recently, was thought not to inhabit this island at all. The calling card of this mysterious bird is a drumming sound of bill on bark, hammering away to make a nest hole for its young and to also stake a claim on its territory. This is the distinctive drumming sound of the great spotted woodpecker, which has thankfully returned to our island to breed in the last few years. Great spotted woodpeckers can be found all across Europe and as far east as Japan, but Ireland was thought to be one of the few European countries not to have breeding woodpeckers. However, this has recently changed and

at least 100 woodpeckers are thought to be breeding in the broad-leaved trees of Wicklow.

If you ever find yourself walking through a Wicklow woodland and suddenly hear a squeaking that sounds like one of those stuffed toys that dog-owners give to their puppies, you may just have come across a family of fledgling woodpeckers. The great spotted woodpecker has a little tuft of red on the top of its head and each fledgling can be easily distinguished by its distinctive crown. It is a sight and sound that was missing in our forests for a long time, but at last it seems we may now have a chance to see this bird on Irish soil once again. The chirpy little call that the fledglings use is a very strange phenomenon. Usually fledglings hide silently in the undergrowth the moment they leave the nest, fearing they might fall victim to a lurking bird of prey. But the fledgling woodpeckers seem so delighted to be out of the tree hole that they cannot contain their excitement.

This amazing wood also has another survival story playing out behind its canopy of leaves. One of Ireland's rarest mammals is the pine marten or *cat crainn*. It is a member of the stoat and badger family and, like the badger, is a solitary and reclusive animal. It was thought to be extinct in this country by the turn of the twenty-first century, mainly owing to excessive human hunting. Its rich chocolate coat and golden creamy front makes the pine marten one of the most attractive mammals that we have and it is easy to imagine why there would have been a high price paid for its long, bushy tail. Its Irish name translates as 'tree cat', which gives you a good idea about its habitat and shape. The strong claws and legs enable it to climb trees with great speed; it uses its razor-sharp teeth to stab down on its prey or to protect its young. Around this time of year, the

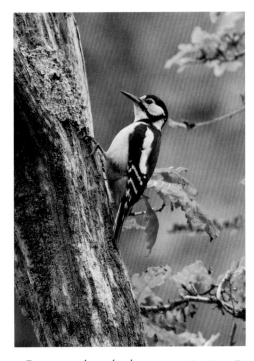

Great spotted woodpecker *(photo by Shay Connolly)*

Grey squirrel (photo by John C. Murphy)

pine marten usually gives birth to two or three kits, who remain in the den for up to six weeks after birth, before venturing out to forage and hunt in the company of their mother. Once widespread across the country, pine martens are now generally found in the west of Ireland and the midlands, but here in Tomnafinnoge Wood is as good a place as any to see one in the wild.

The pine marten has also become an unlikely player in the preservation of another Irish mammal that has been climbing coniferous trees since the last ice age — our vulnerable native *iora rua*, or red squirrel. One of the main reasons for the recent decline in the red squirrel's population is the famous group of eight American grey squirrels that were offered as a gift in Castle Forbes, County Longford in 1911. The story goes that the duke of Buckingham gave a basket of eight squirrels as a wedding present. Unfortunately, when the wedding party went out onto the lawn, the animals escaped from the basket, ran into the forest and began breeding like, well, grey squirrels. Incredibly, this one-off introduction of a small number of grey squirrels into a foreign habitat has had a devastating impact on the fortunes of our own native red squirrel. Over the next hundred years, the conquering grey squirrel has successfully competed with the red for food and habitat, which has proven a real problem for the native species. This is due to the red's reclusive nature, selective diet and, above all else, inability to digest acorns (which the grey squirrel does not share). There are places in the midlands where the red squirrel has now all but disappeared and research carried out in the last 20 years shows that the decline is endangering the red squirrel's very survival. However, it seems all is not lost. Recently, evidence has suggested that the decline of the red squirrel is halting in some woodland areas, and that this change of fortune may be connected with the return of our old friend the pine marten. One of the pine marten's favourite foods is grey squirrel and it has inadvertently begun to redress the balance between

the introduced species and the native one, giving the red a chance to reclaim a foothold in its native habitat. The reason the pine marten favours the grey squirrel rather than the red might simply be the fact that the greys are bigger and easier to catch, while the smaller, lighter red squirrels are able to climb out onto smaller branches that cannot support the weight of the pine marten.

It always makes me smile to see a small red scurrying up a tree as I walk along a woodland track — a welcome sign that it is fighting the good fight. The earlier the squirrels can breed, the greater their chances will be, and this all depends on the abundance of the autumn seed. In years where there is a rich harvest, red squirrels will breed in January or February, giving birth to a litter of kittens around March. In the following few weeks the time will come for the kittens to be weaned from their mother and the mother can perhaps produce a second litter during the summer. Incredibly, in little over a year, the young will be mating themselves and the wondrous cycle of nature will move on.

When visiting a woodland walk like the one in Tomnafinnoge, it is hard to ignore the diversity of wildlife that thrives in such unspoilt surroundings. Young children appreciate these nature walks more than most. Adults often miss the small things that children stop and marvel at. I suppose this is partly to do with the different visual perspective children have of the world, but it is also down to their enthusiastic wonder, which makes everything seem so fascinating. Once we begin to look at the natural world through a child's eyes, a lost magic returns. The famous linguist and political analyst Noam Chomsky has for many years challenged the view that children acquire language by conditioning and imitation alone, arguing that the speed at which children acquire language suggests that they have an innate predisposition towards learning words and rules of grammar. Could it be said, then, that children

Redcross in May (photo by Shay Connolly)

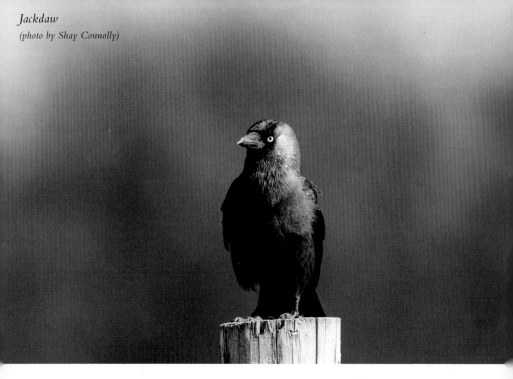

have a similar innate predisposition towards the wonders of the natural world? Children are relentlessly curious about their environment they find themselves in and, if given the opportunity, will spend hours exploring rockpools or woodland trails, looking for something unusual that might get pride of place on the school nature table. I strongly believe that the curiosity of a child is something that must be nurtured by both parents and teachers — but, unfortunately, it can become blunted if it is not encouraged. I always find it so disappointing when a child eagerly shows their mam or dad a bird's feather, or an unusually shaped shell, only to be told, 'Put it down. It's dirty.'

The Murrough, along the Wicklow coast, is another wonderful place to enjoy a family walk or to bring a class on a nature trail. Whenever accompanied by young nature enthusiasts, I find that a helpful way to encourage their curiosity is to give them a list of things to find along the way. Blending a child's inquisitiveness with the healthy spice of competition makes a wildlife treasure hunt a perfect way to spend a few hours out of doors.

On a bright May morning I bring some young members of my own family down to the Fen walk, and before we leave the house we decide to hold a competition on who will have the largest spot-list. By the time we even get out of the car, my prediction has been surpassed. Along the grassy ditch we spot a long orange-and-brown spotted insect on a leaf. We write down a description that will help us to identify it later, but for the time being we give it our own nickname. Once we enter the fen, a tapestry of wildflowers

appears. At every new flower, we pause to write a description of what we see. We list the tiny field speedwell with its delicate blue petals. We spot the tubular foxgloves that rise high like cathedral spires, shadowing the marsh violets and willowherbs below. Two jackdaws that are startled by our approach fly out from the branches above our heads, causing the entire fen to rustle. Butterflies cross our path at every step, silently fluttering from one flower to the next in their intricate summer costumes that fill the air with captured light. We add a green-veined white to our list, along with a tortoiseshell, a peacock and a painted lady. A dragonfly can be seen standing on the surface of still water, with its black-spotted wings stretched out to dry in the warm sun. We add it to the unidentified list, calling it 'checkers'. We then spot a rare clouded yellow on a leaf, at rest after its long migration north, and a cinnabar moth with its bright metallic red markings on a charcoal wing. Another moth that can occasionally be seen is the hummingbird hawkmoth, which migrates here to feed on the abundance of wildflowers during the summer. In flight, hummingbird hawkmoths are superficially similar to hummingbirds, with the fast-moving hum of their wings and their long tongue appearing like an angular beak from afar. It is understandable that they can cause confusion, but unfortunately there are no hummingbirds in Ireland.

Down by the gate the bog ponies are waiting for us, as if they can smell the treats in our bag. We climb up on the gate to let the ponies munch on the cut-up carrots and apples we have brought and they nod their heads approvingly. We walk on through the field where tall nettles make the way impassable. The only solution is a piggy-back ride across to the woodland trail on the far side. Continuing on our trek, we find a bluish-green spotted eggshell under a chestnut tree. It is a blackbird's egg that looks like it has been predated by a rook or a magpie. This is the unfortunate reality of this time of the year. Many of the eggs will not hatch, and those that do will still face low odds of survival. We take a photo of the empty eggshell and look around to see if we can spot any fledglings, but there's no sign. Hopefully the mother is still sitting on her remaining eggs and has not been forced to abandon the nest completely.

Along the right-hand side of the woodland path leading us back to the sea, tall reeds gently whistle in the breeze. The whispering grass is the home to many of our wetland birds' nests. Birds like the secretive water rail may be patiently sitting and waiting for the eggs to hatch, waiting for the hungry chirping sound from their black, fluffy fledglings with their white, stumpy bills. If they are in there, they will remain under the secluded cover of the reeds. Returning to the sea, we bathe our nettle-stung feet in the refreshing waves before making

our way back to the car. Back home, we sit down to count out our spot-list. It has surpassed all our predictions. We look up the insect we saw on the leaf and write 'soldier beetle' beside its description, and beside the dragonfly with the black spots on its wing we write 'four-spotted chaser'. We count our entire spot-list, which fills up three pages and, thankfully, does not contain one Pokémon.

Lily flower (photo by Seán Ó Súilleabháin)

On an evening stroll down to the Breaches in late May, I meet up with Niall Keogh. Niall is one of those dedicated BirdWatch Ireland wardens who monitor the success of the little-tern colony. He tells me that two little-tern eggs were laid in the past day and are the first of the season. The eggs are pale with brown and grey specks, making them perfect for camouflage amongst the beach's stones, but also making them very vulnerable to unobservant walkers. That is why the entire stretch of beach around the Breaches is closed to the public, with the success of the little tern's breeding season down to the dedication of Niall and his team.

With the end of May approaching, the summer holidays are so close they can be tasted. Once students have sat their final exams and teachers have that last paper corrected, the summer may begin. The last weekend of the month often brings glorious weather that seems to cruelly coincide with exam time. On a fine Saturday morning everyone seems to be up and enjoying the change in the weather. Joggers can be seen pounding the paths and brightly coloured cyclists go by, not in twos and threes but in tens and twenties, as they climb the steep Wicklow Hills. In Greystones the more sedate option is to simply sit outside and watch the world glide by with a Mediterranean ease, sipping lazily on a morning coffee. White-sailed boats pebbledash the harbour, and among the cliffs the more intrepid canoeists weave around Bray Head. On the pier at Greystones, fishermen cast their rods, with the reeling of the line peeling crisply across the bay. Call-and-response echoes out from the open fire-doors of the local community hall, where the Saturday-morning taekwondo club

shout out their moves. Down by the beach, young children on tricycles and scooters shoot off down the coastal walk, deaf to their parents' halting pleas. On a bench, an elderly couple sit side by side in the bright morning sunshine, silently taking in the activity around the bay. Among the rocks, gulls scavenge for food. They dip their beaks into the shallows in search of lichen or minnows, while a lone black-backed gull pecks a greasy brown-paper bag, the remnants of someone's Friday-night fish supper. Down in the sea, some hardy swimmers are already taking their morning dip, arms stretched out above their heads like passengers on an old western steam train being held up by Billy the Kid. Once the first wave comes up above the waist, the hardest part is over, leaving nothing else to do but dive. I have written out my summer to-do list, and one mid-year resolution is to join these morning swimmers. But not today. Today I stay here on *terra firma* and admire their courage.

May's white face is here. Up on Bray Head, the white button flower of the hawthorn has awoken to join the early arrival of its companion, the blackthorn tree. The flickering candle-like flower of the chestnut tree has also sparkled into life, spreading its white branches over walls, villages and ditches. Walking in the Glen of the Downs, the elderflower is abundant, sweeping across in a canopy of waxen scent. I decide to return with a holdall shopping bag, taking a few bunches home with me to make some fresh homemade lemonade. First, I wash the flowers, then I boil 3 litres of water with 900 grammes of sugar. I add a lemon and orange with zest, followed by the elderflowers and 75 grammes of citric acid. Bottling it, I leave it to stand overnight and then, the next day, strain it and leave it to chill. It is the perfect home brew that can be enjoyed on a warm Saturday afternoon as you sit leisurely reading in the back-garden sun-trap; or if you prefer, in the evening, sipping leisurely with friends in place of a gin and tonic — the perfect parting glass to toast the passing of a glorious May.

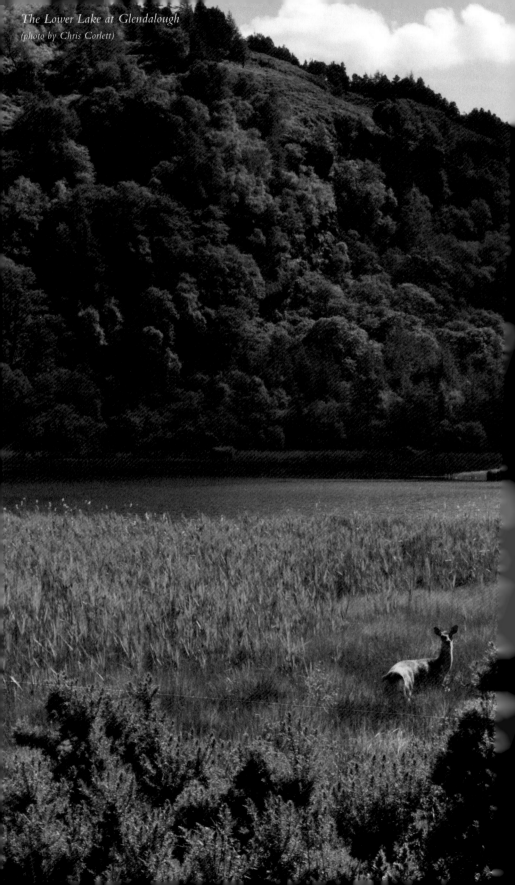

The Lower Lake at Glendalough
(photo by Chris Corlett)

June

Everything flows; nothing remains.
— Heraclitus

June. The voice of young summer. When walking by a body of water on a bright evening in early June, I love to stop and listen to the rhythmic dragging sound of the lazy tide as it gently dislodges smooth stones from the shore; or to sit and count the cadence of lakewater caressing the bottom of an old, abandoned fishing boat tied loosely to the bank. When walking in a meadow, you can also hear summer in the humming engine of a bee or the occasional quiver of a butterfly. In June the day awakens to the cacophony of birdsong announcing daybreak, while long, warm evenings in the back garden are often brought to an end by the soft cooing of a pigeon or dove. But there is another sound that tells us that summer has finally arrived. It is a sound synonymous with the life cycle of a school, and only in early June does its sweetness begin to ripen. It is the sound of the automated school bell ringing out in empty corridors as the last of the happy students set out on the first days of their summer holidays. That thin, metallic clang through the speakers has ruled the lives of teachers and students for a whole 9 months, marking each 40 minutes with a sonorous punctuation mark. The bell's first morning toll reminds students that the school day is about to begin, with the nine-o'clock bell proclaiming that, if you're not sitting at your desk by this stage, well, you're already late. It regulates when one class enters and when another class leaves; when you can eat; when afternoon classes begin; and, finally, when you are released for home. Sometimes I think how a teacher's life is measured out, not in coffee spoons, but in ringing bells. The bell is

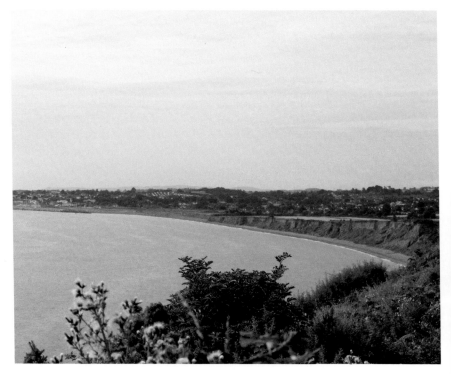

Greystones North Beach (photo by Seán Ó Súilleabháin)

the authoritative voice of the school and, to my ears, a nasal and persistent whine that holds you in its power. However, with the arrival of June, this merciless force that has held you in its tight grasp suddenly becomes limp and powerless. When I hear the empty ringing through the corridors as we set up for the end-of-year barbecue, it suddenly sounds just a little bit pathetic. It is like the call of a prison guard who has suddenly lost all authority; or, perhaps, a once-dictatorial ruler who has at long last been ousted. He calls and calls for phantom classes to begin but, alas, nobody is listening. Nobody cares. Summer is here.

In the seasonal relay there has been a smooth transition between May and June, with the fine weather encouraging families to pack the car and visit the Wicklow coast. Families spread out deckchairs and picnic rugs laden with supplies for the day. In Greystones, children scamper up and down the beach, filling buckets with water and sand as they dig and tap in the hope their castles will emerge whole. Parents and teenagers sit back and take advantage of the very rare chance for an Irish suntan. Teenagers throw frisbees or play volleyball over a half-torn net. For exam students, Saturday's plan of

cramming is rescheduled and calculus, *Hamlet* and the *modh coinníolach* are all briefly forgotten. An ice-cream van's wind-up jingle plays from the car park, tempting us with the taste of smooth, whipped ice cream that drips sticky-sweet down the cone.

As the glorious day fades to evening, the families finally decide to fold up their towels and fill the waiting cars with their creased blankets and bags. The sparkling light of the sea fizzles out, with a solitary reader the only person remaining. The only movement is the quick flick of a page, revealing the next twist in a story of love or murder that refuses to be put down until the last of the light dips below the horizon and a memorable June day turns to night. Soft starlight ignites through the inked-up sky and the final sound that can be heard in the darkness is the rise and fall of the tide over broken shell.

A night-time walk along Greystones's seafront is a real treat during these early June evenings. The long evenings stretch out until after ten before the dotted amber glow appears over Wicklow Head. The modern blue lighting along the town's coastal path must make it look like a small landing strip from the air. It is hard to imagine that men were once employed to light up the gaslamps at night and snuff them out come dawn. In Máirtín Ó Direáin's poem 'Fear lasta lampaí', he writes about a small, disfigured man who was employed to walk the streets of Galway every night to ignite each gaslamp by hand. The poem honours the dedication of a forgotten profession, marvelling at how the *fear lasta lampaí* went about his job, despite being laughed and mocked at by the people of the town:

> Ba dhraíodóir an fear beag
> A raibh solas ina ghlaic ...

Down by the harbour, laughter and music reverberate out from the warmth of the Beach House and Dann's Bar, illuminating the cold, cloudless night with a welcome to any passer-by who wishes to step in for a drink. In the harbour, sailing masts tinkle gently in the faint breeze, like horses' restful neighs after a long day out on the paddock, while above the sea, the oldest *fear lasta lampaí* of them all majestically rises overhead. The moon reflects a white, glimmering road through the watery darkness, its timeless face frozen in tranquil repose.

The fine weather has continued on into the Monday, so I decide to take a morning drive up to Lough Dan, which is a ribbon lake nestled deep in a glen between Roundwood and Laragh. It is somewhat off the beaten track, but the mountain walks that look down on this glacier-formed lake lined with spruce

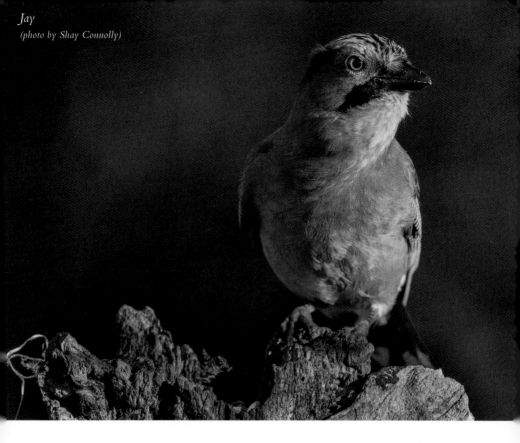

Jay
(photo by Shay Connolly)

and gorse have some of the most spectacular views in Wicklow. It is a place I return to again and again and, any chance I get, I try to introduce this wild and solitary landscape to anyone who happens to visit us. From the lower trail, the meandering Cloghoge and Inchavore Rivers run silently through the valley while, standing on the higher path, one's eyes are instantly drawn down to the depths of the shimmering lake below, before slowly rising to take in the rugged majesty of Scarr Mountain, Knocknacloghoge and Kanturk.

On a windy day, catspaws scuttle across the lake, constantly whirling and spraying up dark water, as if the water is being stirred by a giant's invisible finger. But on a calm June day, the still water perfectly reflects the greens and rich ochres of the rising mountains with mirror definition. The first glimpse of the lake appears through the trees from the roadway just beyond the Sea Scout campsite. There is a small area where about five cars can park on the left-hand side of the road, before you make your way up the steep road that leads towards Lough Dan. In the fields beyond the low stone walls bluebells are still in bloom and, along the banks, an array of columbines, lesser stitchworts and heath speedwells all display the colours of summer. Further up the hill, tall spruce trees link across the road, creating an arboreal arch of woodland shade. As I trudge up along the narrow road, my heavy footsteps

startle something in the trees above. A rustle of leaves and wings suddenly reveals a colourful jay high up in the canopy. This reclusive bird very rarely shows off its striking pink plume but, as it emerges, its chequered blue-and-black wing-band is clearly visible. A few more steps ahead and another jay flies out from its perch and into the safety of the wood on the opposite side of the path. There are plenty of nuts and seeds at this time of year but, come autumn, like a squirrel, the jay will begin to store acorns as a means of seeing off the cold, harsh winter.

Continuing up the road, the trees gradually clear, revealing Lough Dan in all its panoramic glory. The peaceful silence of this hidden gem is a great way to soothe the stresses of a busy modern life. Down by the lake's shore, two canoeists break still water, creating the finest of ripples spiralling out in symmetric rings. Their amplified voices rebound in the echo-chamber of the saucer-shaped mountains, travelling all the way up to where I stand above. A light breeze rustles the tall spruce, gently swaying their pointy tops, while a twittering goldfinch calls out in flight. In the distance, a bullfinch pipes softly as it makes its way down the sweeping hills to the water's edge. Crossing over the wooden bridge, I turn left up the hill before making my way through a small wooden gate on the right-hand side, which leads onto a fern-lined trail. At the top of the hill the valley sweeps down gently towards the bank and I find myself standing high above this spectacular ribbon lake. The views stretch right across farms and fields, framed by a thin line of blue where land meets sea in the far distance. At first I think I am the only person present, but down amongst the ferns I see a man sitting still. For a moment I think he is simply admiring the natural beauty of his surroundings, but then I notice how his head is bowed in reverence to the landscape before him. In his outstretched right hand he holds a paintbrush. Remaining very still, he studiously observes the gentle, subtle movements of light on the lake, before slowly dipping into his palette and recreating what he sees on the white canvas before him. What a relaxing way to appreciate this wonderfully secluded countryside.

The impressionist painters are acknowledged as having set the trend for *en plein air* painting, moving from the comfort of the studio to the immediacy of the outdoors. It was Vincent van Gogh's brother, Theo, who bought him his first outdoor easel, equipped with a paintbox to carry all his paints and brushes, as well as a canvas spacer so that he could safely transport his work back to the studio without damaging the fresh paintings and sketches. In one of his letters to Theo, van Gogh states that such equipment was 'essential' for the outdoor painter. Perhaps the warm weather of the south of France

suits this type of painting, but the poor Irish artist must put up with much more trying conditions. The upside, however, is that a sudden shift from rain to breaking sunlight inspires artists from all over the world to come and capture the constant fluidity of an Irish sky. On this particular June day at least, my artist friend has perfect conditions in which to paint. He also has the luxury of no one being around to stop and look critically over his shoulder at the work in progress. I suddenly become aware that I'm doing just that, and immediately move on so as not to disturb his peace. This kind of intrusion was one of van Gogh's pet hates. In another letter to his brother an exasperated van Gogh complained that, while painting outdoors one day, a man spat a wad of tobacco from an open window and splattered his canvas. One can only imagine the reaction of the fiery Dutchman.

Continuing further up the trail, the other half of the lake suddenly appears in view. Across on the far side, an old lake house stands by the shore, its slate roof brightly reflecting the shimmering sunlight of the morning. Up on the left there is a granite bench, inviting walkers to sit and enjoy the view. Carved on this smooth stone bench are the opening lines from a John Millington Synge poem called 'Prelude':

> Still south I went and west and south again,
> Through Wicklow from the morning till the night.

Synge is usually associated with the west of Ireland and specifically the Aran Islands, where the lilt of the Irish language and the wild landscape were an inspiration for his most famous plays. But it was on his childhood visits to Greystones where he was first to taste 'all that was salt in the mouth' and walking amongst the Wicklow Hills where he first felt a landscape that was 'rough to the hand', as W.B. Yeats described him. Born into an upper-class Protestant family in Rathfarnham, Synge's father's family were landed gentry who owned Glanmore Castle in Ashford. It was not in the confined opulence of the drawing rooms that Synge felt most at home, however, but in the open, untamed expanse of the mountainside. In 1893, the Synge family spent the summer in a rented house at Lough Dan, and it was from here that he set out on his long walks 'to converse with mountains, moors and fens'. He immersed himself entirely in the solitary wilderness of the Wicklow landscape, and perhaps it is from this very spot where he penned those lines. I always stop to pause by this bench, taking a moment to listen and observe. The inscription tells us that it is dedicated to the hill-walker Ronnie Petrie, who also clearly loved

this walking way. I cannot imagine a better way to be remembered by friends and loved ones than a simple stone rest in such stunning surroundings.

On one of my visits here, I was sitting on this very bench when I suddenly heard a slight rustle to my left. A hare had hopped out onto the track from a small clearing in the gorse. He stopped and boldly returned my stare, no more than six feet away, showing no sign of fear at my presence. Hares are the fastest land mammals in Europe, reaching speeds of up to 72 kilometres per

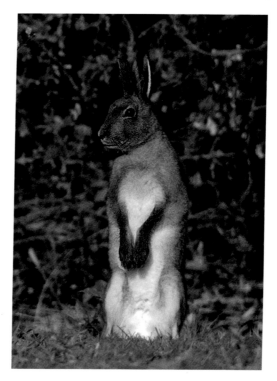

Hare (photo by Shay Connolly)

hour. A hare at full speed would cut Usain Bolt's 10-second 100 metres in half. I refer to the hare I saw as a he, but actually it is very difficult to know from afar whether it's a buck or a doe. The 'mad march hare' is associated with boxing fights between hares during breeding season. I used to think that these infamous bouts were two rival bucks gallantly fighting it out to win the attention of a doe, but this is actually not the case. In fact, it is the poor doe herself who must fight off the persistent males. A doe may have to fight off six or seven bucks in one day before she finally makes her choice.

As I watched this inquisitive hare, my attention was broken by a shrill, piercing call that seemed to echo through the valley and, when I looked back to where the hare had been, I just caught his rump disappearing into the undergrowth of the trees. Again the shrill call could be heard coming from somewhere down in the valley, but the source remained a mystery. It had a rising and falling quality, like the sound of a car alarm. At the end of the wood, the lake returned into view and I scanned the expansive landscape with my binoculars. I could hear the call, but I had no idea where it was coming from. And then there it was, high up above the lake. Its wing movements were

fluid and relaxed, making a long M shape. To the naked eye I could just make out a dark outline, but through the binoculars I could see it had a distinctive white underbelly. Similar in size to the great black-backed gull, this solitary bird glided effortlessly across the water. It was the magnificent osprey. I held it in my gaze as it flew closer.

So this was the source of those mysterious calls that startled the hare. It was the first and only time I ever saw this elusive bird of prey in the wild. The hare had no reason to worry, though. These birds of prey are mainly fish hunters, equipped with dagger-like talons that enable them to grab a trout or salmon on the wing. The talons lock onto the bird's scaled victim with a vice-like grip, before it devours the entire fish (including its bones), which perhaps explains its Latin derivation, *ossifragus*, meaning 'bone-breaker'. What a sight it would have been to see this bird hunt. I stood and watched until it disappeared over the distant mountains to the north, its presence lingering long after it was gone.

Ospreys use Ireland as a fuelling station on their way to and from west Africa, with successful breeding taking place in Scotland, England and Wales. This bird was most likely making such a journey and using Lough Dan as a pitstop; I had heard that two ospreys were also looking at Pollaphuca as another possible place for nesting. Perhaps the osprey will one day be reestablished in Ireland, emulating the success of the red kite. What a welcome sight it will be after such a long absence. During the excavation in Fishamble Street

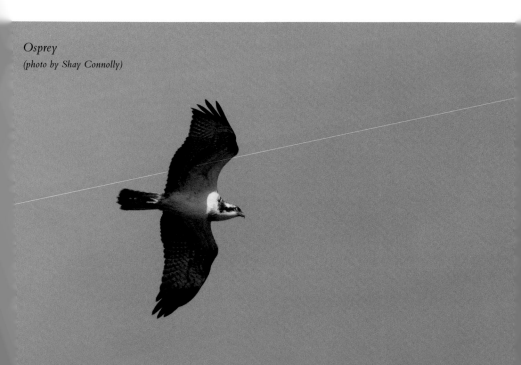

Osprey
(photo by Shay Connolly)

in Dublin, some thousand-year-old osprey fossils were found, suggesting that they were once a much more widespread and familiar bird. There are numerous Irish names for the osprey, including my favourite, *coirneach*, which means 'tonsured', probably because of the bird's white head, which looks like a monk's tonsure in the reflecting sunlight. It's also known as *seabhac cuan* and *fiolar mara*, meaning 'harbour hawk' and 'sea eagle' respectively — so our ancestors were obviously quite familiar with both the appearance and habits of this rare and beautiful raptor.

Another ancient inhabitant of Ireland that brings us even further back in time is a fish that was last found in Lough Dan in 1988, the Arctic char. This cold-water fish is native to the Arctic and sub-Arctic and swims up to fresh water to breed. It can be found extensively in deep glacial lakes and is common in Scandinavia and Siberia, but unfortunately it is thought to be close to extinction in Ireland. Being one of our oldest inhabitants, the presence of the Arctic char in Lough Dan was a direct link to prehistoric life on our ice-covered country thousands of years ago. In G.N. Wright's wonderful 1827 edition of *A guide to the County of Wicklow* he states that, although the gentry were not aware that char could be found in Lough Dan, the peasantry of the area were fully aware and knew their worth. In northern England, he says, a char (no larger than a herring) would sell for a shilling, with September being the best month to go char fishing. Sadly, today there are no char left in this lake and the sight of an osprey catching an Arctic char on the shores of Lough Dan is something that will probably never be witnessed again.

Moving west along the track, the path slopes down into the depths of the valley, where the meandering Inchavore River flows into the lough, making this land rich and fertile for wildlife. Signs of our ancestral past lie all around these rising mountains that circle the lake and the ruins of the peasants' homes that are mentioned in Wright's book can still be seen. Up until the middle of the nineteenth century, furrows and ridges known as lazy beds were dug into the earth for planting potato crops. They were dug into the mountainside by spade, with seaweed being used as fertiliser. I can only imagine the hard lives these men and women had, living high up in this isolated valley, using the natural resources they had at hand as a means to survive. The lazy beds are now all grown over with grass and ferns, but their remnants can still be seen. Scars of our tragic past run like a historical timeline back to those fearful years of the mid-nineteenth century, when the staple potato crop began to fail. Down in the valley are the remains of what was once a famine village. There are no inscriptions to be found, with the names of the inhabitant lost to time:

'Someone would know: I don't.' These words echo in my head when I walk amongst these ruins, reminiscing on Philip Larkin's poem 'Church going', in which he observes the demise of an old empty church:

> Grass, weedy pavement, brambles, buttress, sky,
> A shape less recognisable each week ...

Here in the valley, there is no sign of a church that I can see — and yet, they must have prayed. Was it out in the open air, or did they have to walk to another village? Was there a teacher that lived amongst them who taught the children to read and write? What stories and songs did they recite at night as the smell of turf filled the air? I try to capture some ghostly image of what this place must have looked like before the famine struck, but I do not think I can do it justice. I can only sit where they once sat, looking around the remains of what was once their home, and think and listen and remain silent. Larkin was right: this is 'serious earth'.

Another way to enjoy the peace and solitude of Wicklow is to do a spot of fly-fishing on its many lakes and rivers, with the Aughrim River being one

of the most popular. Parking outside the Woodenbridge Hotel, you can buy a one-day fishing licence before setting out on the river. This historic hotel was built in 1608 and is one of the oldest hotels in Ireland. Inside, the walls are covered with memorabilia and old photographs, reminding us of the hotel's rich history. Initially it was a popular staging post for travelling merchants on their way to do business in Dublin, and it is this very hotel where Éamon De Valera spent his honeymoon, with the bridal suite being named in his honour. Michael Collins also stayed in this hotel when conducting secret meetings with British army officers during the Irish Civil War in 1922. Irish history is nothing if not ironic. Across the road from the hotel there is a small rural garage and it was in this spot where John Redmond addressed a monster meeting in 1914, on the outbreak of the Great War, encouraging all Irishmen to fight and go 'wherever the firing line extends'.

But on an agreeable June evening, it is not the firing line but the fishing line that is of concern. I meet up at the hotel car park with my good friend Éamonn Dunne, who first introduced me to fly-fishing. We make our way down the bank to where the river widens into an open stretch of water and there are fewer overhanging branches to catch the line. Here, even the sound of the distant country road disappears. It is pure, unspoilt solitude. Standing in the middle of the river, I begin to appreciate Éamonn's love for river fishing. Catching a fish is a secondary concern for him. It is more about the ritualistic

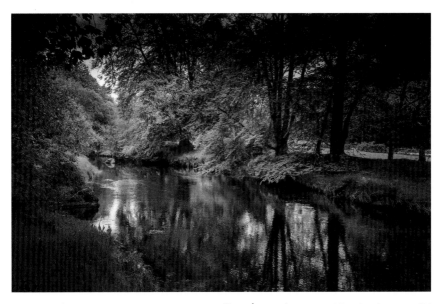

Derrybawn river scene (photo by Shay Connolly)

process of finding his favourite spot on the river, and then that first whish of the cast that cleanly slices the evening silence. He uses a four-count beat in his head that works like a metronome, helping him maintain the rhythmic flick of his wrist. I listen to the sound of the gentle flowing water smoothing over a millennium of watery, caressed stone. I stop and feel the gentle tug of water around my legs. I look at the glistening light through the trees, broken by the occasional splash of a hungry fish that is far too clever to be fooled by the likes of me. Eventually a very real feeling of calmness flows through my body. It is one of those rare moments when everything stops and I am simply standing in the here and now — an ever-changing but constant present — content in the knowledge that I am alive at this exact moment.

I watch the river's continuous flow as it twists and turns over briar and boulder before gurgling its way around the bend and out of sight. It both invites exploration and resists disturbance. I think about how the fish and animals and birds who live in and around this moving body of water know and see this world with much greater insight and depth than we ever could. We are, at best, passing visitors, sharing for a short while this solitary place of calm.

Rivers have always attracted me, especially young rivers that emerge from a mysterious source high up in some unknown, mountainous bog. Young rivers have a unique song that is full of exuberant energy as they make their way towards the sea. Stones and branches try to impede their course, but the flow can only be diverted for a while before a new way is found. We can learn a lot from rivers. The creative process of ideas, thought and output are all present in the journey of a river. When we speak about the process of creation, we use terms like 'the source of inspiration', 'the flow of ideas' or 'the tide of subconscious thought'. Ideas stem like tributaries from our memory before we channel these thoughts into one final 'creative outpour'. Of course, rivers are also a metaphor for our own life journeys. We each emerge from the mystery of darkness and undertake an individual voyage of light. Just like a river, our lives take twists and turns as they attempt to manoeuvre around impeding obstacles. There are places in our lives when we enter phases of great energy and movement; and other times, usually in the latter part of the journey, when we are more inclined to wind down into a meandering, reflective calmness before making the final, inevitable exit into a new and unknown state. Heraclitus said that you can never stand in the same stream twice — *panta rhei*, 'everything flows'. I look over at Éamonn and his expression is the same as mine. Éamonn glances over and smiles. He does not

need to speak. I know what he is saying: 'See, I told you. You're hooked.'

Back down by the Breaches by mid-June, the little terns will be well into their egg-laying. There are always some accounts of predation by crows, or an opportunistic sparrowhawk, but thanks to the wardens' protective dedication, the first chicks should hatch by early July. The colony is a cacophony of calls, with the white adult terns nosediving into the sea in search of breakfast. Despite their diminutive size, they are fiercely protective of their nests. Even though the area on the beach where they lay their eggs is completely cordoned off with electric fencing and barriers, the terns sometimes have cause to deploy their own inbuilt defence mechanisms. As I walk by the nesting area one morning, I notice that one of the terns has begun circling low over my head and is calling out sharply. I have obviously wandered too close to a nest and he is telling me, in no uncertain terms, to back off. Terns are even known to swoop down like stealth bombers if they feel their eggs or chicks are in danger.

For garden birds like the blackbird or the robin, the chicks are already fledging, leaving the relative safety and comfort of their nest and facing into the many dangers that await them in the outside world. This is a crucial time for them. For a fledgling, the wisest thing would be to find somewhere secluded to hide for a few weeks until they have grown; but, unfortunately, the harsh truth is that most of the fledglings will be predated before they get that far. In fact, if even one chick from a nest survives to maturity it may be seen as a great reward for its hardworking parents.

June creeps steadily on, with purple-streaked evenings stretching well into the late hours of the night. Even after the sun has dipped beyond the horizon and night has set in, the vulnerable fledglings are not free to relax. The blue, cloudless skies of day reveal the brilliance of a clear, illuminated sky at night. The longest day of the year is 21 June, which sometimes coincides with the first summer full moon, or strawberry moon, when it occurs at the time of the moon's closest approach to the earth. The result of this phenomenon is called a 'supermoon,' which is about 15 per cent larger in the night sky than the average full moon. The reflected light of the sun bathes the dark earth in cool, grey shadows, filling up the darkness with brilliant moonlight, giving nocturnal predators an added advantage in the hunt for young, vulnerable fledglings.

The Wicklow Mountains are an especially good place for any amateur astronomer to observe the night sky on a cloudless night, so I decide to take a midnight drive up to the Military Road that runs over the Featherbeds.

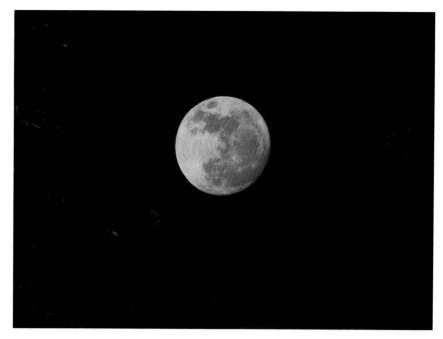

'*Supermoon*' *(photo by John C. Murphy)*

The night I choose for the drive is 16 June, which is the date when Bloomsday is celebrated. Every Bloomsday I try to visit a new destination, following in the footsteps of Leopold Bloom and Stephen Dedalus as they walked and talked their way through the streets of Dublin in 1904 in James Joyce's *Ulysses*. In the past few years I have visited some of the more famous landmarks that are mentioned in the book, including a packed Davy Byrne's pub, where Bloom ate his Gorgonzola sandwich, and Sandymount Strand, where Dedalus walked into eternity. This year, however, taking advantage of the clear summer nights, I decide to follow a less-travelled path. It is the location of the humorous but somewhat sad tale Lenehan recounts to McCoy as they walk through the back streets of Temple Bar. After seeing Bloom in a second-hand bookstore, McCoy mentions to Lenehan that Bloom has a great interest in astronomy, at which Lenehan bursts out laughing, remembering the time when he and Chris Callinan took an early morning jarvey home with Leopold and Molly Bloom over the Wicklow Mountains, after a night of food and booze at the annual dinner in the Glencree Reformatory.

'It was a gorgeous winter's night on the Featherbed Mountain,' Lenehan remembers. Leopold looked up at the blue night sky and began to tell Callinan the name of each constellation overhead. Unfortunately for Bloom, while

he was busily admiring and describing the stars, Lenehan was admiring and groping Molly's white breasts as they bounced up and down with each jolt of the carriage. Molly then leaned in to him so as to give him a better view.

'I was lost, so to speak, in the milky way,' he cruelly jokes to McCoy.

Despite this being a very brief scene in the book, I've always found it poignant. It foreshadows the rendezvous that is to take place later on in the day with Molly and her lover, Blazes Boylan. The fact that Bloom knows the affair is happening and is powerless to do anything about it makes it all the more tragic. Perhaps he also knew what Lenehan was up to that night as they journeyed home over the Featherbed Mountains, with Molly snuggling into Lenehan and Bloom conveniently looking away at the stars. When I reach the top of the Military Road, I pull in and look up at the stretch of sky where Bloom and his companions would have observed the stars on their journey home to Dublin that night. As I set up the telescope, I think about that final thing that Lenehan says to McCoy as he comes to the end of his anecdote.

'Ah, he's a cultured allroundman, Bloom is,' he says with sombre admiration.

There is a definite sense of guilt and perhaps even remorse in Lenehan's voice at this point, as he slowly realises that Bloom deserved much better. Despite his jokes and sneers, Bloom is a better man than he can ever hope to be.

'There's a touch of the artist about old Bloom,' he admits deferentially.

Magherabeg Beach
(photo by Seán Ó Súilleabháin)

July

And does it not seem hard to you
When all the sky is clear and blue
And I should like so much to play
And have to go to bed by day?
— Robert Louis Stevenson, 'Bed in summer'

In Robert Louis Stevenson's poem 'Bed in summer', a young child complains bitterly about the unfairness of being sent to bed as summer's evening sun seeps through a half-open curtain, cruelly tempting the child with one more hour's play. I think this must be a universal thought experienced by most young children as they reluctantly trudge up the stairs to bed. It certainly reopens early summer memories for me, as my five-year-old self peeped out on a world still wide awake, while I was forced to close my eyes and go to sleep.

And yet, despite July's early lesson in injustice, this is really a month for children. For the older students, exams are thankfully resigned to distant memory, and now it is the younger children's turn to bid goodbye to teachers and classmates and to enjoy the long summer months of blissful freedom.

The coast of Wicklow boasts a diverse area in which to explore. It offers the choice of discovering mountain and forest trails to the west or unspoilt beaches and cliffs to the east; and there are few beaches in the country that rival the stunning Brittas Bay. On the first weekend of July, if the weather is fine, many families head to the bay. Swimming and sandcastle-building are the most popular activities when enjoying a beach on a summer's day, but rockpooling can also be great fun. All you need are some snorkels, or even a

clear, empty ice-cream tub and a net, and you have all the essential tools to step into the micromarine world that exists on the threshold between land and sea.

Exploring rockpools brings out the undiscovered marine biologist in children. As a child, I loved lifting rocks and seaweed by the shore and I would spend hours hunched over, observing the strange, unnameable creatures going about their business. Nowadays, even when most children have access to smartphones and tablet computers, rockpooling has lost none of its wonder. Given the opportunity, young eyes will still eagerly scan the pools in search of marine wildlife in their natural habitat.

From above, these pools look still and lifeless, but once you begin to investigate you can see there is a city of marine life scurrying around, feeding and hunting. On any given exploration you may find hermit crabs, limpets, molluscs, shrimps and sea anemones in the shallow water and among the rocks. The limpets may not look like they are up to much, being stuck firmly onto the rocks and encased in their hard shells, but they are, in fact, slowly but constantly, moving and feeding on bits of seaweed. I always think of limpets as the Hansel and Gretel of the rockpools. Having no eyes, they cleverly leave a trail of slime that is unique to them, which they use as a map to find their way back to their original place on the rock.

Brittas Bay Beach
(photo by Chris Corlett)

But, as clever as the limpet is, it too can be outsmarted by an even more adaptive predator — the small dog whelk. If limpets are the Hansel and Gretel of the rockpools, they can quickly become the vulnerable three little pigs, stuck in their house, when this visitor is around. This oval pointed shell slug climbs up onto the limpet's shell, before dissolving a tiny hole at the top, then drilling inside and feeding on the soft, salty flesh. The poor limpet trapped inside does not stand a chance. You have to be a hardy customer to survive in an environment where sea water is constantly rushing in and flooding your home twice a day. I suppose your choices are simple: cling on for dear life like the barnacle or limpet, or find a suitable place to hide like the house-hunting hermit crab. The motion of the tide is the lifeblood of the rockpools, but it is important for observers to keep an eye on the sea, as high tide can come in quite quickly when your attention is focused on the marine life within the pools.

After exploring the rockpools, a stroll down by the tide's edge can offer some distinctively shaped shells for the nature table, like empty razor shells. These long, slender shells look like cut-throat razors and are usually found when the inhabiting clam has died and the shell has been washed up onto the shore. The clam itself is rarely seen, spending its life buried deep in the seabed, using its 'foot' to dig into the coarse sand, but keeping one end exposed to extract any organic matter in the water. I have never eaten one, but apparently this soft, sweet-tasting mollusc was a favourite dish of the Vikings. Ham-and-cheese rolls may now be a more likely option than grilled razor fish for hungry families enjoying the five-kilometre beach of Brittas Bay on a sunny July day. Although most visitors respect this idyllic location, there is unfortunately a minority who leave more than a trace of their presence after they depart. There are no high-rise hotels dotted along the Irish coast, obstructing the natural beauty of the landscape, but littering and dumping on our beaches destroys these scenic spots for everyone, not to mention the harm it does to the wildlife.

Another way to enjoy Brittas Bay is to take a stroll among the sand dunes that run all along the beach to the tip of Mizen Head. These dunes are a protected area under the European Union Habitats Directive and are home to some rare and red-listed flora, including wild asparagus, spring vetch and meadow saxrifage, while up on Mizen Head the outflow of a small river has been cut off by the sand, creating Buckroney Fen, where lapwing, snipe and curlew can be seen.

Back in the seventeenth and eighteenth centuries, this coast was a prime area for smuggling, and one of the most famous smugglers at the time was

a man called Captain Jack White. Smuggling was a very lucrative business and, despite being illegal, it was a widespread activity. The smuggling trade was especially important for the Irish if England happened to be at war with France, which disabled Ireland from trading directly with the continent. Captain Jack White had a small landing place by the cliffs known as Jack's Hole, where he smuggled all sorts of contraband for both rich and poor alike. Once the goods had landed, he brought them to the safety of his drinking house, where men could safely receive their imports without being seen.

White's smuggling activities were under the supervision of a part-time magistrate, who had his own financial interest in the affair. Unfortunately for White, this arrangement turned sour one night when a row broke out over a particularly large amount of smuggled cargo that had been loaded in from a French ship. Despite the magistrate having greatly benefited from their arrangement in the past, on this particular night a dispute broke out between the two men (probably caused by the magistrate demanding a higher percentage of the profit). When White refused, he was arrested and charged with illegal smuggling, before being tried and sentenced to death. It is believed that he was hanged off the cliffs above his landing place and his body was then callously thrown into the Irish Sea. But his name lives on through Jack White's pub on the N11, which is said to be built on the grounds where Captain White's old shebeen once stood.

Returning north along the coast road back to Wicklow town sits Silver Strand, a magnificent little beach tucked away amongst the cliffs. The beach is accessible through Webster's Caravan and Camping Park, where you can pay for a day visit. In July, glistening fields of wheat rustle down to the cliffs' edge, while the clear sea inches its way noiselessly around the cove. Laughter rises up in a hum of excitement from the bathers below while, further out on the horizon, white sails rise and fall in the silent, breaking waves. The sandy cove would be a perfect setting for a scene from *Treasure Island*, with Long John Silver resting on his wooden leg as he plots his next move in the hunt for the buried treasure. On a fine July day, the water is so clear and tropical that it is impossible to resist the temptation of going for a swim. Around to the right of the cove there are a number of caves, where smugglers like Jack White may once have stood, waiting to unload their cargo of wine and spirits from wooden barques under cover of darkness.

How different sea and land look in July compared to the high waves of January or the rain-soaked earth of March and April. Wicklow in July is ablaze once more with golden meadows of wheat and winter barley that will be

Wild strawberries (photo by Shay Connolly)

ready for harvesting come August. Of course, rainy days are not a rarity for an Irish summer but, as much as we complain about the weather, we must remind ourselves how fortunate we really are. You just have to think of some African and Asian countries where women and children walk great distances to reach a safe source of clean drinking water. Our fertile countryside and rich abundance of flora and fauna depend on our mild climate, which we can sometimes take for granted.

But it is not only the wildflowers in bloom and the fledgling birds that signify the arrival of an Irish summer. The wild Irish strawberry characterises this season of growth like no other. During the month of July, it is impossible to drive down a country road in Wicklow or Wexford without seeing a stall selling a punnet of this favourite fruit, with its sweet fragrance enticing you to stop and indulge. The Irish name for the strawberry is *sú talún*, or 'juice of the earth'. Sitting out in the garden on a sunny afternoon, enjoying the delicious taste of summer, is one of nature's simple luxuries. Growing up, strawberry-picking was a favourite activity in our house. We eagerly filled our baskets to the brim, while my younger brother plonked himself happily in the middle of a strawberry bed, filling his mouth with this sticky, delicious fruit, not even stopping to wipe away the mucky juice that streamed down his chin.

Victor's Way Indian Sculpture Park
(photo by Caoimhe Fox)

There is an old Cherokee creation story called 'The first strawberries', which is like a Native American version of the Adam and Eve fable, where the First Man and the First Woman are put on the earth in mutual harmony. But they argue and fight and, finally, the First Woman marches off into the forest in anger. Remorsefully, the First Man prays to the Creator to put wildflowers by her feet so she will stop and smell them, and to make wild berries appear so that she will stop and eat them; but she continues walking. Finally, the Creator picks the most delicate white flower and places it with the sweetest berry. When the First Woman sees this, she stops and tastes the fruit. The heart-shaped fruit with its delicious juice cools her anger. She returns to the First Man and they forgive and embrace each other. Cherokee families still keep strawberries in their homes as a symbol of love and togetherness. Above all, this is a moral lesson about pride and not letting the sun go down on your wrath. One of the reasons I love these fables and old myths is the kernel of universal truth that lies at their heart — whether they are Native American stories, epic Greek sagas, or our very own *scéalta Ruraíochta agus Fiannaíochta.* You can learn a lot about a country's traditions and values from the stories that are passed down and remembered.

If opening your mind to the cultures and beliefs of other countries is what you are after, there is one place in Wicklow that invites you to do just that — Victor's Way Indian Sculpture Park, situated just outside the village of Roundwood. The park opens between April and September and is really an incredible place to visit during the summer months. Its owner and creator is Victor Langheld, who was born in Berlin in 1940. He spent much of his life travelling through India in search of what he described to me as 'the real truth' behind the message of the sadhus or Hindu holy men, before funding the construction of the many sculptures that can be now seen in the tranquillity of the Wicklow Mountains.

The first time I stumbled across this place, I was simply driving by and saw a small road sign that read 'Indian Sculpture Park'. It is not something that you expect to see on an Irish country road and, with my curiosity piqued, I pulled in to see what it was all about. What I saw left me stunned. I could not believe such a place existed. First of all, there was no ticket-seller, just a simple box asking you to be honest enough to contribute a modest entrance fee of a couple of euro for the maintenance of the grounds. You enter through a 20-tonne black granite tunnel, which represents a huge birth canal, before coming out into a large open field lined with nine massive stone sculptures of the Hindu elephant-god Ganesh. These sculptures were carved under the supervision of a master temple-sculptor in Mahabalipuram, India, with each one taking over a year to complete. Each Ganesh is in an individual pose. One of them is playing the flute. Two are dancing. Another statue, which is humorously entitled *Paddyganesh*, is playing the uilleann pipes, with a pint of Guinness resting by his feet.

Paddyganesh, *Victor's Way Indian Sculpture Park*
(photo by Seán Ó Súilleabháin)

If this is not random enough, you then enter into the Enchanted Wood and follow the path that leads you to seven of the most startling and mesmerising statues imaginable. The statues represent the journey of Siddhartha (Buddha) as he journeys on his quest for life's meaning and spiritual enlightenment. The statue entitled *The dark night of the soul* is an incredible work of art. It is a copy of a stone sculpture carved in the first century AD that is now in Pakistan. Standing at 14 feet 6 inches high, this bronze statue depicts Siddhartha meditating on the problem of human suffering through severe austerity, and the representation shows Siddhartha slowly starving himself to death in graphic detail. His ribs are clearly visible through his taut chest and the protruding sinews in his neck emphasise the pain and concentration in his large, hollow, black eyes. It is only when you walk around to the back of the statue that you notice a subtle touch of ironic humour in the piece, which gives a strange sense of relief to the viewer. Buddha has a small Nokia mobile phone tucked away in his robes.

This is a place that inspires, but does not demand, silence. No matter how many times I visit, I always leave with a real sense of inner calm. The thing I like most about the Indian Sculpture Park is that it is built in harmony with nature, not against it. Usually works of art like this are in a stuffy building behind ropes with 'Do not touch' signs guarding them, but here there are no restrictions. The statues invite you to touch and feel each intricate carving and, as you move from one exhibit to the next, you become unconsciously aware of your surroundings. You feel the summer breeze on your face and the birds chirping in the trees. Mud squelches under your boots and the air is thick with the aroma of last year's decaying winter's leaves. All your senses are stirred in this living, breathing museum. I get an incredible sense of serenity as I follow the trail with Buddha on his path to enlightenment. And yet, despite its spiritual emphasis, the park itself asks nothing of you. You can simply enjoy the installations as wonderful pieces of art, reflecting in the peace of the beautiful setting; or, if you choose, you can stop and meditate on what each statue represents. It is left up to you how you wish to experience it. It is a truly wonderful experience.

Another place I occasionally stop and visit is the German Military Cemetery tucked away in the hillside of the Glencree Valley. Just like the Indian Sculpture Park, you might be initially surprised that such a place even exists in the heart of the Wicklow Mountains, and even more surprised when you read that 134 German military personnel from both world wars are interred in this converted quarry. Unlike the Indian Sculpture Park, however, there is a great sadness prevailing this hollowed-out chamber. The peaceful surroundings of

the valley, with the cool shade of the overhanging trees and the gentle flow of the Glencree River, stands in direct contrast to the tortured and violent deaths of the men who lie buried here.

Walking slowly around the winding path, you can read the name, rank and date of each man engraved on small, square stones. Many of the graves are those of Luftwaffe pilots whose planes ran out of fuel, perhaps, or who got lost in bad weather as they flew over Ireland. Others include navy personnel who drowned at sea and whose bodies were found washed up around the Irish coast.

Forty-six of the graves belong to German civilian detainees who were being transported to Canada from Liverpool on board the SS *Arandora Star* when it was torpedoed by a German U-boat close to Bloody Foreland off the coast of Donegal in July 1940. Six German prisoners of war from World War I, who died in a British internment camp in Ireland, are also buried here. The other graves are of unknown soldiers whose stories will, unfortunately, never be known. But for one marked grave at the back of the cemetery, there is a remarkable and most bizarre story. It is the grave of the German spy, Dr Hermann Görtz.

The extraordinary story of Görtz's time in Ireland is like something taken right out of a Peter Sellers spoof spy movie. He fought in World War I but, in 1935, with his military career fading, he moved to Kent to gather information on the RAF Manston Air Base. When notes, sketches and photographs of the air base were found on the premises he had been renting, he was arrested for espionage and sentenced to four years' imprisonment. He was deported to Germany in 1939, but only a year later he was on the move again, when he made an audacious parachute jump into County Meath under the cover of darkness. His mission was to link up with members of the IRA and find out whether the IRA were in a position to assist Germany in the event that they invaded Northern Ireland. However, when he lost his transmitter during the jump, he was forced to walk to the only address he had on his person — that of Iseult Stuart, the wife of the writer Francis Stuart, who was living in Laragh, County Wicklow. There is an incredible account in his personal letters of how he swam across the Boyne and walked over the Wicklow Mountains over four nights, with his World War I medal jangling in his pocket. There is even a farcical account of him stopping at a garda station along the way to ask for directions.

While Görtz was attempting to make connections with the IRA and other sympathisers, unbeknownst to him, the Irish intelligence service G2 were

informed of his presence and decoded his letters. Görtz duly received his replies, encouraging him to continue with his work, unaware that the letters were actually from Dublin and not Berlin, as he imagined. He continued to send information about the secret work he was doing in Ireland without ever realising that he was in fact leading the authorities right to the doors of other agents and fellow sympathisers. To keep Görtz committed, he even received a promotion to 'Major', a rank that is erroneously and ironically engraved on his tombstone in Glencree to this day. Görtz was in hiding for 18 months, moving from safehouse to safehouse in Dublin and Wicklow, before he was finally arrested and interned in a prison in Athlone.

Once the war was over, Görtz was released. Whereas other detainees softened their beliefs, Görtz continued expressing his hardline political views. He wished to stay in Ireland and campaigned for political asylum, but in 1946 he was arrested again and handed a deportation order. Fearing for his safety if returned to Soviet Germany, he appealed to the Supreme Court for political asylum, but his request was denied and his deportation became imminent. Sitting in the waiting room of the Aliens Registration Office of Dublin Castle, he was told that a plane was being organised for his immediate departure. Calmly smoking his pipe, he quickly took something from his pocket and popped it into his mouth. Before the detective had time to react, Görtz had crushed a small glass phial of cyanide between his teeth and swallowed the contents. Despite the officers attempting to remove the poison from his mouth, it was too late. Görtz was dead within the hour. He was buried in Deans' Grange cemetery in full military uniform, including the swastika draped over his coffin. In 1974 his remains were transferred to Glencree Cemetery, where his grave can still be seen today, marked by a stone sculpture of a sword entwined with barbed wire, which he hand-carved himself when he was in Athlone Prison — a symbol, perhaps, of how he saw his own troubled life.

Despite knowing something of the strange story of this unusual man's grave and intrigued by the historical events that surrounded him, I always find myself being drawn more towards the anonymous graves that line this cemetery. The individual humanity of these men has been taken away completely, and in death they are defined simply by military rank or plot number. The overriding feeling I get when I look at the graves of these unknowable men — men who were probably much younger than I am now — is one of tragic and futile waste. Görtz wished to remain in Ireland out of fear — and he, for one, got his wish. But these other graves bury a deeper sadness, a sadness carved out of a story that expresses the universal tragedy of war. These anonymous graves

are heavy with the mute grieving of loved ones who may never have found out that their missing father, brother or son remains forever silent in the beautiful resting place of Glencree. Here they lie still, under this foreign soil, nameless and voiceless. Here in this peaceful valley, there is a place that still speaks of the terrible anonymity of war and the dispassionate scattering of its unfound children.

Across the road from the cemetery sits the impressive building of the Glencree Reconciliation Centre, which is now used to host programmes and meetings dedicated to a dialogue of peace and reconciliation for all victims of violence. Back in 1945, this building was a refuge centre for thousands of German and Polish children who were left orphaned after the war. Many of these children were eventually fostered in Irish homes and some remained here for the rest of their lives, making Ireland their new home. Out of all the deep wells of hate that are dug by the blades of war, there are often examples of humanity such as this, which go unrecorded in history. It is from such wells of despair that heroism, bravery and simple acts of kindness spring.

Up on the cliff walk, nature is also playing out its own dramatic saga of protection and nurture for its vulnerable young. Only a few months ago, the Greystones cliff walk was calm and peaceful, with only a few solitary

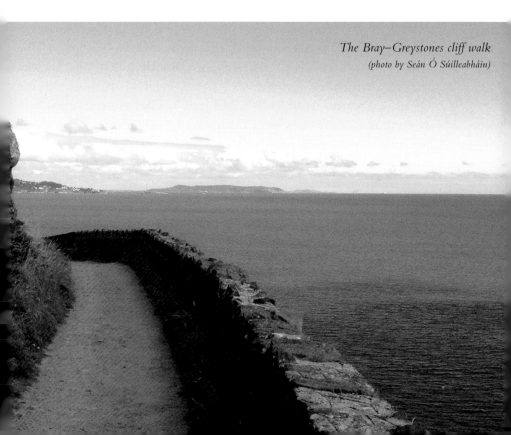

The Bray–Greystones cliff walk
(photo by Seán Ó Súilleabháin)

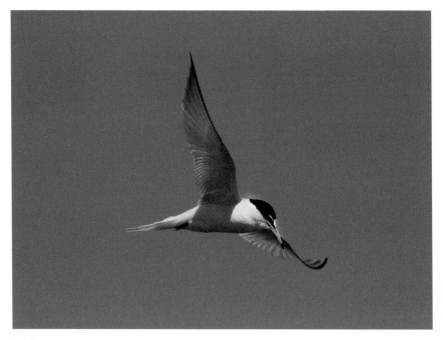

Little tern (photo by Shay Connolly)

cormorants stirring down by waves. But now, in the heart of July, if you follow the cliff path that leads to the top of Bray Head and stop to peer down on the rocks, you will notice that an incredible transformation has taken place. The coast is alive with the calls of seabirds of every shape and size. The entire cliff face is the location for a great feeding frenzy, with kittiwakes, herring gulls, fulmars, cormorants, great black-backed gulls and guillemots all flying back and forth from the cliffs to the sea in search of food for their hungry chicks. This ornithological metropolis is like rush hour in New York, with each bird call mirroring the consistent honking of gridlocked traffic; except here, there is constant movement. I try to keep my eye fixed on a single herring gull and follow its sweeping flight from its perch to the sea, but before long it escapes my tracking eye, blending once more into the raucous, white melting-pot below.

At this stage of the year, the young fledglings should already be practising their flying skills as they call out into the air. To most ears, the collective calls are a disordered miscellany of screeches, but every bird has its own unique pitch, enabling each chick to distinguish its parents' call amongst the tumult. Up on the ledge, one parent nudges a young chick off the precipice while the other parent waits below in the water, encouraging it to take the first scary step

off the high rock and fall into the waves below. This moment in nature was beautifully captured in Liam O'Flaherty's famous short story 'His first flight'. It is a key event in the development of the young bird, but it also comes with great risk. After the perseverance and dedication of the parents in protecting the egg, and the constant feeding of the chick, this one jump into oblivion can decide everything. All it takes to spell disaster is for the chick to land on a sharp rock, or tumble onto a ledge where a predatory gull is hungrily waiting, and all will be lost.

Watching how these seabirds glide and swoop is just mesmerising. The true masters of the open clifftops are the fulmars, who glide effortlessly through the air without even the effort of a wingbeat. Once they catch a pocket of wind, they are able to hang as if attached to an invisible wire and drift up and down from the steep rock face to the crashing sea below. They are equipped with a little tube on the top of their beak which enables them to filter the salt from the sea water when feeding, before returning back to the nest, which is often on the very edge of a rocky precipice.

Another bird that has a very distinctive flight pattern is the Manx shearwater, which spends most of its time out at sea and only comes in to land to breed. The Manx shearwater is designed for an open-sea existence, having long, powerful wings and legs that are tucked to the back of its body, enabling it to sweep low across the surface of the sea in search of food. When it does come in to land to breed, it is usually under the cover of darkness. It returns not only to the same place, but even to the exact same burrow it occupied the previous year. Out at sea Manx shearwaters are like fighter jets, dipping and diving across the waves, but on land they suddenly become awkward and ungainly. They are unable to hold their bodies upright, so their 'walk' is an undignified scramble or shuffle, with their belly resting on the ground, which unfortunately, makes them very vulnerable to predation by rats and other gulls.

Back down on Kilcoole Beach in July, many of the little-tern eggs will have hatched and, as long as there are no high tides, it should be another successful breeding year for these remarkable birds. The men and women from BirdWatch Ireland deserve the credit, after dedicating so much of their time over these past few months to ensuring that the little-tern chicks and fledglings are given every chance of survival. It is a story of success against all the odds. The wardens keep interested walkers up to date about the news of the colony through a small chalkboard they have on display, informing us regularly about how the eggs and chicks are doing. Some opportunistic oystercatchers and ringed plovers have also chosen to lay their eggs on this protected part of the

beach, inadvertently benefiting from the terns' protection. Out off the coast and on the marsh, an incredible amount of wildlife is spotted and recorded, with some very rare visitors appearing in this rich habitat, including the yellow wagtail, the Arctic skua, the storm petrel and the green sandpiper. This just goes to show how important places like the Breaches are for our native birds.

As July moseys on and the long, warm evenings continue to light up the evening sky with glorious colour, a sudden change begins to take place. The wildflowers in the meadows still fill the fields and coastal walks with their kaleidoscope of colour, and the thick woodland is still in its rich summer bloom. But it is not so much a change in colour or light that becomes noticeable now, but the dramatic silence that suddenly ascends. Around mid-July, many of the garden birds cease singing, signalling the end of this year's breeding season. It is as if the song of the birds has been suddenly muted; now it is the silence of voiceless late summer that is heard echoing from tree to tree. All the drama of the nesting season is over for another year — the calling out for a mate, the nest-building and egg-laying, the hatching and constant risk of predation. The successful fledglings that have made it, despite the odds, begin their own perilous journey into maturity, playing their own part in the ceaseless cycle of life. All of that hectic hive of activity during the previous months comes, quite suddenly, to a silent stop. Nature finally pauses, inhaling deeply to catch its breath, before drifting softly and leisurely into early autumn. The end of summer becomes very noticeable in the mornings now, when walking through the woodlands of Devil's Glen or Knocksink Woods. The sounds of the river tumble along ceaselessly, but the songs from the trees are, for now, perfectly quiet.

But as soon as one song fades, nature finds a new tune to dance to. Walking through the Newcastle Fen at this time of year, you cannot help but notice that the silenced birdsong has been replaced by the bass drone of the bee as it makes its way from flower to flower in search of nectar. Accompanying this hum is the distinctive chopper-cymbal buzz of the damselfly and dragonfly, manically darting from pool to stem on those magnificent iridescent wings in search of a mate. The flamboyantly named banded demoiselle is a damselfly that lives up to its fancy name. It has a most striking cobalt-blue body, and in direct sunlight it flashes flecks of brilliant turquoise.

But the creature of late summer that most captures the imagination of child and adult alike is the butterfly in flight. When I was a child, my dad bought me a display of butterflies that included the whole of the life cycle — from egg to pupa to caterpillar and, finally, to butterfly. I remember bringing it

in to my teacher in first or second class as a display for the *bord dúlra* or nature table for all my classmates to see. Now my wife, Emma, uses it in her own class to show the students the different colours and shapes a butterfly can have; and, despite all of the technological distractions in a child's life today, this simple presentation still captures their imagination. Maybe this is why July is such a great month for children, being full of sound and colour. Those who do go out and explore with their children will undoubtedly be rewarded for their efforts. A short walk by a beach or forest path, or even some time taken simply observing and pointing out the many visitors that appear in the back garden, can open up a new world that could otherwise go unnoticed. Children will never grow tired of counting the spots on a ladybird or seeing how many 'eyes' the peacock butterfly has, once given an opportunity. We are now living in a time where our own eyes are more inclined to look downward to an image on a screen, rather than up and out on the natural wonders that are all around us. By encouraging our children to go out and walk and explore the natural world, we are passing on a gift that will last them a lifetime. And if this means that a little concession needs to be made during the glorious summer evenings and the march to bed is delayed for a little while longer, well then, so much the better.

Lough Tay
(photo by John C. Murphy)

August

Light's long evenings slowly fade
With whispering breath of summer's shade.
— Seán Ó Súilleabháin

Hungry July comes to an end and now, in early August, our minds turn to the harvest. Now is the time for reaping the rewards of the season, with the summer's sun and rain having fuelled the growth of the tall, heavy stalks that now stand awaiting their inevitable fate. But before this begins, for just a few short days, a calmness descends across the land, embracing the meadows in a most respectful stillness. There is a wooden bench in the Newcastle Fen where I love to read, or simply sit and silently watch the autumn dusk spread itself low over the ripening fields. This is a time to pause and reflect on the months gone by and to wonder about the months to come. However, this moment of calm, where time seems motionless, is of course an illusion. August may try to lull us into the belief that nothing will change, but the birds and animals have long memories and are not so easily fooled. In the soft evening breeze, the squirrel and the jay know what is coming and quickly gather food to see themselves through winter's scarcity. The clothes of the hot summer days may be here for a little while longer, but a sudden darkening cloud above the Wicklow Hills remind us of the shortening days to come. We might think summer will last forever but, alas, the seasons are constantly moving on nature's eternal merry-go-round.

The first two weeks in August is the traditional time of the harvest. In almost every field along the coast road from Kilcoole to Arklow, large mechanical harvesters kick up clouds of dusty yellow as they inch their way

through the long crops, leaving stumps of golden bristles in their wake. Crows follow the ferocious twirling blades like black-clad politicians at a funeral. It is easy for people like me to romanticise the harvesting seasons of the past, suggesting that something was lost with the advancement of the industrial revolution, when one machine suddenly replaced thousands of farm labourers armed with scythes and sickles as they prepared to cut the crops by hand. I am sure if I ever actually attempted this back-breaking manual labour for even five minutes, my nostalgic idealisation would quickly vanish. And yet, with the number of songs, paintings and works of literature that depict the harvest season, it is clear how central this time of year has been to so many cultures down through the ages. From Egyptian frescoes to the great Russian novels, or even our own Irish bardic poetry, the harvest has always been looked at as a time of hard work, reward and thanks; when the exhausting manual work is finally completed, the artist takes over. The harvest then becomes the canvas for creative interpretation, a seminal event in our calendar to be recorded for generations to come.

On the first weekend of August, the Great Sugar Loaf is as good a place as any to get a panoramic view of the harvest. The reward for reaching the top is an expansive view from Dublin Bay that stretches all the way down the northern-Wicklow coast. From the summit you can take in the 360-degree view of north Wicklow and Dublin. To the south lies the glacial Glen of the Downs with a constant stream of silent cars zooming up and down the serpentine road far below. Straight in front sits Bray Head, with its iconic

cross clearly visible against the sea-blue background. Turning to the north, Howth Head protrudes like a protective hand, guiding the ferries in and out of Dublin Bay. To the west, rolling hills and rugged farmland run all the way from the village of Enniskerry to Roundwood and, in between, the curved silhouette of the Wicklow Mountains looms low on the horizon. The heavy mechanical harvesters and tractors can be seen everywhere, trudging beetle-like across the fields as they mow and gather crops. Again, I think of how it must have looked from the top of this great rock when men and not machines once filled the fields like ants, swishing their scythes in rhythm to a harvest song. In Leo Tolstoy's novel *Anna Karenina*, there is a wonderful description of the philosophical landowner Levin, who finds solace in the transcendent experience of joining in with his serfs mowing the meadows. At first he is self-conscious. His technique is awkward. But, after some time, he begins to master the scythe and the rhythm and motion of the blade slowly cast a spell, creating an out-of-body experience where 'The scythe cut[s] of itself.' Levin's unhappiness is lifted through this spiritual reawakening through nature and hard work, and he describes the ritual of reaping the meadows as 'happy moments'.

In the Gaelic festival of Lúnasa, this spiritual bond between the self and the land is also entwined with the reaping of the summer harvest. Named after the Celtic God Lugh or Lú, the festival of Lúnasa traditionally took place between the summer solstice and the autumn equinox, and in pagan times it would have been this time of year when the sun god would have been honoured for granting a bountiful autumn harvest. The festival would have been commemorated through athletic sporting events or funeral games, similar to the ancient Olympic games of Greece. These games were held in honour of Lugh's mother, Tailteann, a representation of Mother Earth, who would have to die each year to provide the crops and fruit from the land. When Christianity replaced the pagan festivals, religious ceremonies, mountain pilgrimages and animal fairs became the central focus of the harvest celebration instead. This tradition is most famously continued to this day with pilgrims walking Croagh Patrick every year on Reek Sunday and at the Puck Fair in Killorglin, County Kerry, where a wild goat is captured in the mountains and brought down to the town to be crowned King Puck.

Following in the footsteps of our mountain-climbing ancestors, this is generally a perfect time of the year to hike Djouce Mountain. Standing at 725 metres high, the mountain is a relatively manageable climb, and along the pathway you are bound to meet a number of mountain-bikers and hill-walkers

who are tackling the entire 127-kilometre-long Wicklow Way. If starting from Dublin, the way begins on the outskirts of Marlay Park on the foothills of the Dublin Mountains and finishes a week later in the village of Clonegal in County Carlow. The Djouce section is the second day of this famous trail, and in it some of the most spectacular views can be seen. In the early summer months, skylarks can be seen leaping high into the air as walkers pass by, piercing the mountain air with their shrill song, but by August they too have grown silent. The wind rustling purple heather-beds is now the usual sound accompanying hill-walkers at this time of year. Lingering mist often impedes visibility early in the morning but, as soon as the day warms, the veil is lifted, revealing stunning, panoramic scenery that stretches right across the Wicklow Mountains. In the south-west, Luggala Mountain looms large over Lough Tay, with its Guinness head glistening far below, almost inviting thirsty mountain hikers to stop and sip from its giant glass. To the north, the young Dargle River rises and runs towards Powerscourt Waterfall, and to the south-east the Roundwood Reservoirs shimmer in the half-light between sun and cloud. Along this mountain trail sits the J.B. Malone monument, dedicated to the writer and avid hill-walker who first proposed the Wicklow Way walking route in the 1960s. His television documentaries, books and articles encouraged people to get out and appreciate the great outdoors on their doorstep. His original plan was to form a looped route around Wicklow, but this was later revised to accommodate local landowners who objected to some parts of the route crossing their land. It was also proposed that a long-term plan be set in place whereby a linked walking way would cover the entire island of Ireland. At the time of writing, there are over 4,000 kilometres of National Waymarked Trails across the country.

The Gaelic name for the Wicklow Way is Slí Cualann Nua. *Slí* is the Irish for 'way' and Cuala is the ancient name for the area between south Dublin and north Wicklow, originating from the Celtic tribe the Cualainn, who are mentioned on Ptolemy's map of Hibernia in the second century AD. Slí Cualann was the old route that linked this area to Tara, where the high king of Ireland once sat and ruled over the entire country. A large inauguration stone called the Lia Fáil marked the place where the kings of Ireland would be crowned, and it would have been along this ancient Slí Cualann that noblemen would have had to travel to show their subservience and loyalty.

Once you reach the top of Djouce, you are invited to stop and rest on the stone peak that marks the mountain summit. Like many unspoilt places in Wicklow, I do not imagine this mountainous landscape having altered

all that much since those ancient days. The writer and philosopher John O'Donohue described mountains as having a dreamlike memory that runs much deeper than our fleeting human existence allows. He describes them as 'noble guardians' of the memory of place, who stand as 'lookouts in some sense for the infinite and eternal'. Once I reach the summit of Djouce, I rest and breathe in the reassuring permanence of these old keepers of time, before finally, and most reluctantly, turning my back on the round peaks and beginning my descent back into the lowlands from whence I came.

A night-time visit to the Wicklow Hills between 10 and 13 August is also the perfect place and time to observe the annual Perseid meteor shower. Carriggower Hill above Kilpedder is the usual place I go to watch this celestial show, as earth enters into the remnants of Comet Swift–Tuttle passing through our solar system on its 130-year orbit around our sun. The small meteors that enter our atmosphere are the debris from the comet and are often referred to as shooting stars, although they are actually only about the size of a grain of sand. They enter our atmosphere at speeds between 11 and 73 kilometres per second, causing them to vaporise at extreme heat and creating spectacular streaks of light in our night sky. The elements within each tiny meteor can be read through the colour of the light it produces. An orangey-yellow glow indicates sodium; magnesium creates a greenish-blue light and red streaks are produced by silicate meteors. As long as it is a reasonably clear night with no light pollution and you are prepared to stay up a little later than usual, you will not be disappointed. The shower begins slowly, with only one or two streaks

appearing and disappearing as darkness falls but, after midnight, more and more cut through the night sky, building up to a crescendo, revealing nature's very own laser spectacle.

Another mountain walk I enjoy at this time of year is the picturesque valley trail from Lough Tay to Lough Dan. It begins at the gates of Luggala Estate, where a steep path winds its way down into the valley below. Along the way wrens, stonechats and goldfinches flitter from fence to furze bush, while up above the silhouettes of buzzards may be seen circling and gliding against an expansive sky. To the left, sweeping green fields flow down to the valley floor, where the trail meanders gently beyond the hill towards Lough Dan. A landscape such as this invites the walker to discover the secluded intimacy of the vale with a sauntering, unhurried step. The mountains rise up in a tide of rock as the visitor descends into this pristine valley, cocooned in its ancient embrace. To the right, the bank of the Cloghoge River drains from the upper end of Lough Tay, before ambling its way towards Lough Dan, seaward bound. Once you reach the bottom of the valley, you will hear the languid flow of the river to your right. Just beyond the wooden bridge is a walking stile that leads to a tree-lined trail path before opening into a lush, green field filled with hundreds of grazing deer.

Standing by the old stone wall, you are far enough away to be able to admire these shy, graceful animals without disturbing or startling them. In

Lough Tay
(photo by Shay Connolly)

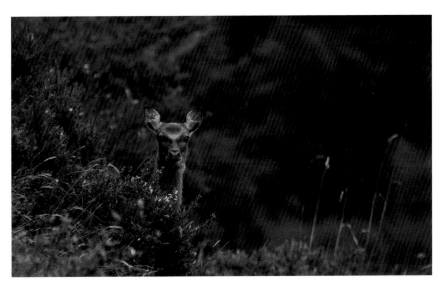

Sika hind (photo by John C. Murphy)

August, they are still in their red-and-white speckled summer coats, but soon this will darken into the greyish brown of their winter attire. May-born calves will still look quite fragile on their feet, remaining very close to their mothers, but the stags stand aloof, proudly displaying their V-shaped antlers, which are shed during winter and then regrown in summer. By October, the rutting season will be sounded by the deep bellows of the stags echoing across the valley, and it is then that these impressive antlers will come into use, with each stag battling desperately for the right to mate.

The deer in Luggala are a hybrid of the Japanese sika deer that were introduced by Lord Powerscourt in 1859 in Glencree, not far from here. The smaller sika deer mated with our native red deer, resulting in Luggala Estate having the largest population of sika deer in Europe. Since the last Irish wolf was shot in Carlow in the eighteenth century, the Irish deer have no predator but the poacher. The culling of the deer in season is essential in controlling numbers, but unfortunately some greedily zealous poachers have been attracted by the soaring price of venison in Europe; as a result, there have been accounts of reckless slaughter. Some poachers, armed with high-powered rifles, use the cover of darkness to hunt up to 15 deer per night. This is of serious concern for the National Parks and Wildlife Service, who have noticed huge increases in poaching in the last few years.

Continuing south along the trail, you eventually arrive at the old lake house on the eastern shore of Lough Dan. Here you can sit by the lake shore and

rest at your leisure. Returning by the same path along the Cloghoge River, you have the choice of continuing back up the steep hill to the gate entrance or, if you are feeling adventurous and energetic, tackling the steep climb that leads to the summit of Luggala Mountain.

Before the bridge an overgrown trail leads through the gorse and ferns, and following the worn trail you quickly rise up above the valley floor. After a few minutes, if you stop to rest, you will see that the herd of deer are now nothing more than tiny flecks of red in the field far below. Further up again, the view sweeps right across the Wicklow Hills, leading all the way to the coast and out to sea. On a very clear day, as you near the summit, the coastline and mountains of Wales become visible. Looking eastwards, I often wonder if there is someone at that very moment who has just climbed to the peak of Snowdon and is now looking back out over the Irish Sea, returning my gaze.

Continuing over Luggala, the trail leads precariously close to the mountain cliff, which suddenly plunges downwards to the edge of Lough Tay, far below. Thatched huts and long, angular ships tied to a wooden pier could be seen on the lakeside beach over the last few years, where the hit TV series *Vikings* was regularly filmed.

Close to the beach sits the famous Luggala Lodge, with its turrets and narrow, cathedral-style windows. This famous house is nestled in amongst tall trees, secluding it from view from the high Sally Gap road. From the top of Luggala Mountain, its whitewashed walls glisten in the bright sun, giving the building something of a Mediterranean feel. The owner is Garech de Brún, a member of the Guinness family who rents the lodge to rich visitors who wish to escape to a picturesque, sylvan wilderness and stay in a fairy-tale castle by the famous Guinness Lake, although a week's stay will set them back €25,000. This estate has been in the Guinness family for over a century and, by all accounts, Luggala Lodge has hosted some wild parties over the decades. Movie stars like John Huston and pop royalty like Michael Jackson have all been guests in this magnificent, secluded residence. Garech de Brún is a renowned and generous patron of the arts, who founded the legendary band The Chieftains in the 1960s. Another legendary 1960s band, The Beatles, immortalised his younger brother Tara Browne in the song 'A day in the life', which makes reference to Tara's tragic death in a car crash in London in 1966, when he was just 21.

Another famous visitor who stood at the shores of Lough Tay was the philosopher and mathematician Bertrand Russell, who visited Luggala as a young man with the land reformer Michael Davitt. In his autobiography he

remembers being moved by the beauty of the lake, contemplating his own mortality as he looked out on the waves washing up on the pebble shore:

> I have associated it ever since, though for no good reason, with the lines:

> > Like as the waves make toward the pebbled shore,
> > So do our minutes hasten to their end.

When visiting Ireland years later, Russell returned to the area to rekindle this memory from his youth, but was brought to Crone Wood above the lake, rather than returning to the pebbled shore he remembered so fondly. With disappointment, he concluded remorsefully, 'one should not attempt to renew old memories'.

Unlike Russell, when I visit this place I never feel disappointed. Each season has its own unique interpretation on the shifting landscape, with constant fluidity of colour, light and shade. On a clear autumn day the mountainside is covered in rich purples and greens but, come winter, the peaks are often hidden under a sea of freshly fallen snow, with only bare stalks emerging like telescopes to survey the lonely wilderness. Just like the deer who shed their summer coat as the winter season approaches, or the

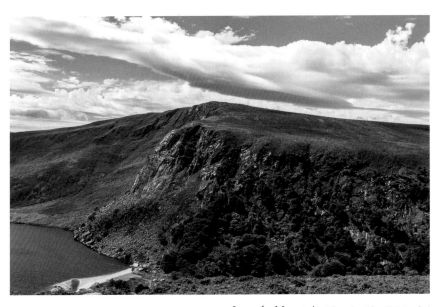

Luggala Mountain (photo by John C. Murphy)

farmer who swaps his light, cotton shirt for thick wool, the land has many wardrobe changes throughout the year. But even in August the weather can change quite dramatically and unexpectedly. Descending from the mountain top, it is important to keep a careful eye on the twisting precipice to the left, especially if a drifting mist limits visibility. Mountain Rescue Ireland constantly advise people to bring warm clothing and a charged mobile phone and to be aware of the weather forecast beforehand, especially if they plan to climb some of the bigger mountains like Lugnaquilla. Being injured or lost on top of a mountain as night falls, with the temperatures dropping fast, is a frightening position for anyone to be in.

The sonorously named Lugnaquilla means 'hollow of the woods' in Irish, and standing at 925 metres high, it is the highest summit in the Leinster province. Its peak can be seen from many of the famous lookout points along the Wicklow Way. The three main routes to the summit of Lugnaquilla are from the Glen of Imaal, if you are approaching from the west, Glenmalure from the south, and from the east, the lesser travelled Aghavanna route. Of these three routes, the Glen of Imaal trek is the longest in distance but the most direct. Care must be taken when starting from this direction, however, as the route crosses the Irish army's artillery range. When scheduled firing is taking place, access is prohibited. If you choose the Glenmalure route you will take in some impressive landscape along the way, such as the glacial hollow of Art's Lough and the vertiginous drop that runs along Fraughan Rock. This is probably the most scenic of the three routes mentioned, but it does have its own challenges. It is a more remote passage across unworn mountain and ,when attempting it for the first time, it is a good idea to travel with someone who knows the route well.

The third route, Aghavanna, where the Military Road comes to an end, is situated in the heart of the Ow Valley. This stunning valley is not as well known as the more touristy destinations of Wicklow, but has much to offer either the intrepid walker or the Sunday driver. It is a place I love to visit when I want to remind myself of the pure isolation you can feel in the Wicklow Mountains, even though you are still relatively close to Dublin city.

To approach Lugnaquilla from this destination you begin at Aghavanna Bridge, a place which has been described as 'the last place God made'. The Ow River (a phonetic echo from *abhainn*, the Irish word for 'river') runs down through the valley and is often the only source of movement in this heather-blooming wilderness. During the winter months, the Ow is a popular spot for experienced whitewater canoeists tackling rapids and waterfalls, which also accompany the path as you it winds its way up through the forest towards

Peregrine falcon (photo by Shay Connolly)

Lugnaquilla. Once you emerge through a break in the trees, a sweeping vista of the entire Aghavanna Valley lies below you, with the rising summit towering above. As you ascend further up the mountain, an impressive corrie known as the South Prison lies on your left-hand side. This is a favoured spot for experienced mountain-climbers to hone their rope skills. As walkers trudge laboriously over rocky shale, peregrine falcons may be seen flying majestically overhead. These birds fill me with a sense of awe any time I see them in their natural habitat. They are the fastest creatures on earth, reaching speeds of over 320 kilometres per hour when diving through the sky in search of prey. I cannot help but marvel at their ability to survive in such mountainous isolation and, when I spot these magnificent birds soaring over this rocky landscape, I am left in no doubt about who owns this domain. I manoeuvre with respectful trepidation over boulder-studded cairns that cascade down into what is locally called a 'prison'. But for the falcon, it is no such thing. This quarry is their castle walls and they are the watchers at the gate.

No matter what way you approach Lugnaquilla, the sense of achievement when you reach the summit is the real reward, as well as the incredible panoramic view of all the highest peaks in the province, identifiable with the help of the brass view indicator on the top. During the descent, there are usually two things that cross my mind. Firstly, how did the United Irishmen traverse such inhospitable landscape in the winter of the 1798 Rebellion to find refuge in Glenmalure Valley? And secondly, do I have enough time? Being lost or stranded on the mountain as darkness falls would be an unpleasant experience.

Darkness is not always a disadvantage, though and in 1914 an event took place on Kilcoole Beach in which it was positively necessary. The Kilcoole gun-running is not as famous as the Howth gun-running, where, on 29 July, the yacht *Asgard* loaded its German-purchased munitions in broad daylight

off Howth Head. The second destination for the gun-smuggling was Kilcoole Beach, where Sir Thomas Myles's boat *Chotah* arrived at midnight on 2 August with 600 German rifles, after being transhipped from the yacht *Kelpie* off Bardsey Island in the Irish Sea. Among the disguised volunteers who stood on the beach that night to load the rifles into their waiting charabanc was a young, up-and-coming volunteer by the name of Éamon De Valera. Fifty years later, he returned to the same spot as president of Ireland to unveil a plaque mounted in stone that can still be seen today. A century later, the Kilcoole gun-running is still commemorated with parades, speeches, costume dress and re-enactments.

Another salient figure in our country's history is Charles Stewart Parnell, who was born in Avondale House in Rathdrum in 1846. This large Georgian house stands on 500 acres of forest parkland and August is always a nice time to visit the gardens and walk around one of the many forest trails to see the giant redwoods, as well as the rich diversity of native Irish trees that line the paths. The man mainly responsible for founding the Avondale Estate was Samuel Hayes. He had Avondale House built in 1777 and had hundreds of trees planted around the grounds. He was a man who believed in sustainable woodland management and tried to encourage the Irish parliament to show a better regard for the preservation and cultivation of native Irish trees. The grounds were bequeathed to John Parnell in 1795 and, when Charles took over the management of it in the latter half of the nineteenth century, he continued the tradition of tree-planting, becoming affectionately known as the 'Great Oak of Avondale'. This was a reference not only to his love of trees but also to his steadfast political views. Both Parnell and Hayes knew the importance of a long-term conservation strategy regarding woodland management and looked to the old Brehon Laws as a guide to encouraging love and respect for the biodiversity of our native forests. Unfortunately, the

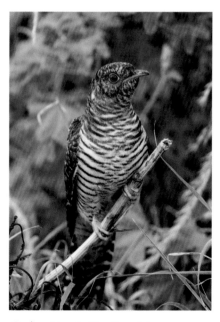

Cuckoo (photo by Shay Connolly)

majority of our Irish forests today are comprised of Sitka spruce, a conifer that originates in Canada and the western United States, which was chosen for quick growth and maximum profit, and its success was to the detriment of our native woodland. This was not the vision these pioneering men had for the future of Ireland's forests.

Thanks to the foresight of Hayes and Parnell, some of the trees planted in the nineteenth and twentieth centuries are still standing in Avondale today, and Avondale is now a favourite place for families to come and enjoy a picnic, kick a ball, or take a stroll through the grounds and connect with our native past. Grey squirrels are very common here, but I have spotted one or two reds also scurrying around. Foxes and badgers are sure to be here, waiting for the darkness to fall before they appear, and, with its rich variety of trees, the estate is also a very favourable place to nest for some of our resident birds. Pheasants, song thrushes, blackbirds, goldfinches, wrens and robins are just some of the birds that can be seen or heard as you stroll around the park.

As August inches forward, the bright days become noticeably shorter and the glorious summer evenings give way to orange- and pink-streaked evening skies. The failing light of autumn will soon cause the deciduous leaves to stop making the chlorophyll that keeps the summer leaves so lush and green. In late September the great autumnal show will begin, when nature displays its diverse palette. I hope to return to Avondale on some frosty morning in October, when this great arboreal display will be at its most beautiful.

The warm evenings of late August and the shortening light not only affect our trees, but also play a vital role in the journey of our migratory birds. The calm weather usually typical of late August, accompanied by the darkening evenings, prompts our migratory birds to prepare for their long journey south. One of the first visitors to return to Africa is the cuckoo. Cuckoos are more often heard than seen, having one of the most distinctive and recognisable calls in the forest. Despite their reputation as parasites, they are stunning birds to watch. Thanks to the unusual technique of laying an egg in as many as 20 different host nests, they are able to take to the skies much sooner than most. The feeding and rearing of their chicks by adoptive parents takes place when the real parent has already left. Some cuckoos have had satellite tags attached to track their incredibly long journey over France, Spain, Morocco, the western Sahara and the Congo, to their winter's destination in southern Africa. This migratory route naturally tests the bird's endurance and the decline in their numbers in recent years may be a result of change to their habitat and the availability of food on our shores.

The swift is another early leaver, departing long before the swallows or the martins. Over each summer, I become very fond of the sight of a groups of swifts swooping over the wetlands, or down by Greystones Harbour, as they feed on the evening supply of midges and flies. These aerodynamic birds have the amazing ability to switch off one side of the brain and sleep, which gives them an added advantage as they make the arduous journey over the arid desert flatlands of the western Sahara.

On a glorious sunny evening in late August, I take the strawberry path from Kilcoole village down to the coast. Swallows swoop over the shadowed fields before resting briefly on high electrical wires, while the rooks gather in their rookery, their collective raucous call sounding another day's end. A large buddleia tree droops over an old wall, with its long, magenta flowers still attracting late butterflies like the peacock and the painted lady, although one of my favourites, the orange-tip, has already disappeared for another year. I step over a few red admirals that remain motionless on the grass, signalling that their season has also come to a close.

At this time of year there comes a changing of the guard in our treetops, with summer's floral blooms giving way to autumn fruit. The bramble, the holly and the blackthorn have all lost their delicate flowers, sprinkling the dark soil with white confetti before their rich-blooded berries fill the branches. As the colours of the trees begin to change, so too do the woodland and coastal paths beneath our feet. The wildflowers that have splashed colour on our roadsides have already begun to disappear, their coloured fireworks fizzling out one by one. Slender willowherbs, pansies and bindweed have all begun to fade and for a few weeks there is a noticeable lack of colour, with summer's brightness fading as the year enters a brief tunnel of darkness, before re-emerging into golden autumn light.

Looking out to sea from the Breaches at this time of year, you just might spot a Risso's dolphin. These animals prefer deeper waters and are usually seen around the western and northern coasts of Ireland, where they hunt for squid on the seabed, but in August they swim down the east coast to breed in shallower waters. Their round, bulbous heads and truncated snouts make them distinctive from other dolphins, as do the white scratches on their skin, which are possibly caused by teeth-raking with other dolphins.

Back up on the cliffs, however, there is a noticeable decrease in activity among the sea birds, with their job now completed for another year. Some will already have returned to sea. Any chicks that have survived predation must now face a long, cold winter that will be sure to test their resilience. Down by

the Breaches, the little terns are getting ready to leave. In two years' time we will hope to see this year's chicks return to this very same stretch of beach to lay their own eggs and let the great cycle continue. This time of year is also one of the best opportunities to spot some of our rarer passage migrants. The wetlands by Kilcoole and Newcastle are perfect refuelling spots, where sanderlings, ruffs and whimbrels stop and feed before continuing on south to warmer climes. The distances these birds travel are truly amazing and, as I watch the waders feeding on the rich wetlands, I am once again reminded of just how important our estuaries are — not only to our resident birds, but to our passage-migratory birds and winter visitors too. Unfortunately, owing to changes in agricultural practice over the years, many of these wetlands themselves have become endangered, which has had a destructive impact on the wildlife that depends on them.

As August drifts lazily into September, there is a pervasive melancholy in the air. Not only are our warm sunny days closing in, but the end of the year is also drawing near. Keats saw autumn as the perfect season for mourning, and Yeats used autumn as a symbol of his maturing years, while Wordsworth and Dickens reflected on how nature's seasonal maturity limns death's looming shadow. But for children, it is the shadow of the classroom that looms larger than everything else.

Outside in the twilight, nature falls silent. The bees have left the clover and only the kind robin and perky wren now sing to welcome in the unwanted September guest. And yet, there is still time. Perhaps just one final visit to the beach to build that last sandcastle? Or one last walk down a country meadow that is already darkening in a thick, honeyed dusk? Just one final moment to remember the last few days of summer's freedom.

This human desire to freeze time and capture a brief moment of pure joy is the exact wish expressed in Eavan Boland's poem 'This moment'. She watches a child playing in the back garden as the summer-evening light falls. Being called in, the child jumps into her mother's arms and, for the briefest of moments, the arrow of time suddenly stops. The moment is captured in an impressionistic style, with the contrast of the night framing the light from the window 'yellow as butter'. But, of course, this ephemeral moment is consigned to memory as soon as it happens. The world outside is oblivious to such a tender encounter, indifferent to the wish for time to stand still. The stars keep shining, the moths keep fluttering and the 'apples sweeten in the dark'.

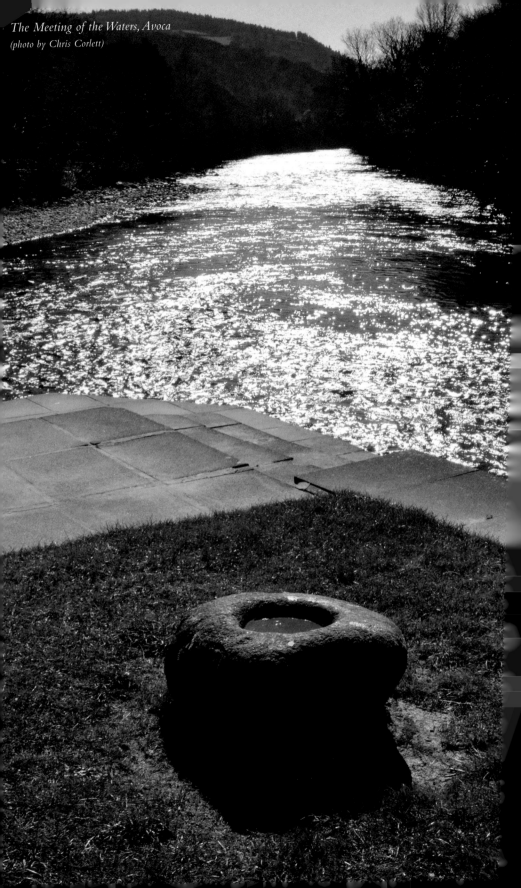

The Meeting of the Waters, Avoca
(photo by Chris Corlett)

September

Late August, given heavy rain and sun
For a full week, the blackberries would ripen.
— Seamus Heaney, 'Blackberry-picking'

September's arrival is more often than not a gentle affair. It breaks the news softly that the long-lingering summer that seeped unnoticeably into August has finally slipped away. The Indian summer of September squeezes out the last of the low heat on our backs, before winter makes its villainous entrance once more. But before those dark, cold mornings arrive, we have this bountiful month of late harvest and forest fruit to look forward to. Depending on the intensity of the previous summer's warmth, heavy branches might begin to release their ripe apples to the ground, like a tired mother laying down her sleepy child for bed. The trees' lush summer leaves begin to show the first few signs of the passing year, which are, of course, also engrained in its internal rings of time. How fortunate the trees are that the year's maturity is portrayed through vibrant yellows and reds, compared to the badger-streaked strands that mark our own autumn. Up above these golden canopies, clouds drift low across the sky, obscuring the sun in a veil of autumnal shade — a portent, perhaps, of colder days to come.

The Gaelic term *Meán Fómhair* translates as 'mid-autumn' but, in reality, early September only feels like the season's beginning. It marks school's return, where new goals are written down in well-intentioned ink and canteens around the country come alive once more with tales of the summer's adventures. If the academic year is just beginning, the farmer's summer toil is now winding down. The last of the harvesting will be done in the next few weeks, followed

by the yearly count and the weighing and stocking of the season's bounty.

Down country paths and laneways, briars begin to blot the countryside with sweet blackberries. Soon families will be out with their pots and bottles to gather enough berries to make a tasty jam or blackberry pie. The tradition of gathering nuts is a little less common these days, but was once a very popular practice, laden heavy with tradition. According to Nick Groom's book *The seasons*, 14 September, or Holy Cross Day, was the best day to go picking nuts. If you do go nut-harvesting in September, you will most likely need a long stick to reach them, as nuts like hazels, sweet chestnuts, acorns and walnuts are still high up in the trees. But, come October, the branches begin to droop to the ground and litter the grass beneath with tasty offerings. The squirrel will not thank you for taking them but, if done in moderation, nut-harvesting is a real autumn treat. There is a great feeling of satisfaction in picking and eating what nature freshly provides, instead of going into a supermarket and buying overpriced food, out of season, that has been sprayed with pesticides and flown thousands of miles from far-off countries.

At this time of year, while the evenings are still relatively bright, I love making my way down to the old fen, knowing the early September air will be filled with the sweet smell of blackberries. Along the roadway the berries are still green and hard but, deep in the fen, the moisture from the wet earth offers round, plump fruit waiting to be picked. Heaney's poem 'Blackberry-picking' describes the berries as being full of 'summer's blood', with the 'big dark blobs' staining his hands and tongue. Childhood memories of running from one briar to the next, picking and tasting one of autumn's little pleasures, are vividly rekindled. Down by the shore, stones gargle in the throat of a lazy incoming tide, while a gentle breeze rustles across the sedge, whispering the world to sleep. In the meadows, resting cows rise and follow any passing visitor with inquisitive eyes, while up amongst the trees disgruntled rooks debate the business of the day before finally settling down in agreement. When picking berries on an evening such as this, you cannot help but feel an overwhelming sense of pure inner contentment. The silence of the fen slows everything down. The murmur of the sea, or a bird's occasional flutter, is the only sound that accompanies the periodic plump of a berry dropping into a bottle or tub. Whether you are spending time with family and friends, or simply enjoying your own company, this is a perfect way to disconnect from the busy world — rhythmically picking berries for your supper.

If the autumnal shade of the woodlands foreshadows summer's retreat, coastal pathways are also touched by the falling light of September. Come

five o'clock, the sun is already dropping low in the west, casting long shadows along the cliffs from Greystones to Bray. As dusk settles, that clear blue sky we have become accustomed to during the summer evenings no longer stretches across the horizon. In its stead, drifting clouds fracture the linear meeting of sea and sky, making everything seem that little bit closer. The temperature is still comfortable for an evening stroll along the cliff face, but the fading light struggles to keep up. The coastal flowers have all but wilted and drained away, their seeds having returned into the darkness of the wet earth until next spring. Now, a simple fern-green is the dominant colour that sweeps all the way down to the pebble shore. Up on the rocks, the frenetic activity of May and June has finally come to an end, but some of the old locals like the cormorants and the shags still remain, observing with a critical eye the young visitors who are about to take their leave for the very first time. No longer do we hear the cacophony of calls echoing from the cliff face. Breeding time is over. Instead, the young are being instructed on the skills of survival in an unforgiving life out at sea. Birds like the gannet leave in search of warmer waters in the south, with some going as far as the west-African coast, while the young Manx shearwaters slip away unnoticed in the night, beginning their long migration west across the Atlantic to their wintering quarters off the coast of Brazil and Argentina. This is a journey these young birds have never completed before — and yet, instinctively, they find their way.

Wild red flowers
(photo by Shay Connolly)

Down in Bray Harbour the house martins are also getting ready for their migratory voyage south, while up on the sandy potholes of the north-Wicklow cliffs the sand martins have already vacated their burrows. In Wicklow Harbour, the silhouettes of swallows can be seen gathering on electrical wires in the late afternoon, each slender body resembling a musical note in summer's requiem. The orange glow of the town is filled with the outline of their swooping flight patterns across the river, as they fatten up on a diet of insects and flies to help them endure their long-distance flights. Just like their unannounced appearance in April, they will suddenly disappear without a sound, not to be seen again until next spring. They, too, face a desperate migration across the Sahara in search of the wintering-grounds of southern Africa. Many of these birds will die along the way and, with the decline in their numbers globally, it is important that we maintain any nesting sites if we are lucky enough to be chosen as hosts, whether in our garden sheds or in the eaves of our houses. Next April, these amazing birds will return to the very same nesting sites they were born in but, unfortunately, new developments and zealous homeowners will have destroyed some of them for the sake of so-called aesthetic appearances.

Another incredible migration that takes place at this time of year is the journey of the painted-lady butterfly, sometimes referred to as the 'butterfly

Painted-lady butterfly
(photo by Shay Connolly)

of Ireland'. Until recently, it was thought that the painted lady made a one-way 2,000-kilometre high-altitude journey from Morocco to Ireland to avoid the soaring heat of the African summer — which is an amazing achievement, considering the size of this delicate creature. However, it has been discovered recently that the painted lady does not simply die in Ireland. Come September, some actually attempt the return journey back to Morocco again. The number of painted ladies that arrive in Ireland each summer depends on the amount or rainfall in Morocco. Heavy rains result in healthy vegetation, which in turn feeds larger numbers of caterpillars. The more caterpillars there are, the larger the number of butterflies there are to fill our Irish summer. So Morocco's rainy season impacts directly on Ireland's wildlife. Nature is constantly reminding us of our interconnectedness. An action in Ireland, be it positive or negative, can affect wildlife thousands of kilometres away. Through the amazing migratory flight of the delicate painted lady, we are reminded that borders are a man-made concept. Really, we should keep in mind not only our impact on our own country, but also our responsibility to the planet as a whole.

Two places where you are almost guaranteed to see the arrival of the painted lady (and many other migratory butterflies and birds during the summer months) are the fantastic Mount Usher Gardens in Ashford and the Killruddery Gardens in Bray. Both were included in the famous BBC gardener Monty Don's favourite gardens to visit, with Mount Usher being voted 'Best Garden' by *Gardeners' world* in 2010.

William Robinson, the famous Irish gardener who championed the wild-garden approach instead of the manicured Victorian patterned garden, is the inspiration behind Mount Usher. This nineteenth-century Robinsonian garden is designed around the banks of the Vartry River, which runs through its heart. Its weirs and small suspension bridges lead you back and forth from bank to bank and you may lose yourself in the exotic colours and smells of this beautifully wild and organic garden. I try to visit here at least once every season to wander through the weaving paths and, with each visit, it is like seeing it all for the first time. Early spring arrives, with the daffodil bulbs, crocuses and bluebells all bursting into life, as well as the silken, pink-white cupped flowers of the magnolia tree blossoming overhead. During the summer months, the air is filled with the sweet smell of nectar as the garden comes alive with the colour and sound of butterflies and bees busying themselves amongst the azaleas, along with glorious dragonflies and damselflies zigzagging over still water. But, for all the colour of spring and summer, I think autumn is my favourite time. In a garden such as this, the smell of foliage releases the earthy

goodness that begins in mid-September. As the months mature, trees like the Japanese maple or the tulip tree create a fusion of yellows, oranges, purples and reds along the walks and riverbank, filling every inch of the garden with an incredible abundance of autumn colour.

September is also a great time of year to visit Killruddery House and Gardens, which is really more like a park. The grounds were bequeathed to Sir William Brabazon of Leinster by King Henry VIII in the mid-sixteenth century, and the gardens are the oldest of their kind in the country, dating back to the seventeenth century, under the design of the French gardener Bonet. He was a disciple of the great French landscape designer André le Nôtre, who designed the gardens at the palace of Versailles outside Paris. The house that stands today dates back to the 1820s and was built in the Tudor-revival style. Although it has been refurbished and scaled down, it still includes many of its original features, including the impressive domed roof and large chimney breasts. The glass orangery, which was built in the 1850s, was modelled on the famous Crystal Palace in London and is lined on both sides with Classical Italian sculptures. It comes as no surprise that this exquisite place is a popular location for filming, with the house and gardens appearing in films such as *My left foot*, *Angela's ashes* and *Far and away*, as well as the television programme *The Tudors*.

Like Mount Usher, summer is probably the most popular time to visit the gardens, but for me the trees are at their finest during these autumn months. Lime and beech hedges line the walkways in the centre of the garden in an area known as the Anglers; apparently they look like goose feet when viewed from the house. Two long, narrow ponds run from the Anglers towards the house, reflecting the shadows of the tall trees in their still waters. An impressive statue of Venus is situated beside the wilderness, which hosts some of the oldest and rarest trees, and from there you can view the Beech Hedge Pond, with its large iron statues depicting the four seasons.

You could easily spend an entire afternoon on this wonderful estate and still have something new to explore on your next visit. It is also a wonderful venue for some open-air concerts during the summer months. In September you can avail of guided walks through the grounds with the head gardener, or go on a foraging and jam-making tour, where you can pick some of the various berries on the estate, including haw, elder, rowan and blackberry, before returning to the kitchen, where you are shown how to make a perfect jam. The best part of all is that at the end of the demonstration you are given your own individual pot to take home with you. If you think jam-making is a little too sedate,

Red kite (photo by Shay Connolly)

you can always try the Hell and Back race on the Killruddery Estate, which consists of ten kilometres of army-style obstacles through river and muck.

Taking a walk through the walled garden, you can see all the seasonal fruit and vegetables that can be sampled in the tea-rooms. However, this is not just a garden for grown-ups. There is plenty of open space for families to come and picnic, with the Victorian garden maze being a favourite place for children of all ages to play hide-and-seek or chasing. You can also walk around the local farm to see the pigs, or stop to admire McLoughlin the cockerel, who is a firm favourite with visitors, as he struts his pen with flamboyant authority.

A bird that is definitely one of my firm favourites is the regal red kite. This bird of prey was relentlessly persecuted from the sixteenth century onwards and, by the mid-eighteenth century, was all but extinct in Ireland, Scotland and England. Wales was the last stronghold for the red kite, but even there it was close to extinction by the beginning of the twentieth century. In the late 1980s, a programme to reintroduce the red kite back into Scotland and England using stock from Spain and Sweden was very successful, spearheading plans for a reintroduction to take place in Ireland. In 2007, 30 young red kites were released back into the wooded landscape of Avoca, County Wicklow and in 2010 two red-kite chicks successfully fledged. They were the first to be born on this island in over 200 years.

Unfortunately, the red kite is not out of danger and some attitudes still need to be changed. Most people support this great project, but there have been reports of some being found poisoned and at least one being shot in the last few years. But, despite these tragic incidents, the red kite is now once again soaring high over the mountains and villages of Wicklow. The success of this project is testament to the dedication and determination of the men and women the Irish Raptor Study Group, the Welsh Kite Trust and other stakeholders who drove this momentous challenge to its successful outcome.

However, if you want to get a little closer and look directly into the piercing eyes of these regal birds, then the Woodlands Falconry in the Rathwood Garden Centre just beyond Shillelagh village is definitely worth a visit. Here you can see and hold some magnificent birds of prey, including Grace the red kite, Diego the little owl, a vulture by the name of Princess and James the golden eagle, who had a starring role in *Vikings*. My friend Dan McHugh, who works with these magnificent birds of prey, lets both adults and children hold and pet some of these birds, while discussing their diet, natural habitat and the importance of the work that is done to protect them. You can also book in to accompany one of the keepers on a hawk or falcon walk, where you can admire their flying and hunting skills up close. And still, for me, the real thrill is to see these birds in the wild, where they are surviving and indeed breeding in their natural habitat. The first time I saw a red kite in the wild was when I drove down to Avoca one Saturday morning a few years ago. As soon as I got out of the car, I looked up and saw the characteristic fingertipped wings effortlessly gliding high above the valley. It was a very special moment — not simply because of the sheer beauty of the bird, but also because I knew how close we were to never witnessing this awesome sight again.

Apart from the red kites, Avoca village itself is a very picturesque place to visit, and was famously used as the setting for the programme *Ballykissangel*. It is also home to the oldest weaving mill in Ireland, which dates back to 1723, when a large copper mine was situated in the Avoca Valley. The mill was a vital component in the lives of the workers, supplying them with corn and woven fabric until the closure of the mine in the early 1980s. The old mill, however, is still going strong and the Avoca hand-weaving business has become an internationally recognised brand. The Wynne sisters took over the mill in the 1920s and redeveloped the product, introducing colour to the fabrics for the first time. The success of their business saw their tweed being used for no less than a royal waistcoat for King George VI and blankets for baby Prince Charles and his siblings. Photos of these three remarkable women can be seen

inside the restaurant today, bent over and engrossed in their skilful weaving, with their aquiline faces not too dissimilar to that of the red kite.

The story of the Avoca mill mirrors that of the red kite, too, in how both were almost irrevocably lost in the last century. The mill was in danger of destruction until Donald and Hillary Pratt took a great risk in purchasing it in 1974. At the time, it had fallen into terrible disrepair. Their risk paid off, however, and now the Avoca brand is being run by the second generation of the Pratt family. Their business has become a great Irish success story.

Just as you enter the village of Avoca, you will come across the famous Meeting of the Waters (Cumar an Dá Uisce), where the Avonmore and the Avonbeg (meaning 'big river' and 'small river') join to create the Avoca River, on which the mill stands. Thomas Moore immortalised this place with his famous Irish melody 'The Meeting of the Waters':

> There is not in the wide world a valley so sweet
> As that vale in whose bosom the bright waters meet;
> Oh! the last rays of feeling and life must depart,
> Ere the bloom of that valley shall fade from my heart.

W.H. Bartlett's nineteenth-century painting *The Meeting of the Waters* shows two birds skirting over the flowing waters in the foreground, with a crescent moon half-hidden behind drifting cloud. A wisp of smoke from a country cottage can be seen trailing through the trees in the background, with a few houses on top of the hill looking down into the valley. It is somewhat idealised, perhaps, but it gives us an idea of what Moore would have seen when he stood on the bank and penned those famous lines. Even today, when you stand on the bank between these two flowing waters and stop to take in the view, you quickly realise that very little has changed since then. The tranquillity and beauty of this spot is still unspoilt, attracting visitors to stop and admire its views to this day.

Moore's other famous ballad, 'The last rose of summer', is another sentimentalised lament on the loss of summer and youth. The cycle of the changing seasons plays such an important role in how we live our lives that it has come to symbolise the universal themes of birth, death and regrowth. For example, we see it mirrored in Christian symbolism in Jesus being begotten, dying and rising again, and in the Greek myth of Demeter and her abducted daughter, Persephone.

Now, as the September days slip by, Demeter is already beginning to fall into her winter melancholy. Light is fading each evening, and around 22

September we celebrate the autumn equinox, where day and night have the same number of hours due to the earth's tilt in relation to the sun's light. For a brief moment every year, both hemispheres are illuminated equally, before the summer days begin to lengthen in the south, while in the northern hemisphere we enter into the cold cycle of winter's darkness.

The scorched grasses of July and August have been revitalised with heavy September rain. The bright mornings will soon fade, which some people find understandably depressing if they have to travel to work in darkness and return each evening when the day's short light is already spent. But, thankfully, that is not the case just yet. September still has enough light left to enjoy both. In fact, one of the benefits of the darkening mornings is the fabulous September sunrises. In summer, only very early risers witness a salmon-streaked sky — the sun is already high in the sky long before most people have even thought about stirring out of bed. It is good to remember that every season has its own little rewards.

Apart from dramatic sunrises and berries, September kindly offers us another treat to make up for the loss of colour from the halcyon days of summer: the wild mushroom. There has been a decline in the number of places where wild mushrooms can be found these days, but up until the mid-twentieth century wild mushrooms would have been a central part of any autumn farming fair. In eastern-European countries, knowledge of which mushrooms were edible and which ones were not would have been passed down from generation to generation, but in Ireland we never really had a history of eating anything but the field mushroom. However, in the last few years, there has been a growing interest in healthy local and organic food, with more and more people growing their own vegetable plots and herb gardens, and also going out and exploring the local woodlands to pick wild berries, nuts and mushrooms during the autumn season. The spraying of artificial fertilisers on fields that contain fungicides is another concern for mushroom-gathering and finding a rich, unspoilt spot can be quite rare these days. But, if you do find one, you will find yourself returning to it again and again.

One such place is the fen in Newcastle. This unique, diverse habitat is a wonderful spot to find a wide variety of mushrooms during September and October. Some mushrooms only grow at the root of specific trees and conditions need to be perfect, but if you visit the fen around this time of year you will see an explosion of mushrooms of all shapes and sizes. The penny-bun bolete and the chanterelle are quite easy to recognise and are two of the most sought-after culinary mushrooms available — delicious when cooked in

garlic butter or dried and used for stocks or sauces.

The Slavic countries have a rich tradition of mushroom-gathering and there is a Czech word of warning that says, 'All mushrooms are edible — but some just once.' It is a good piece of advice. Some of the poisonous mushrooms that grow in Ireland can cause severe illnesses, including kidney failure. Nicholas Evans, the author of the book *The horse whisperer*, had to have a kidney transplant after eating a poisonous mushroom by mistake. The large, bright-red mushroom called the fly agaric is the type of mushroom

Shaggy ink cap mushroom (photo by Shay Connolly)

you instantly think of when you imagine a mushroom in a fairy tale. It grows near birch trees, and there was a spectacular example of one a few years ago in the middle of the fen. Unfortunately, this is one of the poisonous varieties, so it is better to admire it from afar and leave it to the fairies.

A mushroom that even the fairies would not want to mess with is a small, pale variety with a rounded pileus or cap. Do not be fooled by its appearance — its name should cause alarm bells. It is the deadly death cap, the most poisonous mushroom on the British Isles. Although the colours otherwise vary, the death cap, found in Wicklow, has a pale olive-green tint with a ring around its stem. This little mushroom has quite a deadly reputation throughout history, being held responsible for the deaths of both a Roman emperor and an Austrian king. The emperor Claudius Caesar is said to have been served a plate of Caesar's mushrooms by his stepson, Nero, which was laced with the juice of the death cap, resulting in Claudius's death and Nero's succession. In 1740 the Austrian King Charles VI also died days after eating a dish of sautéed mushrooms; his death led to the War of the Austrian Succession. Although ingestion can be fatal, with no known antidote available, the number of fatalities in Britain and

Ireland is actually very small. This may be due to the lack of of a mushroom-picking tradition in this country, but the advice for the novice mushroom-picker still remains — stay away from anything that is not easily recognisable. If you have someone whose advice and expertise you trust, great; but, if you are beginning on your own, make sure you are in no doubt about what you are picking, and triple-check your mushroom with reliable sources before eating it. Some countries offer an identification service through local pharmacies, but unfortunately this does not exist in Ireland. However, one of Ireland's leading mycophagists is Bill O'Dea, who is available on Twitter (@Mushroomstuff) and will happily identify any mushrooms you come across from photographs. If you do not fancy risking eating wild mushrooms, you can still always enjoy their wonderful shapes and colours as you walk through the woods.

Another way to enjoy wild mushrooms without any risks is to attend a local farmer's market. Selling everything from homemade jam to brewed cider, these markets are a great way to support small, local businesses. You can speak directly with each farmer about his or her product and know exactly what you are buying. In a time where convenience and mass conglomerates dictate what we eat, this is one example of how people are returning to good, wholesome food, buying directly from local farmers or street-sellers. One of my earliest memories is of my mother carrying me down the stairs in the morning, when I was about two or three, and stopping on each step to show me the *Cries of London* prints that hung on our wall. These seventeenth-century engravings depicted various farmers and street-vendors of London trying to sell their products and goods. The prints included an old, itinerant rat-trap seller, a girl with a basket of sweet cherries, a milkmaid with a churn, and three old farmers' wives from Croydon selling leeches and snails. These markets would have been full of the sounds of all the different callers shouting out for custom.

In Ireland, meanwhile, the market fair was not just an important place to do business, but also a place to catch up on local news or gossip and to stock up on much-needed winter provisions. They had a darker side, however. After the famine, many families were forced to send their young children to hiring fairs, where they were hired by landowners on six-month contracts to be used as cheap labour on their farms. Some of these children would have been as young as seven years of age and would have been forced to work long hours in harsh conditions.

At this time of year, many of the hiring markets took place on 29 September, or Michaelmas Day. They would have been filled with desperate men and women pleading for some kind of work. Hiring markets were held at this time

of year, where wealthy landowners traded and hired for the coming season. In Thomas Hardy's novel *Far from the madding crowd*, such a market takes place and each labourer signals his trade by the item he wears or carries. The carters and waggoners had a piece of cord wrapped around their hats; the thatchers wore a piece of straw; and the shepherds held their sheep-crooks tightly in their fists.

Where Hardy gives us a pastoral view of the hiring markets in Britain, the poem 'An spailpín fánach' gives a more caustic account of the life of the wandering labourer in Ireland. The overriding feeling in this poem is one of anger and shame, where men, women and even children were degradingly looked upon like animals in a cattle-mart.

The background to the poem 'An spailpín fánach' is the uprising that broke out in Ireland during the final years of the eighteenth century. In this poem, the *spailpín fánach*, or 'wandering labourer', vows never again to humiliate himself at these hiring markets and instead vows to join the 'croppies' in their fight against the British forces. The 'croppies' was the nickname given to the Irish peasant rebels who supported the cause of the United Irishmen during the 1798 Rebellion and who resorted to using farming implements such as scythes and sickles as makeshift pikes in their desperate and ultimately failed attempt to drive back the loyalist forces during those bloody months from May to September of 1798.

Wicklow and Wexford were the two most successful rebel counties during this time, but following defeat at the battle of New Ross, the battle of Arklow and the battle of Bunclody, the rebel fighters took to the hills of Wicklow, where they remained for five years, waging guerrilla warfare against the British army. For this type of insurrection to work, strong leaders who knew the layout of the land were essential, and one of the most successful of these guerrilla leaders was Michael Dwyer. Today, if you take a drive over the Featherbeds, or across the Sally Gap to Glendalough, or even further south to Glenmalure, you are most likely travelling on the road that was built by the British forces over 200 years ago in their attempt to capture Wicklow's most famous outlaw.

Dwyer was born in the small townland of Camara in west Wicklow, where he ran the family's farm. During the 1798 Rebellion, his uncle, John Dwyer, was executed along with 36 suspected rebel prisoners in the Massacre of Dunlavin Green. This fuelled Michael's hatred of the British. Under the leadership of General Joseph Holt, Dwyer fought as captain in the 1798 Rebellion, but by mid-July the uprising had suffered some heavy defeats, and he and thousands of rebels retreated into the hills of Wicklow. From then on, Dwyer's legendary

status grew as he used guerrilla warfare to attack loyalists and yeomen in a sustained campaign of highland fighting. These successful tactics marked Wicklow out as the last rebel stronghold in the country. The wild bog terrain of the Wicklow Hills made the transportation of heavy infantry and cannon impossible, forcing the British to finally construct the Military Road, which ran from Rathfarnham in Dublin right across the Wicklow Hills and ended in Aughavannagh in south Wicklow. It was an incredibly ambitious project, taking nine years to complete under the guidance of the engineer Alexander Taylor. Its highlights the desperate lengths the British were forced to go to in their efforts to defeat the rebels and capture the elusive Dwyer.

While most of the original Military Road has now been overlaid with tarmacadam, a small section of the original cobblestone road can be seen in the Old Massey's Estate in Killakee in the foothills of the Dublin Mountains. However, there are two buildings in the hills of Wicklow that are still standing today, which tell two very different sides of the Michael Dwyer story. The first building is now the Glencree Reconciliation Centre, but in Michael Dwyer's time it was a British military barracks, built to dominate the landscape of this serene valley. This intimidating building housed over a hundred soldiers and represented the might of the British forces in the heart of the rebel stronghold.

The second building is a much less impressive structure, but behind the whitewashed walls it speaks of the blind determination of these rebel fighters. The Dwyer-McAllister Cottage is located in Derrynamuck in west Wicklow, deep in the Glen of Imaal, surrounded by Lugnaquilla, Table Mountain and Keadeen. If you visit the cottage in September, you

Stepping stones at Trooperstown (photo by Chris Corlett)

may hear sporadic gunfire reverberating around the purple hills as you walk up the back lane. The Glen of Imaal is used by the Irish army for target practice and the echo of salvoes shattering the peace of this remote valley creates a tense and unexpected atmosphere for a first-time visitor. But this is nothing new to the memory of these mountains, which were witness to a dramatic event that took place at this very cottage over 200 years ago.

In 1799, Michael Dwyer, Sam McAllister and another dozen men found refuge for the night in three local cottages. Local sympathisers risked their lives by giving food and shelter to these men but, on this particular night, an informant betrayed them to the British forces and the cottages were soon surrounded by Scottish Highlanders. In the following shootout, two men were killed and one man was badly wounded. The wounded man was Sam McAllister, who bravely stood in the doorway of the cottage to draw the fire, allowing Dwyer time to escape out the back and down the snow-covered mountainside to safety. Dwyer remained on the run for another four years, before finally negotiating a surrender in December 1803. Two years later, Dwyer left Ireland for the last time, being transported in 1805 to a lifetime's exile in New South Wales in Australia. He died there in 1827.

Unlike some of the leaders of these turbulent times, such as Robert Emmet and Wolfe Tone, Michael Dwyer is somewhat forgotten in Irish history today. The reason for this may be to do with his sad decline in his later years, or the fact that he didn't die in Ireland like these other patriots, leaving no real monument or grave to honour his legacy. Perhaps the best way to remember him is to travel up to the rugged mountains of Wicklow and look out across the bogs and barren landscape he once traversed with his men. Standing on top of the Sally Gap on a late September afternoon, I follow the Military Road as it winds its way over cairn, col and bog. I stand and marvel at this 200-year-old stretch of road, which begins at the foothills of the Dublin Mountains and ends in the heart of south Wicklow. It is a road that was built in pursuit of one man — a man who helped shape not just the history of our land, but the land itself.

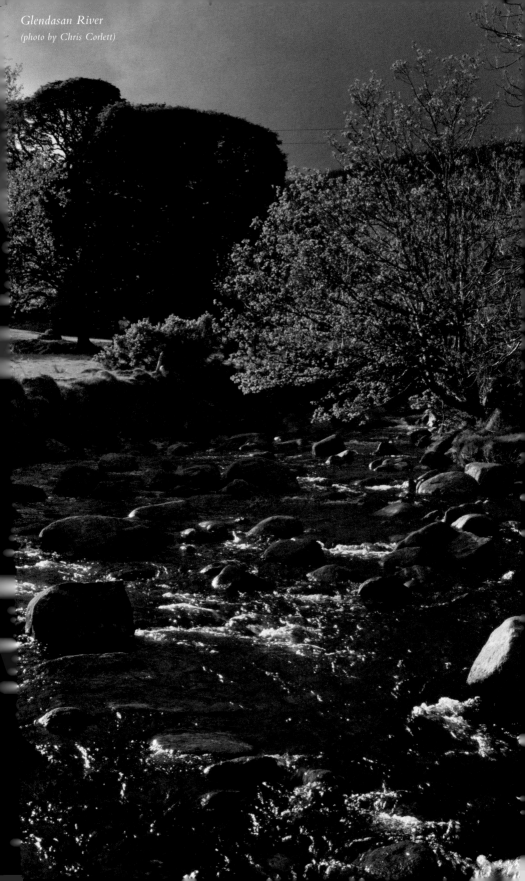

Glendasan River
(photo by Chris Corlett)

October

An rud is annamh is iontach.
('What is rare is wonderful.')
— Irish proverb

October opens its account with rain. Heavy stormclouds drift in from the west, filling muddy pools in the tracks where cattle once grazed. The landscape darkens and, for three days and three nights, water buckets down biblically. By the fourth morning a fragile sun sieves its way through the parting clouds, releasing flecks of light that sprinkle down on the wet earth below. There is more light than heat in an October sun, but its sudden appearance is all the more welcome for its brevity. Wet leaves release their glistening death-rattle beauty when caught by the breaking dawn, illuminating fields and roadside gutters with an unexpected spark. On a morning like this, you really have no option but to go outside and walk amongst the trees.

After being blessed with some glorious days of summer, it is easy to become complacent about such nice weather. But now, after three days of continuous heavy rain, waking up to one bright, sunny morning in October is like finding a tiny nugget of gold sitting in the bed of a mountain stream. What is rare is wonderful indeed. In this month of decline, such days are precious. Writing can often be an enemy on days like these. You are torn between the demand to reach your daily count and the temptation to get up from the desk and enjoy the outdoors. The American writer Nathaniel Hawthorne knew this predicament, but had no hesitation in making his choice:

Raindrops on fuchsia
(photo by Shay Connolly)

I cannot endure to waste anything so precious as autumnal sunshine by staying in the house.

I tend to agree. You need to make the most of these brief spells of sunshine. Who knows when they will return? October gusts will soon exhale, calling time on the briefest of respites. Winds will wrap their fierce hands around trunk and crown, shaking wildly. Scattered leaves will soon cover every path, field and ditch, soaking the countryside in a mulch of decaying foliage. And even when the gale retreats, the few bastion leaves that do remain will eventually loosen their grip, too, falling one by one in a tearful harmony of leaf and heavy rain. Robert Frost in his poem 'October' pleaded with the autumn winds to slow down, spare the falling leaf for just a little while longer and not succumb to winter's demands too early:

> Hearts not averse to being beguiled,
> Beguile us in the way you know.
> Release one leaf at break of day;
> At noon release another leaf
> One from our trees, one far away.

In a mild year, the leaves will survive until mid-November before they succumb to their inevitable fall. If this does happen, a spectacular display occurs. September's yellow deepens to the rustic colours of true autumn. Some of the best places to see such colour in Wicklow include the Glen of the Downs, the wooded walks around Enniskerry and the Vale of Clara. In wooded areas like these, the beauty of this month can be just breathtaking, but an autumn walk through a path of falling leaves can also bring out a certain melancholic reflectiveness like in no other season. Spring offers rebirth, summer growth and winter the hope of a new beginning. But that universal feeling of beautiful loss is nowhere more strongly felt than in the month of October. For John Donne, Dylan Thomas and Truman Capote, this was the best month of all. Virginia Woolf, however, felt that the older she got, the less she enjoyed this time of year. For her, the month of October brought only sadness, which became a seasonal embodiment of her own inevitable demise. Spring was her preferred season and it was on 28 March 1941 when she made her final walk down to the River Ouse in East Sussex, where she tragically drowned.

Apart from the trees, there is also a sadness in seeing our avian summer visitors depart our shores, with many people marking winter's true arrival with the sudden disappearance of the swallow. But it is not long before summer birds are replaced by winter visitors, filling our misty skies with the beating rhythm of their forgotten wings. First the brent geese appear, like great oarsmen from the north. When they reach their destination and finally set foot on land, the wetlands are filled with their triumphant barks and celebratory calls. They announce to the world that they are here once more, having survived their long migration across land and sea. How many of these brave migrants were here just six months ago, before they left to breed in the Canadian Arctic? How many were lost along the way?

On the second week in October I notice a greylag goose amidst the large number of brent. An early arrival, perhaps, the remaining numbers not being expected until early November. With only about ten wintering sites across the entire county, we are blessed that a small number of greylag geese winter on the Kilcoole wetlands, with Pollaphuca Reservoir being another favourite destination for these rare, iconic birds of Ireland. The geese are followed shortly by the migratory swans. Our resident mute swans, who have had the place to themselves until now, are joined once more by their smaller cousins, the whoopers, who have spent the summer months in Siberia.

The first appearance of fieldfares and redwings occurs in mid-October, with the main influx arriving in November. The arrival of these wintering

thrushes suggests a nice, mild winter ahead, but if the temperature drops too low a continuous harsh frost or snowfall will have devastating effects on their numbers. These thrushes have a large breeding ground, with redwings breeding in Iceland, Scandinavia, northern Russia and almost all of Siberia, whereas fieldfares range from eastern France through Scandinavia, Russia and as far as northern China. Both types of thrush fly south during the winter season, with berries being an important part of their diet. I always remind myself only to pick berries in moderation, keeping in mind that the birds need them more than we do. Hawthorn, rowan and yew are some of these birds' favourite foods, but they also forage for snails, worms and slugs. When feeding, they fly with the wind and, if disturbed, they rise from the ground together in a Mexican wave and perch on a nearby fence or wire, before returning to the ground to feed once danger has passed. A great way to encourage these birds to visit during winter is to plant a hawthorn or rowan tree in your back garden. Failing that, leaving some cut-up apples on your lawn might also entice these striking birds to come and feed.

I am constantly surprised by the wide range of birds and butterflies you can see from your kitchen window if you go to the small trouble of creating a suitable habitat. There is a mutual benefit between the trees, which supply berries in autumn, and the birds that feed on the fruit to store up energy for the colder months ahead. Many birds rely on berries as their primary source of food, but the trees also rely on the birds for their survival. When a bird eats the berry, it disperses the seed to another fertile piece of soil, ensuring the continuation of that tree if the seed takes hold. Nature's bartering system is a very efficient symbiotic relationship — a relationship we might do well to study and learn from in our own lives.

The Glen of the Downs Nature Reserve is a popular place to visit in this month, when the trees are in full colour. Situated between the villages of Kilpedder and Kilmacanogue, the name for this valley in Irish is Gleann Dá Ghrua, meaning 'glen of the two brows', probably relating to the Great and Lesser Sugar Loaf, which can be seen as you walk up the valley. The valley was formed by a glacier that cut through the quartzite rock during the last ice age, but it was another type of incision into the valley that caused a huge amount of protest during the late 1990s. The plans were to widen the pre-existing road to a two-lane dual carriageway in an effort to reduce the number of fatalities on this dangerous stretch. The construction was greatly delayed by eco-warriors, who lived amongst the trees for three years, protesting against the destruction of this natural habitat and the felling of some native trees. Driving through

the valley at that time was a little bit like being a character in Joseph Conrad's *Heart of darkness*. There was a strange sensation that invisible eyes were staring out at you from either side as you travelled through, watching every movement from their secluded treehouses in the wooded darkness. The standoff lasted until 2003, when a High Court ruling ordered in favour of the road being built and the forest-dwellers withdrew from their arboreal residence. In the 1827 edition of his book *A guide to the County of Wicklow*, G.N. Wright describes the gap between the two hills as only letting enough room for a 'good carriageway' to pass, with the hills 'clothed with wood from the lowest level of the valley to their summits'.

Today, the much larger N11 cuts through the valley, but the walk up to where Bellevue house once stood can still be accessed by a dangerous turn on the left-hand side if coming from the direction of Bray. However, with the amount of traffic using this road today, you need to be careful to slow down well in advance before taking this turn. Exiting is even trickier and, with no lights on this stretch of road, great care is essential, especially at this time of year, as the light drops suddenly behind the valley hills.

Male blackbird (photo by Shay Connolly)

Once you are safely in the car park, though, you soon forget all the dangers and politics and simply enjoy this rewarding valley walk for what it has to offer. The broad-leaf rowan, ash, cherry and oak are some fine examples of our native trees and October is usually the best time to see them. The continuous sound of cars whizzing by is a little incongruous at first, not really belonging in a tranquil area such as this, but as you rise further up into the valley the canopy of trees quickly absorbs the obtrusive din. Nature reclaims the airspace as you climb higher and, by the time you reach the top of the wooded path, the echo of engines cutting through the valley becomes little more than a distant hum.

In late autumn, bare branches can be seen twisting around each other and stretching out in a desperate attempt to catch the last drops of light before the sun dips below the valley. With the wide variety of different trees to be seen as you pass through the glen, it is no surprise that there is a great abundance of wildlife present here, such as the fox, the badger and the resurgent red squirrel. The sparrowhawk, a specialist woodland hunter, may also be spotted, flying through these trees in search of an unassuming blue tit or blackbird.

This entire area was once owned by the La Touche family and was known as Ballydonagh Estate, with a magnificent eighteenth-century country house called Bellevue House that once overlooked the valley. The grounds included

Kingfisher
(photo by Shay Connolly)

glasshouses, well-kept gardens and numerous panoramic walks across the valley, which the wealthy David La Touche used as his favourite country residence. Wright gives a detailed description in his book of the buildings and surrounding grounds, which would have been an exquisite place to visit at that time. If it was still standing today, it would be a great tourist attraction like Powerscourt or Killruddery House; but, unfortunately, in the early twentieth century, much of the land was sold and Bellevue House fell into disrepair. In the 1950s the house itself was demolished and later Delgany Golf Course was built where the house once stood. It seems a pity that this should be the fate of this once-grand country estate, but at least we have the glen still intact and the remains of the Octagon looking out over the glen, where panoramic views of the valley can still be enjoyed.

On top of Bellevue Hill sit Kindlestown Woods, boasting woodland trails that lead to some sweeping views of Greystones and its harbour. Also through the glen runs a small, meandering river called the Three Trout Stream, which is a tributary of the glacial mountain lakes. It runs through the glen and under three bridges, before making its way out to sea near Charlesland Golf Club, just south of Greystones. This small river is a great place to spot some of our reclusive river birds, including the grey wagtail, the dipper and the elusive kingfisher.

At this time of year, small rivers like the Three Trout Stream play a very important role in the journey of some of the most amazing migrations of all — not of birds, this time, but of fish. The river trout migrates after one or two years out in the open sea and swims back up to fresh waters to arrive at the exact same spot where it was born. This is an incredible journey and, as for migrating birds, it is thought that the earth's magnetic field is perhaps one way in which the fish navigate their journey home. The Atlantic salmon travels even further. Starting off as a small egg in a mountain stream, it swims all the way down to the open sea before heading to the north Atlantic, around the Faroe Islands and Greenland. It spends three years there, feeding and fattening itself up, before attempting the same journey home, where it will hope to breed successfully. Like the trout, the salmon attempts to return to its original river and swim back upstream in search of its exact spawning-ground. After successfully breeding, most will die off in the shallow streams, leaving their eggs to continue on this great cycle, but some have been known to attempt the great journey for a second time. It is one of nature's greatest migrations and it is still not fully understood. The sight of an Atlantic salmon or trout in a river shows that there is a high level of oxygen in the water and

that it is relatively free from pollution. These ancient waterways that have been used for millennia are vital to the survival of these fish but, like so many of our native species, there has been a dramatic decline in numbers in the last few years. Overfishing, changes in habitat and a lack of food sources, as well as migration routes being blocked by dams, quarries or other impediments, have all contributed to this decline.

In the depths of our lakes there is another incredible journey taking place. On a dark night in mid-October, creatures that have been living under rocks begin to leave the safety of the homes they have dwelt in for up to 20 years and head for the open sea. In contrast with the salmon and the trout, the eel uses the lakes as their feeding-ground and the sea as its breeding-ground. Once the mature eel begins its migration, the urge to reach its destination becomes so strong that it even takes to land and slithers snake-like through fields and ditches to find the open sea. Very little is known about the migration of the European eel and there has been great concern for its survival over the last decade. It is believed that it travels an incredible 5,000 kilometres to reach breeding sites in the Sargasso Sea, off the coast of the Bahamas, but the journey itself is clouded in mystery. Scientists have been trying to unravel exactly where the mature (or silver) eel goes when it enters the sea. In 2006, 22 eels were satellite tagged off the west coast of Ireland, and they revealed that they do not simply travel directly towards the Sargasso Sea, but swim instead towards the Azores, probably using the ocean's currents as a faster way to cross the Atlantic. They reach depths of 1,000 metres during the day but surface again at night, using the temperature of the water as a way to control their metabolism. Once their eggs have spawned in the warm shallows of the Sargasso, the larvae then make the return journey home across the Atlantic with the aid of the Gulf Stream.

This journey takes between one and three years, and they finally reach the European shores as small, transparent glass eels. Once they arrive at the coast, they search out freshwater rivers where they will become elvers. Their urge to swim upriver is just as strong as their parents' urge was to reach the open sea. They can crawl across grass and dig through wet sand *en route* to their destination in our lakes and rivers, where they hope to mature and then begin the long arduous journey once more.

Since the 1980s there has been a very worrying decline in the number of European eels reaching our shores, and scientists are desperately trying to find the answer to the problem and reverse the situation. Habitat destruction, overfishing and climate change are all possible causes, along with a new parasite

that has been found in the swim bladder of the eel, which may affect its depth regulation as it crosses the Atlantic. In 2009, numbers were at their lowest ever recorded, but thankfully, in the last year, there has been a remarkable increase in the number of eels swimming up through our rivers. Whether this is a one-off bumper year, or whether the eel is truly making a comeback, is yet to be seen.

The Wicklow Mountains are where many of these important freshwater rivers begin their journey and it is a real thrill to find the source of the Liffey or the Dodder high up in the Featherbeds. At any time of the year it is a stunning drive to take, but in autumn the colours of the mountains come into their own. The white summer bog cotton has now been replaced by the lilac colours of thick heather, covering the deep, wet earth of the blanket bogs. One of the great features of being out on the mountainside is the incredible silence that prevails all around you. I think it is important that, in our busy lives, we return to a place where the sounds of the modern world are not continuously bombarding our senses. We have become so accustomed to the noise of rush-hour traffic, house alarms going off or electric lawnmowers cutting every last blade of grass that it is only when we hear the pure silence of the mountains do we begin to realise what we have been missing. I love sitting in a remote, expansive place that simply engulfs you in its own natural voice.

Stags (photo by Shay Connolly)

I think it is important for our inner selves to be silent in nature. I feel sorry for people who live in massive cities like Tokyo or Beijing, where the sound of nature has been all but destroyed by the roar of industry and consumerism. In Wicklow, we are lucky enough to have the sea and the mountains on our doorstep, where the perfect setting for meditation is available for free any time you want it.

The mountains also have their own unique sounds, whether it be the rustle of the conifers as the breeze sways their tall frames or the beginnings of a mountain stream trickling continuously over bog and stone. In October, there is also another sound that distinguishes this time of year — the deep bellow of the stag. Throughout the year, the stag is a solitary, silent animal, but when the rut begins he suddenly finds his voice, warning any other stags in the area that this is his turf and he is taking no prisoners. His impressive antlers have been growing all year and are now hard and ready to be used as instruments of war if necessary. The call of the stag is a battle-cry that can be heard echoing right across the valley. It is one of the most memorable calls that can be heard among the Wicklow Mountains.

By tasting the wind, the stag senses whether the hinds are in heat and, as he waits, his testosterone levels build and build, causing him to vent his frustration on nearby trees or bushes. Sometimes a stag can be seen with grass hanging from his antlers like a badly decorated Christmas tree, as if the foliage will add to his charm and impressive size. When another challenger does appear, both stags size each other up and, if both refuse to back down, there is only one way to settle it. The stags lock antlers and enter into a push-and-shove match that can last up to half an hour, before one stag tires and ignominiously retreats. Surprisingly, despite this exhausting ritual, very few stags are ever severely injured and, once the victor earns the right to mate with the hinds and his carnal hunger is satisfied, he collapses, exhausted, along with all the other stags. Once the mating season is over, the stag returns to his solitary ramblings, while the hinds remain with the herd, before giving birth to their calves in early summer. The best place to hear or even see this annual mating ritual is to take the Military Road up towards the Sally Gap and walk down into Luggala Valley during the month of October.

However, if you choose to continue driving up the Military Road, it will lead you right across the county, from west to east, passing the sister lakes of Lough Bray. This landscape has changed very little over the two centuries since the famous road was built. For me, it is the expansive wilderness of this landscape that draws you in, whether you are cycling, hiking or simply taking

a leisurely drive over the Sally Gap and the Featherbeds. As children, we were brought here religiously for our Sunday walk, to a place we affectionately called Cowboy Country in Glencree, and many of my childhood memories are embedded here. After mass, my parents would pack up the old red Datsun and fill the boot with sandwiches, Wellington boots and several screaming kids, and we would make the journey to this magical place, high up in the mountains. Looking back, I cannot think of a more rewarding gift they could have given us as children. When I return as an adult, I can almost hear the ghostly laughs and giddy shouts of my child-self, running up by the bog mountain or racing sticks in the stream. From the bottom of Bohernabreena we would chug up the steep hill and enter the picturesque valley with its equally enchanting name, Gleann na Smól, or 'glen of the thrush'. From the top of the mountain we would look down on the lake below, where Oisín fell off the white horse as he attempted to dislodge the large boulder. Although this tale was recounted to me many times, just like the inhabitants of Tír na nÓg, it never seemed to grow old. And, as I took a last glimpse out the back window as we returned homewards, I always swore that I had just spotted the riderless white horse crossing the sea before disappearing into the mists of forgotten time.

With October drawing to a close, winter's breath begins to slow things right down. The days have lost their Indian-summer heat, and now an early dusk shrouds the lingering light in shadow. The last of the autumn foraging is taking place, with the birds and mammals storing up their energy to see them through the tough times ahead. An evening walk is still possible down by the Breaches but, in the time it takes to turn back for the car, the sun is already setting. The darkening humps of the hills look like a caravan of silhouetted camels trudging across a desert horizon. Geese make one last flourish of flight before collectively settling down on a grassy patch and bunching up together for the night. While down on the estuary, two swans glide effortlessly across the still water before they, too, disappear silently among the tuneless reeds.

Children, too, have settled down and, after the excitement of the first few days of new faces and summer stories, the routine of school days takes hold once more, with one day blurring into the next. But, at the end of October, a farewell autumn treat lies in store. It is a special night where, for once, night-time does not signal pyjamas and bedtime stories before sleep. Instead, it is the one night where children welcome the setting of the sun and get ready to go out with masked faces and empty bags to be filled with sweets, nuts and chocolates.

It is strange that one animal that is always associated with Halloween is the one animal that would never be seen on 31 October at all — our native bat. During the summer months, just as the light falls, bats can be seen flying in their jerky patterns, feeding on insects, moths and flies. Anywhere there is fresh water and woodland, you will be sure to see a bat silhouetted against the blue of the summer night. There is a small stream that runs at the back of our garden and, every evening from June to August, small pipistrelles can be witnessed navigating their way through the failing light, using their high-pitched sounds or echolocation as a form of radar.

'As blind as a bat' is an unfortunate misnomer. Bats do have good eyesight, but their highly adapted ability to use echolocation is a far more advanced and effective way to hunt. Their high-pitched sounds (mostly too high to be heard by humans) bounce off tiny flying insects. Using the changes in the frequency of the sound waves as they return to the bat's ears, they are able to locate their prey. This ability makes them master hunters of the night skies and well deserving of our respect. They really are fascinating creatures and,

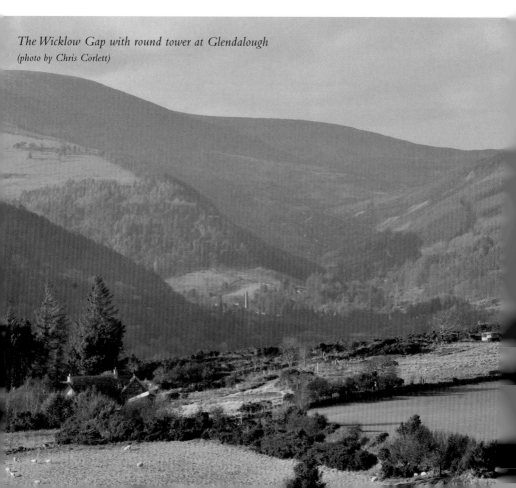

The Wicklow Gap with round tower at Glendalough
(photo by Chris Corlett)

like snakes, have suffered a very negative and undeserved reputation in the past. The stories of them getting tangled up in hair, or sucking human blood, are completely untrue. The nine different types of bat found in Ireland feed only on insects or moths. It is good to remember that, on a warm summer's day, when the midges and flies are ruining your picnic, the bat is out there at night keeping their numbers down. During the winter months, however, a lack of food means that the bat must go into hibernation. Very few mammals in Ireland truly hibernate, but the bat is one of them. They need a cold place like a cave or a subterranean tunnel where they can hang upside down and see out the winter in a torpor-like state. Their heartbeat slows considerably and only when the spring months begin to warm up and the fly larvae begin to hatch do they return to our night skies to feed. But every Halloween the bat is somehow linked with witches, black magic and evil spirits, which is terribly slanderous to the poor fellow, who is simply hanging asleep in some dark cave or old attic loft, without ever knowing what all the fuss is about.

Halloween has its origins in the Celtic pagan festival of Samhain, which celebrated the end of the harvest and the arrival of the winter darkness. It was a time when the great divide between this life and the next was bridged, and the dead were invited to return to communicate with their loved ones. Bonfires were lit to guide and cleanse the cattle as they were brought in for the winter months, but the weaker or older livestock were singled out and slaughtered for the festival's feast. Along with meat, the Samhain feast was also accompanied by the harvest food of fruit and nuts, and washed down with beer and honeyed mead.

The Christian adaption of this old festival is All Hallows' Eve, which began in the mid-eighteenth century and was chosen as a time to remember the 'hallowed saints' as well as family members who had died. The Halloween we have today amalgamates the traditions of the Christian celebration and the older, pagan rituals of the past. Children still play games like apple-bobbing and finding the ring in the *bairín breac*, but the season's fruit games now play second fiddle to sweets, chocolate and popcorn. When a group of children come knocking on our door on Halloween night, I oblige them by giving them their chocolate treats, but I always put in some fruit or a few nuts as well, just so that a little bit of the old tradition remains. Maybe I am imagining it, but I get the feeling that each year we have fewer and fewer children calling at our door. I think we must have a reputation for being one of those 'fruit and nut' houses.

The tradition of dressing up and going from house to house might also have been influenced by the Christmas mummery tradition that was popular in the early nineteenth century. A group of friends would dress up in masks and travel from house to house to perform songs, dances and games, where the host had to guess their identity before being offering food and drink. Some of these customs were brought to America in the nineteenth and early twentieth century by Irish emigrants, where they were first adopted and then modified over time. An example of this would be the tradition of placing a candle in a carved turnip to use as a lantern back in Ireland. Once in America, the softer and more readily found pumpkin replaced the turnip as the traditional fruit of Halloween.

It seems a bit ironic, then, that a festival that originated in Ireland and was brought to America by Irish emigrants has now returned to us in a glitzier, more colourful guise. We seem to have come full circle, with the Americanised version of Halloween having a massive influence on how we now celebrate the festival in this country. In fact, the Halloween celebrated in Ireland today is probably closer to the Americanised version presented on television and film than to the original customs of the past. Even the language has adapted to an Americanised vernacular, with Irish children 'trick-or-treating' or even sometimes substituting the word 'candy' for 'sweets', as in, 'Help the candy-collection party.'

Apart from bonfires and trick-or-treating, Wicklow is specifically good for ghost walks on Halloween night, with the annual Halloween Tomnafinnoge ghost walk in Tinahely, or a midnight tour to Wicklow Gaol, which is apparently the most haunted place in Ireland. A hooded, cloaked figure is also said to walk the graveyard in Glendalough, while Pollaphuca is home to a demonic black horse. Although the bat may not be seen at this time of year, there are some really eerie sounds out there that would terrify you on a dark Halloween night (or on any other night, for that matter) if you were not familiar with where they came from.

One such sound is the scream of the fox, which I remembering hearing one night as I walked down a lonely country road in Brittany. I was reassured that it was the mating call of a vixen, but it stopped me in my tracks and sent shivers down my spine. Another night call that could turn your blood cold is the shrill shriek of a barn owl, which unfortunately is heard a lot less frequently these days, as the barn owl's numbers have fallen dramatically over the past few years. But if you do hear a high-pitched screech that sounds like a witch screaming from the darkness of the heath, do not be afraid.

You are not going to be confronted by the three weird sisters; in fact, you should count yourself lucky. You have just heard the wildest call from our native woodland — an iconic sound of our past, which, in time, may sadly fall forever silent.

Hawthorn tree
(photo by Seán Ó Súilleabháin)

November

With the return of the winter months there comes a silence. The remaining leaves are dropping with every passing day, leaving branches exposed to the chill November air. The rustling of a light summer breeze is long forgotten now and instead a sharp frost covers the ground where deep roots lie buried. Now, when a gale blows through the bare branches, their leafless tongues are powerless to respond. Lear-like, their bodies have been stripped back to their most basic physical form, having to face the winter's storms with an unfair vulnerability. Some animals have fattened up or grown thick coats to help them through these long, dark nights, but the trees face their winter pilgrimage with no such luxury. Skeletal limbs reach to heaven, pleading for their suffering to end with the arrival of next year's growth, but in early November next year's growth is slumbering and deaf to their call.

We have been lucky of late. The heavy rain forecast for the first few days of the month has not delivered on its promise, and instead the cold days have become a wonderful backdrop for long woodland walks. Strolling through the woods come winter creates a different type of sensory experience that is unique to this time of year. Winter has the power to dramatically change a landscape, revealing sights that were once restricted during the summer months. From the top of Delgany Wood in mid-July, the small village lay hidden under a thick green awning; but now, as the year matures, church spires, cottage roofs and winding roads are all visible in this freshly pollard horizon. A winter walk has its own unique soundscape too. The leaves no longer rustle as they once did in a whispering summer evening; instead, having now fallen to the ground, they make the sound of a crisp crunch underfoot following a night's frost, or squelch in oozing mud following heavy rain. Across field and woodland, the fragile light of November's shortening days illuminates an

ashen shade of barren beauty. Is it any wonder Emily Dickinson described this month as 'the Norway of the year'?

A subfuscous evening in November can have all the elements for a perfect woodland stroll, especially when the light and shade dance out their universal rhythm on the ballroom of dead leaves. Night walks can also reward the daring rambler at this time of year. On a cloudless night, moonshine brightens even the darkest of forest paths, bathing the entombed undergrowth in pale silver. Winter night rambles can be some of the most atmospheric walks to do but, understandably, the silence and stillness can be a bit offputting for some people, especially when broken by a sudden movement among the trees. Even a short stroll on a cold or wet November evening can be anathema to some walkers, who prefer the comfort of the indoors at this time of year. Walking boots are often packed away until the lengthening days of spring return — but, of course, this does not have to be the way.

If you do decide to step outside and brace the winter weather, you are, more often than not, greatly rewarded for your effort. Once we realise that walking is not simply a summer activity, or that a 'fine day' does not have to always mean a sunny day, we begin to realise that each season has its own individual beauty. You can do the same walk ten times in one month but, depending on

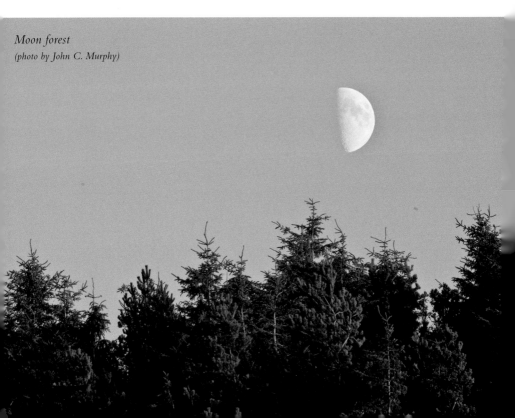

Moon forest
(photo by John C. Murphy)

the time, the weather and the light, it can dramatically alter your experience of even the most familiar of landscapes, making the commonplace seem rare. In his essay 'Nature', Ralph Waldo Emerson reminds us that a winter landscape has just as much attraction for him as anything observed in summer:

> The inhabitants of cities suppose that the country landscape is pleasant only half the year. I please myself with the graces of the winter scenery, and believe that we are as much touched by it as by the genial influences of summer.

Emerson also argues that what we perceive as outward beauty in nature is directly influenced by our own personal feelings. 'Nature always wears the colors of the spirit,' he writes, suggesting that the landscape of our mind has the power to paint beauty in whatever we see. It is not just the physical landscape that we respond to when we go for a walk or a hike. More often than not, our personal feelings affect not just what we see, but also how we see it. Nature acts like a great mirror reflecting back, and sometimes even drawing out, buried emotions within us. A glorious summer sunset can be the saddest view in the world for a person in grief, whereas a barren mountaintop in winter can fill the eye of the inwardly happy walker with pure ecstasy.

Apart from the weather, another argument sometimes made about winter walks is that there is not much wildlife to be seen at this time of year and, at first glance, it does sometimes seem that the abundance of spring and summer abundance has suddenly disappeared. Some creatures have sequestered themselves deep underground, or migrated south, not to appear again until the warmer weather returns and food becomes plentiful once more. It is true that our larger mammals, like the fox and the badger, do choose to conserve their energy by remaining in their setts and dens during the coldest days of winter, but desperate hunger will eventually force them to the surface in search of food. Only a handful of our mammals, like the toad and the bat, ever really enter into a state of true hibernation, slowing their hearts to just a few beats a minute. But of course, there is always something interesting to be seen, no matter what the time of year. You simply have to get out and walk.

The perception that winter is a lost season is simply that — a perception. If you look closely you can find winter's beauty wherever you look. On just one winter morning, I noticed an intricate spider's web weighed down by the night's rain that had dripped through a crack in my shed roof. The tiny, captured droplets shone like liquid diamonds on the woven patterns in the

morning sunlight. Later that day, as I took a short stroll by the banks of the Aughrim River, the simple sight of a red-breasted robin landing on a branch brought a welcome splash of colour against the dun bark. Further down by the bridge, a grey heron waited in anticipation for any movement in the deep pools, before striking with the perfect precision of its angular beak. All terribly ordinary; all wonderfully mysterious. I watched and listened. Yes. Winter was very much alive.

The smells of a winter wood are also unique to this time of year. The sweet odour of decaying leaves and dead wood is so wonderfully earthy that, to my mind, it rivals any meadow of wildflowers in June. The spruce forests of the Wicklow Mountains are especially strong in this season, filling the air with their sweet pine fragrance — a smell that I still happily associate with my own childhood. Of all of our senses, it is the sense of smell that most powerfully triggers our memories and emotional responses. A particular scent can bring us straight back to that time when we experienced it first. Even now, when I think of the time I visited Lake Louise in western Canada, it is not so much the snow-capped peaks or the turquoise glacial lake that first come to mind, but the overpowering smell of the fir trees.

Another winter wonder that can be witnessed on very rare occasions at this time of year is an event that must rank as one of the most amazing natural

sights anywhere in the world. The creature responsible for this spectacular event is a bird you might regularly see feeding in your garden — the common starling. Beginning in late autumn, flocks of starlings gather together at dusk, and by midwinter these flocks are often joined by European migrant birds that can bring the numbers up into the thousands. These massive flocks create a moving cloud in the evening sky that intertwines, spirals and swoops across the sky, making the most fantastic acrobatic shapes that are simply breathtaking to watch. Each individual bird reacts to the movement of the bird next to it, flying in perfect unison to create incredible shapes that, from afar, look like a cloud of biblical locusts. This natural event is called a murmuration. A friend of mine had the pleasure of seeing one taking place over the lakes in Blessington a few years ago. He said it lasted for over ten minutes and he was left spellbound by the experience. The reasons put forward for why the starlings perform these spectacular aerial exhibitions include the theory of safety in numbers, where a predator like a peregrine falcon is unable to focus on an individual bird as they move collectively in one mesmerising, swarming cloud. Another theory I have heard is that a murmuration is a way for the starlings to pass on information about breeding sites within the area. Whatever the reason, it remains for me one of nature's most spectacular aerial displays. A murmuration appears in the first series of HBO's *True detective*, when detective Rust Cohle looks out across the cane fields, sees strange spirals in the sky and wonders if he is hallucinating. Apparently they are a common site in southern Louisiana, where the show is set. But the best footage of a murmuration I have ever seen was captured by two English independent filmmakers who were out canoeing on Lough Corrib. They happened to come across the most amazing murmuration, swooping and swirling above their heads, and managed to capture it all on film.

Grey heron (photo by Shay Connolly)

The weather also plays an important role in the shaping of our winter landscape. We naturally associate wintertime with snow, but in Ireland the first real sign of winter is the frost. 'The third day comes a frost, a killing frost,' Cardinal Wolsey laments in Shakespeare's play *Henry VIII* and, indeed, in the first week of November the sound of scraping windscreens and engines running in the early hours of the morning signals that the commuter's dark winter has returned.

Of course, this is a tough time for our wildlife, especially our garden birds, who can really struggle to survive the cold nights. The extra bit of food put out in our gardens can make all the difference when food is scarce. The 'killing frost' may not be the farmer's friend, nor the gardener's, but no work of art can rival the symmetric patterns created by frost on a pane of glass, or the crystal formations that hang on a heavy branch or blade of grass. A single snowflake uniquely captures a frozen moment in time, transforming the most banal object, like a fence or a nettle leaf, into a work of art. Perhaps this is what Dickinson meant when she compared November to Norway. It is this transforming capacity that invites you to stop and observe in silent wonder the most familiar sights, seeing them again for the very first time.

Down by the coast we can also witness winter's transformation. The sea has found the strength of its voice once more, reclaiming the empty beaches that have been long abandoned by buckets and spades. When standing on the eastern hill in Wicklow town, you get a real sense of the sea's awesome power. From this lookout point, the crescent shape of the coast is visible, sweeping around the harbour and the beach, heading towards Newcastle, Kilcoole and a misty Greystones in the distance. To the south, the cliffs of Wicklow Head and the lighthouse can be seen punctuating the low, overhanging cloud with a bold defiance. The continuous beat of the waves against the land is a sight I always find both threatening and alluring. Up here you can even taste the salt in the air as the spray stings your cheeks.

Wicklow is a town that is literally layered in history. It was built on the foundations of a ninth-century Viking settlement and the ruins of a thirteenth-century Anglo-Norman monastery, which can still be seen at the Abbey Grounds, just off Wentworth Place. Even the name Wicklow is derived from the Viking word Vykyenglo, meaning 'meadow of the Vikings'. The town is not only famous for its old historical buildings and narrow streets, but also for the people and events that helped shape its identity through the centuries. On the very edge of the eastern hill stands the Norman Black Castle, which was constructed in the twelfth century under the supervision of Baron Maurice

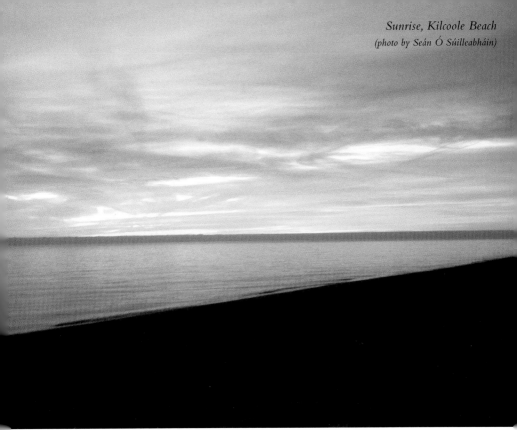

Sunrise, Kilcoole Beach
(photo by Seán Ó Súilleabháin)

FitzGerald after Strongbow awarded him the land following the Norman conquest of Ireland. Today only the skeletal remains of the castle can be seen, but there is enough to imagine what an impressive fortification this would once have been. The original name for the castle was King's Castle but, owing to the many dark deeds that took place there, 'King's' was changed to 'Black'.

It was built on a perfect location, looking out over both sea and land, where it could anticipate attack from either the mountains or the coast. It once had a motte that connected the castle to the mainland and, although the motte has long gone, you can still access the castle by the steep steps that lead onto the rocky promontory. The castle was under constant attack from the O'Tooles and O'Byrnes, the infamous local chieftains of Wicklow who would come down to the lowlands from the Wicklow Hills and attempt to sack the castle. They finally succeeded in doing so in the early fourteenth century.

The castle changed hands once more during the reign of King Henry VIII in 1543, when it was retaken by the English, but was burnt once more in the rebellion of the 1640s. The most tragic story associated with the castle, however, tells what happened when Irish clans attempted unsuccessfully to reclaim it in the seventeenth century. In response to this failed act of treachery, the army of Sir Charles Coote committed a bloody massacre. According to

local history, up to 300 locals were rounded up, locked inside a church and burnt alive. This was obviously a brutal warning to anyone else who was thinking of collaborating with the rebels. The atrocity was woven into the town's toponymy, with the street where the event is said to have taken place being called Melancholy Lane and the surrounding townland being called Ballyguille, or 'town of the crying'.

Over the next few centuries the castle fell into ruin, and now all that remains of the once-important landmark are a few crumbling walls. Such is the course of history. Even castles eventually go the way of men. And yet, a lost, majestic presence still remains in its broken silhouette, standing stoically against a pale winter sky. It speaks of another, more glorious, more violent time, when ancient blood was sacrificed for this now-silent shell.

From the Black Castle you can make your way towards the beach, where sanderlings may be seen scurrying by the water's edge, seemingly unfazed by the lift in the sea breeze. It never fails to amaze me how these winter migrants are able to read the incoming waves with such nonchalance, as they search for small worms and shrimp in the wet sand. Down by the harbour, you might spot fishermen in yellow oilskins, bent over damaged lobsterpots, tying and weaving the knots that have been broken by the rough brine. When I walk these quays, I enjoy reading the imperious names given to some of the fishing boats that have clearly seen better days. Names like *Thalassic* and *Neptune's Navigator* seem somewhat grandiose for some of these old, rusting vessels, bobbing unceremoniously in reams of dank-smelling seaweed.

Apart from the tinkling of the masts and the occasional boat engine sputtering, there is very little activity during this winter month. But, just like the old buildings of the town, the harbour is stained with waterlines of the past. Viking and Norman seafarers would have docked and repaired their boats in this very area. Indeed, by the nineteenth century, Wicklow town was one of the main maritime harbours on the eastern coast of Ireland. A landmark that reminds us of this high time is the Bridge Tavern, which sits proudly on the corner of Bridge Street, a stone's throw from the South Quay.

This building was the birthplace of the famous Captain Robert Charles Halpin, who was born here in 1836. Growing up by the sea and listening to the tales of the fishermen and sailors who would have drunk in the seaman's tavern must have filled his young head with a great sense of wonder, fuelling his desire to head seaward from a very early age. Incredibly, at the age of just 11, he did just that, joining the *Briton* sailing ship that was chartered to collect timber from Canada and transport it back to Europe.

This would have been an incredibly dangerous voyage across the north Atlantic for experienced seamen, never mind for a young boy of 11. But the experience stood to him and, by the time he was 15, he had made numerous Atlantic crossings and even survived a shipwreck off the coast of Cornwall.

But it was to be his experience on the *Great Eastern* (at the time the largest ship on the sea) that would write Captain Halpin's name into maritime history. The ship was originally designed for leisure and cargo crossings between England and Australia by the famous designer Isambard Kingdom Brunel (who, coincidentally, was involved in the design of the Greystones–Bray cliff railway line just a few kilometres up the coast). When Halpin joined the ship as chief officer in 1865, the huge steam liner was chartered to lay submarine telegraph lines between Valentia Island in County Kerry and St John's in Newfoundland, Canada. After a failed attempt in 1865, the two continents were successfully connected in 1866. This was not just a momentous achievement in maritime history, but also a turning point in world history. Global fame followed and Halpin went on to become captain of the *Great Eastern*. From 1869 and into the 1870s, he commanded cable-laying voyages that linked the entire world, from Canada to Europe and from India to Australia, with 26,000 miles of cables uniting the great continents across the oceans. All of a sudden, news and information could be passed around the world instantly — the beginnings of what we now call the 'global village'.

When Captain Halpin retired he was a wealthy man, but he remained in Wicklow, where he built Tinakilly House, which looks out over the Wicklow coast. It is clear that the sea was in his blood. He was not driven to sea through poverty, as others would have been –his family had a comfortable business, which he would have inherited. Rather, it was an innate longing for maritime adventure that inspired this seafaring boy to leave his family. To my mind, it is hard to imagine how his parents could possibly have agreed to such a proposal, but I suppose they lived in different times. Just as gannets or shearwaters cannot refuse the call of the sea once it is time to leave the cliffs, for some people the sea has a magnetic pull that is irresistible. It makes me think of the reasons Ishmael gives for wanting to return to sea in the opening chapter of *Moby-Dick*. He describes a type of melancholic claustrophobia that takes over him when he is confined on land for too long:

> Whenever I find myself growing grim about the mouth; whenever
> it is a damp, drizzly November in my soul; whenever I find myself
> involuntarily pausing before coffin warehouses, and bringing up

the rear of every funeral I meet; and especially whenever my
hypos get such an upper hand of me, that it requires a strong
moral principle to prevent me from deliberately stepping into
the street, and methodically knocking people's hats off — then,
I account it high time to get to sea as soon as I can.

It is interesting that Ishmael uses November as the month that describes
the darkness of his soul, a depression he longs to escape through adventure.
In those dark, wintery evenings, did the young Halpin feel the same pull as
Ishmael expresses here? The reasons given for a life at sea are boundless. For
some, it is the vastness of the open space that attracts. For others, maybe it
is a type of sanctuary where life's demands are stripped back to their most
primal. Some go in search of an inner sense of calm in the uniformity of a
watery desert. For others, it is the thrill of pitting your skills against nature's
wrath. And for still others it is simply a necessity. I am guessing that for
Captain Halpin, even as a young boy, it was the kind of essential need Ishmael
speaks of. He must have stood on Wicklow Pier, watching the sailors come
and go onboard their ships, and simply known, even at 11 years of age, that
his future lay out on the watery horizon. But I still wonder how his mother

must have felt, watching her baby boarding the ship for the first time to begin a dangerous apprenticeship at such a young age, not knowing if she would ever see him again.

The journey the young Halpin set out on eventually brought him fame and fortune, but the ports and harbours around our country are also haunted by sadder events. Tales abound of those who stood on these very docks and watched their loved ones boarding waiting ships to be transported to distant lands, knowing that this would be the last time they would see each other. In Wicklow town, such stories are still remembered. In contrast with the glorious exploits of Captain Halpin, a shadow darkens the narrow streets and port. Looming high on Kilmartin Hill stands Wicklow Gaol. From this building prisoners were transported to Dublin to board the convict ships that would take them to a lifetime of labour in Australia. Some of the prisoners' crimes were petty theft, while others were participants of the 1798 Rebellion. Famous prisoners of Wicklow Gaol included local 1798 rebel Captain William 'Billy' Byrne of Ballymanus, James Napper Tandy, the United Irishmen leader, and Robert Erskine Childers, War of Independence rebel, arms-smuggler and father of a future Irish president.

Thirty-five years before Captain Halpin was born, on 29 November 1801, the ship *Hercules* left Ireland to cross the Atlantic, stopping at Rio before continuing around the Cape of Good Hope and on to its final destination in Sydney Harbour. On the top floor of Wicklow Gaol there is a replica of the *Hercules*, which gives us something of an idea of the cramped conditions these prisoners endured. Under the command of Luckyn Betts, the prisoners were kept below deck in chains but, a month into the voyage, a mutiny broke out. The prisoners managed to take the upper deck, before the soldiers and seamen regained control, killing 13 prisoners in the process, with Betts executing the ringleader, Jeremiah Prendergast. For the remainder of the voyage, the prisoners were kept in unimaginably harsh conditions, not being allowed to come up for air and given only the bare minimum of medical care and food. This harsh treatment resulted in 127 of the 320 convicts dying before the ship even reached Australia. When the *Hercules* finally docked in Sydney in June 1802, Governor King wrote to Lord Hobart, describing the remainder of the prisoners as being in a 'dreadfully emaciated and dying state'. Betts was charged with the murder of Jeremiah Prendergast, but was eventually found not guilty of murder and convicted of manslaughter. His punishment was to pay a fine of £500 to the Orphan Fund of the colony, before returning to sea. As for the remainder of the convicts who survived, Governor King

described them in a letter to Lord Hobart in September as being 'too weak and debilitated as to be ever much use'.

After visiting Wicklow Gaol, or simply standing on the hill, looking out over the harbour, I find myself thinking of these tragic stories. Places such as these bridge the void between our lives today and the forgotten faces of the past. Standing on the very ground where those prisoners once stood, they suddenly become more than just facts and dates bound by the covers of history books. They become real people, who loved, hoped and suffered. To my mind, that is the real power of place. Our buildings, clothes and way of life might have changed, but the wind and rain blowing in over Wicklow Head on a cold November afternoon is the same as what those poor families would have felt as they waved and wailed goodbye to their loved ones for the very last time. Standing on both hill and dock, they would have searched the sea for the death-ships where their fathers, lovers, mothers or children lay chained, watching until the last view slipped beyond the horizon. Looking out into the vast greyness of this November sea, I imagine the frightened, white faces of the chained men, women and children, clamouring to catch one last glimpse of their homeland through the cracks in the wooden prison-ship's walls, their wide eyes desperately scanning the pier for their loved ones, like a drowning man's last gasp of air.

The eastern coast of Ireland has always had people looking out towards the Irish Sea in expectation of foreign arrivals. Peoples such as the Celts crossed the channel to call this land their home. Centuries later, it was St Patrick who arrived by boat to bring the word of the Trinity to the pagans of Ireland. His disciples, in turn, looked outwards and sailed back across the sea to spread Christianity and ecclesiastic teaching to mainland Europe. Later again, it was the fearsome Viking ships that would have been seen upon the horizon, stirring panic and fear amongst the locals. They were followed a few centuries later by the Anglo-Normans and the English, all of whom added to the crucible of Irish identity, each layer topped on the last, in the continuous, evolving definition of our island nation. It is the sea that unifies all these events of our history. On it sailed the perpetrators of terrible violence, but it is also the source of the rich culture that makes us who we are today.

Even when the English had the island tight in its grip, there was still the need to be on constant watch for foreign invaders. The evidence of this concern can be seen in the construction of the round watchtowers known as Martello towers that now dot the northern-Wicklow and Dublin coast. The Martello towers were built to guard against a French invasion during the

Napoleonic Wars and the cannons that surround these little castles remind us of this constant maritime threat.

Nowadays, however, if you see someone with binoculars standing on a high promontory and looking out to sea, it is unlikely that they are observing a military invasion. Instead, it is quite possible that they are looking for that distant spout in the air that signals that whales are swimming just off the coast. Beginning in November and continuing until the end of February, humpback whales swim up the eastern coast from their warmer breeding waters off Africa and Spain to feed on schools of herring and mackerel. There are over 25 species of whale and shark around our coast. The waters off Cork and Kerry are the most likely place to catch a glimpse of some of these magnificent creatures; but, in recent years, the eastern coast has also provided some spectacular sightings of humpback and fin whales, and in 2010 one humpback was recorded breaching 11 times off the coast of Hook Head in County Wexford. A boat is obviously the best way to see this rare activity up close, but even catching a glimpse through a pair of binoculars is a wonderful thrill. I have been lucky enough to see sperm whales in the deep waters of Kaikura on the South Island of New Zealand and humpback whales bubble-feeding off the coast of Juneau in Alaska. Bubble-feeding is an unusual way of feeding, where the usually solitary whale circles underwater with a group of other whales, creating a massive upsurge of bubbles that pushes schools of fish to the surface. The humpbacks then swim up from underneath with their mouths agape, swallowing hundreds of fish in one go. It is an amazing spectacle to witness. On the very same day, in Alaska, we witnessed some rare activity from two adult killer whales and a calf. They breached in front of our boat — something so rarely seen in the wild that even our captain had witnessed it on only a handful of occasions.

But, of course, you do not have to travel to far off places like Alaska or New Zealand to see whales in their natural habitat. During the winter months, when the fishing season is quiet, licensed fishing trawlers run whale-watching tours off the eastern coast, where humpbacks, minke whales and fin whales, as well as dolphins and harbour porpoises, can be spotted. What a wonderful thing to know that these mammals are swimming in the waters just off our coast. We are so fortunate that, no matter where we live in this country, we are never too far away from the sea and we should be grateful that we live in a place whose unspoilt coastline, incredible landscapes and seascapes are ours to explore.

A ten-minute drive south of Wicklow town, about halfway between Silver Strand and Brittas Bay, sits an absolute gem of a beach, which is hidden from

view and not nearly as well known as those other two beaches. Magheramore is a sandy cove nestled in a small, rocky inlet. To reach the small, sequestered beach, you must access a gate with a 'private property' sign attached to it. You are allowed to use this laneway as long as you do not trespass onto the surrounding farmland. It is a credit to the farmers who own the land that they allow public access to the beach across their fields, especially nowadays, when many old walkways are being restricted by 'no trespassing' notices.

Walking down this small country laneway, the difference between the colours of summer and winter is remarkable. A few months back, the laneway was lined with the rich red-and-purple flowers of the fuchsia, the light-pink flowers of the brambles and the poker-flamed montbretia. But now, nothing of that floral colour remains. Once you arrive at the top of the path, however, winter's canvas comes into its own. The panoramic views of beach, sea and sky are captivating, especially when light breaks through the pacing clouds like phantom riders galloping across the strand. All the footprints of summer's abundance have long been washed away, with nature reclaiming what is rightly hers.

At each end of the beach, the shadowed cliffs sweep into the soft, wet sand like a hungry seal displaying its round rump, before plunging out of sight. Down by the rockpools a gnarled trunk sits on the sand like an upturned

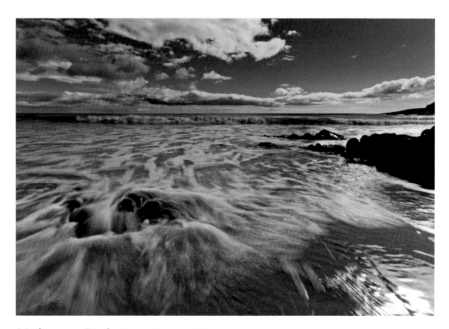

Magheramore Beach (photo by Brendan Cullen)

currach, victim of some forgotten storm. During the summer months I was able to swim from one side of the inlet to the other and even walk over the cliffs to the equally beautiful sister beach, Magherabeg. But now, with the November rain spitting down on the hard sand, these warm, halcyon days are a distant memory. And yet, the wild and almost fierce nature of a winter beach has its own unique charm. Around cave and cliff, the circling wind blows away the last echo of summer's play. Strewn seaweed dots the empty strand where sandcastles once stood, while out at sea the white foam on the horizon has long replaced the tall sails of June. Walking along the beach, I fill my pockets with unusual-shaped shells that I hope to use as a decorative display on our garden shed. Finally, and most reluctantly, I trudge up the steep slope that leads back down the country lane to my parked car. At the top of the hill I turn and take one last glance at the little cove. Under the cliffs some rockpools appear, then disappear in the continuous ebb and flow of the rising tide. Everything is as it was. Eternal. Timeless. The beauty of winter is nowhere more present than on a wild, empty beach in fading light.

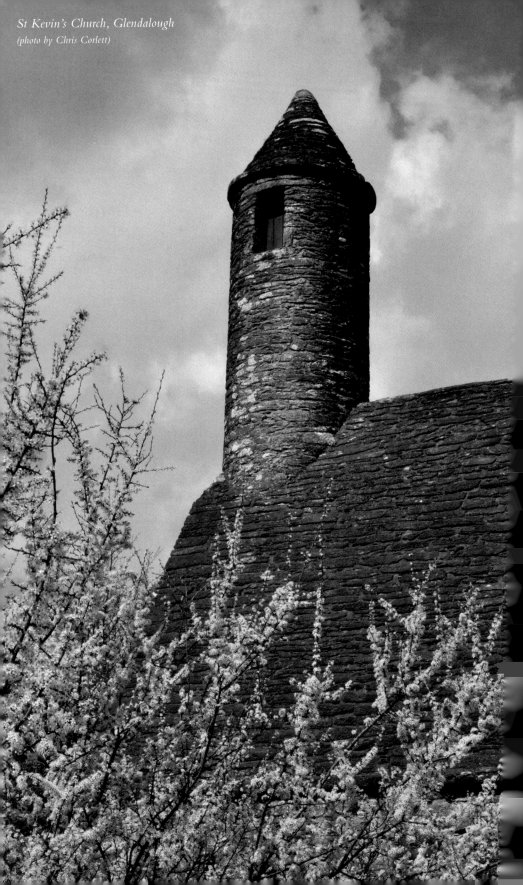
St Kevin's Church, Glendalough
(photo by Chris Corlett)

December

December man looks through the snow
to let 11 brothers know
they're all a little older.
— Dave Goulder, 'The January man'

Straggling December finally arrives with tired and heavy feet. An 11-mile road has now been passed, with only an earthen stone passage up ahead, preparing to welcome the winter light. In years gone by, Yule logs were burnt in the blackened hearth, while on the sill of the kitchen window a solitary candle was placed to guide the wandering traveller home. Soft wax would drip and spread in molten pools over hardened rivulets, each one caked ceremoniously on top of the last, revealing strata of Christmases past. Nowadays, when we speak of Christmas light, we are more accustomed to burnished reindeers' noses or flashing Santa's sleighs as more likely choices of illumination for a house or shop window. But, although the source and, arguably, the significance of Christmas light has changed, our desire to brighten December's darkness still remains unchecked. If we choose to look up at a winter sky at night, the celestial light we see can still remind us of the rekindled rituals that are celebrated at this time of year — rituals that are woven through overlapping strands of myth, custom and belief. When looking up at the light of a star on a Christmas night, we might be reminded of the story of the three wise men searching for the manger in Bethlehem. When observing the sun rising on the shortest day of the year, we may very well ponder another, more ancient narrative. The light of the sun, the moon and even the planets and stars played a central role in the rituals of our ancestors,

who built magnificent stone structures to capture the cyclical light of the heavens.

One such structure in the famous Megalithic monument of Sí an Bhrú, or Newgrange, which is built on the banks of the River Boyne in County Meath. It is a large passage tomb that was built in 3200 BC by a farming community who lived in the Boyne Valley. There are 97 kerbstones carved with decorative rock art encircling the cairn and above the entrance is a window, or roof-box, which is built so precisely that it allows sunlight to shine into the dark 19-metre passage during the winter solstice on 21 December. As long as the morning is clear on that day, the first ray of light seeps into the chamber, revealing the mysterious artwork on the stone-lined passage, before gradually bathing the entire tomb in a golden glow that lasts for about 17 minutes.

'Solstice' is a Latin-derived word meaning 'sun standing still', and this ancient spectacle celebrates the shortest day of the year. But the winter solstice is not the only cosmic event these passage tombs record. Two other equally sized mounds called Knowth and Dowth lie two kilometres east and west of Newgrange. Knowth's passages are the longest passages in Europe, stretching 40 metres east to west. The passages in Knowth were built in alignment

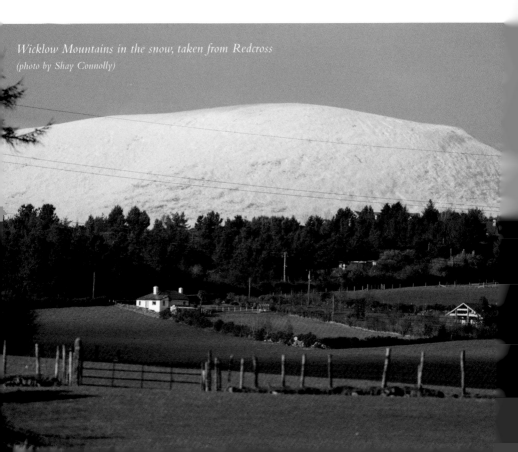

Wicklow Mountains in the snow, taken from Redcross
(photo by Shay Connolly)

with the cycles of the moon, which was an even more complex architectural achievement. In December we open the doors of the Advent calendar to mark each day leading up to Christmas, but these Neolithic builders and watchers of the sky were marking the cycles of the year through wondrous calendars of stone.

An hour's drive west lies the Loughcrew Cairns, which are 800 years older than Newgrange. There are two cairns on this site: Cairn T is accessible to the public, while Cairn L is not. Cairn T is aligned with the spring and autumn equinox, while a limestone standing stone in Cairn L captures the sunrises of Samhain (November) and Imbolc (February). These cairns were once thought to be ancient burial mounds for the dead, but are now generally accepted to have served as astronomical temples or even Neolithic observatories. To be able to build these tombs with such accuracy would have been an incredible feat of engineering at any time, but is especially so when you consider the basic tools the builders would have had at their disposal. What is less known about Newgrange is that the white quartz stone that was used to build the outer wall is not from the Boyne Valley at all, but was actually taken from Seefin Hill, which is located close to Kippure Estate, high up in the north-Wicklow mountains.

If you make the 650-metre climb up the hill, you will come across a much-less-visited passage tomb, which is around 5,000 years old. The stone cairn of Seefin is located on the Kilbride Rifle Range and you should not attempt to visit it when the red flag is flying. Reaching it involves a relatively steep climb, but there is a clear trail by the edge of Kippure Forest that leads you most of the way up, before it turns left and rises over open bog. This is not a suitable walk after prolonged periods of heavy rain but, during dry weather, it is a very special place to visit, offering those who reach the summit a rich reward for their efforts. The stone cairn of Seefin is just one of five Neolithic tombs in this area and, from the top, expansive views over Dublin, Wicklow and Kildare provide the backdrop to what you can see. These passage tombs were possibly burial chambers for kings or chieftains, marking them as very sacred locations where ancient ceremonies and rituals would have once taken place.

It is only when you climb these wild hills that you begin to fully appreciate the enormous effort that went into building the stone structures that dot this landscape. The mind marvels at how these Megalithic people were able to carry quartz from this remote area in the Wicklow Mountains all the way to Newgrange, over 40 kilometres away. The entrance to the Seefin passage tomb is still visible and it is possible (at a squeeze) to walk through the

passage and see the chambers where the remains and offerings were placed. You can also peer into the chamber from above, where part of the roof has collapsed in. If you choose to continue to walk another half hour up to the next hill, you will arrive at the unexcavated cairn of Seefingan, which is visible from Seefin Hill. This is a setting where our history, mythology and literature are entwined through etymology. Seefin translates in Irish as the seat (*suí*) of Finn, or Fionn mac Cumhaill, the Irish mythological hero who was reawoken from his slumber by James Joyce in his final novel, *Finnegans wake*.

Across the mountains, in west Wicklow, sits another megalithic site on Baltinglass Hill, and at 382 metres it is a bit more accessible than the passage tombs of Seefin and Seefingan. Here you will find three passage tombs and two single-chambered tombs surrounded by an iron-age stone ringfort. The passage tombs here are heavily ruined, but a ceremonial bowl is still intact and the bones of three adults and a child were discovered here when it was excavated in the 1930s. Cremations would have also taken place on these ancient sites. The ashes would have been placed in the darkness of the passages, waiting to be touched by the rising solar or lunar light.

The true meaning of these magnificent stone structures is still clouded in mystery, but it is clear that the people who built them were master builders, engineers, stone-carvers and astronomers. The circular structures and spiral art suggest a belief in a cyclical connectedness between light and darkness, life and death. Through the construction of these giant stone timekeepers, this ancient people had the ability to understand the connection between the nature of the land below and the great cycles of the heavens above. They also left a record of their own existence that we are still trying to unravel.

This desire to observe the rising light on a December morning reminds me of an old, friendly priest who would occasionally visit our primary school. One day as our *múinteoir* took the roll call and we each replied with '*Anseo!*' ('Here!') when our names were called, he remarked how he, too, would get up each morning to watch the sunrise over the Dublin Hills, whispering '*Anseo*' as the new day began. Just like the Neolithic builders had done before him, this old priest was not simply bearing witness to the majestic wonder of our great cosmos, but was also humbly acknowledging that he was part of something much greater than himself. When we observe the sun rising as a new day breaks, we become the conscious universe looking back on itself, marvelling at its own creation. It was a great lesson to a class of seven-year-old children and it is a philosophy that remains with me to this day.

I always try to return to Kilmacurragh Gardens in December, as there is a part of the gardens where the light of the winter solstice was also once observed — not through a passage of standing stones, but through a tunnel of trees. After the purchase of this neglected land by the Botanic Gardens in 1996, the gardeners meticulously cleared away all the briars, rogue sycamore and cherry laurel to reveal once again the secrets of this land's ancient past. There is no exact date for the abbey of Saint Mochorog but, according to the head gardener of Kilmacurragh, Seamus O'Brien, it was built several centuries after the seventh-century monastic settlement. The abbey lasted as a hermitage until Henry VIII dissolved all monastic settlements in the early sixteenth century. The old abbey was on the site where the house sits today, but the remains of some of the abbey's outbuildings are to be found

Light filtering through the yew trees, Monk's Walk, Kilmacurragh (photo by Seán Ó Súilleabháin)

in beneath the Chinese Garden. The outer wall of the monks' orchard is also still standing and it is here, in a place known as the Monk's Walk, where one of the most impressive features of the garden can be seen. Connecting yew trees create an arboreal pathway at the bottom of the grounds, which was interrupted when the eighteenth-century pond was constructed. Although the yews were planted in the last few hundred years, it is believed that this ancient route connected the abbey to the famous monastic settlement of Glendalough, further south, and it is on this road that the monks would have travelled to reach the early medieval monastery. But what is really remarkable about this road is that it faces the exact direction in which the winter-solstice sun would appear as night turned to dawn on 21 December. It suggests that this, too, is a Christian version of the Neolithic passage tombs and would have been of great spiritual significance at this time of year.

The yew tree had an ancient tradition of spiritual importance for our pagan ancestors, who saw it as a symbol of everlasting life, possibly because of its evergreen leaves and longevity. Druids associated the tree with spirits of the otherworld, and it would have played a major role in the pagan spiritual rituals of the time. It is not surprising, then, that the yew tree was later adopted as a Christian symbol of eternal life, representing Christ's transcendence of death. Anywhere an abbey or old graveyard is standing in Ireland, yew trees can usually be found, with one of the most impressive specimens growing in the cloisters of Muckross Abbey in Killarney. Since the Franciscan monks chose to build the abbey around the tree in 1448, it shows that this yew tree would have been of a great size and age even then. In all probability it is at least a thousand years old. But even this is not spectacularly old compared to some yew trees around the world. One of the oldest specimens dated is a 60-foot-wide yew tree standing in a Welsh graveyard that is believed to be over 5,000 years old, taking root 3,000 years before Christ was born and around the same time the Neolithic passage tombs were being constructed. Unfortunately, we do not have yew trees of that age in Ireland, as they were systematically cut down in the last few hundred years because their foliage was poisonous to cattle and livestock.

Another place where the splendour of old trees can be appreciated is the sixth-century monastic site of Glendalough, nestled in the valley of Wicklow National Park, which is one of the most popular places among visitors in County Wicklow. The patron saint of Glendalough is Saint Kevin, whose feast day falls on 3 June. This coincides with a large number of visitors arriving in early summer to walk around the famous lakes and the surrounding mountain

trails, or to explore the ancient chapels, tombs and the iconic round tower within the monastic site. Although it is always pleasing to see people enjoying the beauty of one of our most prized jewels, sometimes the large crowds drown out the one thing that makes this place so special come winter — the still and peaceful silence. And it is not only multitudes of tourists that invade Glendalough on a hot summer's day. The heat awakens the midges, whose eggs begin to hatch in May and which, by the height of the summer, can destroy a relaxing walk by the lake with their consistent swarming and indiscriminate biting. In Act 4 Scene 3 of *Hamlet*, the young prince appals Claudius by stating that a maggot has no respect for rank or station, and will feed happily on either, or both:

> Your fat king and your lean beggar is but variable service — two
> dishes, but to one table.

When the Obamas visited Ireland on their European tour in 2011, Michelle and her girls were brought to see the natural and historical splendours of Glendalough. But the news reports that evening showed Malia and Sasha looking absolutely miserable as they repeatedly swatted away the persecuting flies.

During the calm of the winter months, however, the solitude of the valley captures the sounds of what must have attracted the monks here in the first place. I love bringing visitors here when the trees are stark and bare and the only sound to be heard is the swirling of the wind sweeping down the steep slopes of the valley, displacing the dark water of the lakes. It is during these winter months that I feel closest to the Glendalough that Saint Kevin would have recognised when he first walked here in the sixth and seventh centuries. In the coldness of a December afternoon, just before the sun dips behind Turlough Hill, I think of these hardy religious men, sitting in their cold stone cells, meticulously recording by candlelight the genealogies, myths and miracles of dead saints. Peering in though the small slit windows, I see arched backs bent over quill on vellum, creating those sacred spiralling scriptures through word and art. One such manuscript is *Lebar Glinne Dá Locha* (*The Book of Glendalough*), which was written here in the twelfth century and is now held in the Bodleian Library in Oxford.

The landscape of this place may not have changed much since Saint Kevin's Day, but the monastic village itself is only a shell of what once stood here when it was the centre of one of the most important early medieval monastic

sites in Europe. How did these proud men of prayer and craft react when the violence of the Viking raids decimated this tranquil oasis in the ninth and tenth centuries? Or later still, in the fourteenth century, when the English troops destroyed what was left of this once-great ecclesiastic settlement? We have to use the power of our imagination to attempt any recreation of what it would once have looked like before the barbaric onslaught devastated the busy university campus, where religious scholars lived, prayed and worked. Some of the iconic buildings, like the round tower and the cathedral, had to be refurbished over the centuries, and buildings like Saint Kevin's Chapel had to be rebuilt entirely from their original stone. The gateway that leads us into the monastic settlement from the Glendalough Hotel is the most original part of the site, which would once have been roofed with timber, but the original cobbles and inner walls are still visible. When we walk along this path, the heavy echo of history is all around. It is through this entrance that the fictional character Yearling and his poet friend Mathews enter in James Plunkett's book *Strumpet city*, which is set in Dublin during the 1913 Lockout. In one of the rare scenes that takes place away from the streets of Dublin, the rich Protestant Yearling drives out of the troubled city in search of the serenity of Glendalough, on what he describes as 'a little pilgrimage to honour the past'. When he reaches the Lower Lake, he looks back at the round tower that points towards the sky, like a 'finger of stone' rising above ancient bones, and meditates on the fading memory of his father, with whom he visited here 40 years previously. Just as Christmas evokes memories of childhood and tradition, place too can ignite the early personal memories that remain with us throughout our lives.

When I visited here recently I had a similar experience to Yearling's. I was looking up towards the Spink walk that circles the lakes, and I could see patches of high snow running in thin rivulets through the bracken that merged with the Poulanass Waterfall. The dark mountains looked cold and hospitable and even the deer were beginning to come down from higher ground in search of food. Deep in this severe landscape overlooking the Upper Lake is a small, isolated cave, barely visible from the path, and it is here where Saint Kevin retreated in search of spiritual isolation. A slab of cold stone etched into the cliff face, which is known as Kevin's Bed, is where he prayed and meditated over the harsh winter. As I looked up at this inaccessible cave, nestled high amongst the rocks, an early childhood memory returned to me of another winter visit here when I was five or six years of age. I remember my mother pointing up towards the steep slope and telling me how Saint Kevin would

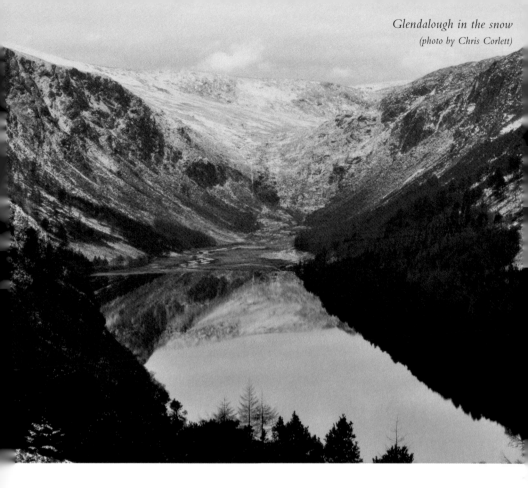

hide up there amongst the mountains and sleep on a large flagstone so as to be closer to God. I looked across the lake in fascination, hoping I might catch a glimpse of this holy man who was living somewhere up there in the valley, and feeling sorry that he had no warm home, nor comfortable pillow to rest his head on a cold winter's night.

My child-self was obviously confusing the present with the past, having no real concept of history or time passing. For me, this holy man was still up there in his cave and his very real presence filled me with wonder and perhaps even a little fear. As we mature, the concept of history is developed in us and we learn to distinguish between past and present; or maybe it would be more accurate to say that we lose the ability to live in the here and now. As we get older, we tend to look back further into the deep-buried memories of our past. Our personal past grows heavy with each passing year, until one day it fills our entire life with who we used to be. But a place like Glendalough also inspires thoughts of a time before we existed, when men and women walked where we are standing now, feeling the same sun warming their faces or hearing the familiar sound of a winter wind stirring deep lake water.

As Yearling stands by the lake and imagines the men who built the round tower stone by stone, he is not simply honouring the past — he is also contemplating his own finite existence. He admires nature's ability to continue ceaselessly, oblivious to time or history, and in silence he contemplates how future feet will walk these paths and fields when he too takes his dwelling place under 'monument and nettle'.

For those who wish to escape from the crowds of Christmas shopping, a walk among the serenity of the Glendalough lakes in December is an alternative way to ease into the festive holiday. On a cold but dry morning, I decide to do just that. Setting off from the Upper Lake car park, I take the path leading towards the miner's village. Around the water's edge the lake is frozen, with leaves and twigs trapped under a cold, opaque glass, but further out, the flowing water causes the breaking ice to creak, shift and reshape in the warming sunlight. The old, cracked voice of the lake is the faint reverb of an age before modern man walked these paths, when ice echoed and groaned in isolated splendour. The sound of the ice moving by the lake is like a microcosm of what took place here over 20,000 years ago, when a glacier slowly carved out this valley. During the last ice age, moving ice slowly compressed under its own weight, extending its way inch by inch over the mountainous landscape like a cold, blue blade. Henry David Thoreau describes nature as the ultimate sculpturer, who uses 'the gentle touches of air and water working at their leisure with a liberal allowance of time'.

Evidence of this master stonemason lies all around this timeless place. As the glacier crept over the granite rock, it carved, sculpted and reshaped the surrounding landscape, leaving an empty space where land once stood. Compared to our own short lives, we can sometimes be misled into thinking that the familiar landscape is steadfast, unmoveable. But we simply have to pick up a soft, round stone from the riverbed to see the real effects of time on a much grander scale. The lakes themselves are remnants of nature's constant construction and deconstruction through movement, pressure and time. When the planet warmed again and the glacier finally retreated, it left behind these two dark pools that peer out from the battlefield, like a slain giant's eyes.

But where nature sculpts slowly and methodically over millennia, man also shapes the landscape — more often than not, through brutal and destructive means. Near the top of the lake lie the dilapidated ruins of what was once a mining village, the site where Thomas Weaver first surveyed these mountains for gold. Instead he found rich veins of lead and zinc in the granite mountainside, so in 1809 the Glendalough Mining Company was set up to

extract this useful metal for export, sparking an irrevocable change in the surrounding landscape. Throughout the century, the mines in Glendalough created employment in the local community and, as the work increased, the population in the area inevitably multiplied. Cottages for the miners' families were built and a school was even established in the village. Once the ore was extracted, it was transported to Rathdrum Station by horse and cart; from there it was sent to Shankill Station by rail and then to the Ballycorus facility near Kilternan in County Dublin, where the ore was smelted. A two-kilometre flue ran up the side of the valley, where the lead was scraped from the tunnel's walls, and a large chimney was built on the top of Carrickgollogan Hill, where the toxic fumes were finally released above Dublin Bay. The job of scraping the lead from the tunnels was highly dangerous and toxic work, and the valley was locally referred to as Death Valley because of the number of men who died from lead poisoning. The price of lead was constantly fluctuating, however, and by the end of the nineteenth century the Mining Company of Ireland ran into financial difficulties and was forced to close down. The Wynne family bought the mines in 1890 and, owing to the demand for lead during the First World War, it revived the Glendalough mines. But once the war came to an end, the British government withdrew their grant aid and the work dried up with it. In 1948 J.B. Wynne set up Saint Kevin's Lead and Zinc Mines, whose two main pits were the Fox Rock and the Moll Doyle, which remained in operation for just under a decade. But in 1957, when a controlled explosion went wrong and a miner was tragically killed, the old mines were finally closed for the very last time.

Today you can still visit the lead chimney at Carrickgollogan Hill. From the peak you can see wonderful panoramic views of Dublin Bay and north Wicklow. The chimney itself is a very impressive structure, too, and even though it is not as tall as it once was it still looms high above the surrounding gorse. Spiralling stone steps wind around the walls of the chimney, but many of the steps are either cracked or missing, so it is not advisable to venture too far up. From the chimney you can follow the flue back down the valley and even walk inside the tunnel, where men once spent their days scraping the lead from the blackened, poisoned walls.

Up in the Glendalough Valley, all that is left of the mine are the empty quarries with the abandoned equipment and machinery, standing as scattered remnants in this once-industrious setting. An old, rusted cartwheel that transported the debris out of the tunnels, or a weathered water-pump once used to dredge the pit, are now all that remain. The Poulanass Waterfall

weaves its way over sharp, upturned rocks, while littered about the hills are numerous slag heaps, shining like alabaster in the low winter sun. Unlike the monastery site below, the mining village is lost and forgotten here in the upper valley, with only the hill-walker or intrepid tourist wandering up this far to walk amongst its ruins. It is no wonder that the miners nicknamed this area Van Diemen's Land because of its remoteness from civilisation. The quarry is the much younger but much uglier sister of the glen. In its own unique way it has a charm all of its own. Some might argue that it has left a gaudy scar on the landscape but, if it has, that scar is a reminder of the harsher times in our recent history, when young men put their lives at risk to extract the valuable metals embedded in the surrounding mountains as a means of providing for their families.

The mountain is now no longer mined for its lead deposits. Instead, the cliff faces of the granite and the mica schist are left to the deer, the wild goats and the peregrine falcons, who use the crevices in the high boulders as nesting sites. The landscape also attracts rock-climbers from all around the country, who challenge themselves with the most difficult and nerve-jangling ascents. It is strange to think of the unimaginably long process whereby the landscape that we see today was created. Over 400 million years ago, before rock-climbers, miners, medieval monks and even glaciers, the Glenealo Valley was created when molten rock forced its way through a bedrock of sandstone and mudstone, creating two land-masses that collided. This formed the crystalline minerals in which the prospectors first found lead. Everywhere you look in this valley, you are looking back through the sands of time.

Another benefit of the arrival of the long December nights is the opportunity to observe the cosmic array of starlight that appears as soon as night falls. In the summer, you have to stay up until after midnight to catch a glimpse of something unusual in the night sky, but for the winter sky such late nights are not necessary. Glendalough is especially good for stargazing owing to its location, remote from any large towns that might strangle natural starlight in a haze of light pollution. If you visit Glendalough on a clear night, the first thing you notice is the remarkable vista of stars that appear, stretching out across the heavens. In fact, when you observe the stars in Glendalough, you are twice blessed, as the constant stars are in fact doubled. From above, they shine out across the blackness of the night and, from below, their reflections twinkle on the surface of the glacial lakes. When I was visiting Machu Picchu in Peru a few years ago, the tour guide showed us a large stone basin in the centre of the lost city, which the Incas

used to fill with water to use as a mirror to observe their deities in the passing constellations. But in Glendalough nature has carved out its own mirror in the form of the lakes, allowing us to look up and back at our very own creators. If we want to read the story of our past, we look to the fossilised clues in the heart of the rocks scattered around our feet. But what if we want to go further back in time — way back to before our earth even existed? Then, of course, we must look to the stars.

A few years ago it was reported that something very special was going to be visible during the month of December. It was believed that a new object was going to appear in our night sky for the last month of the year and it was reported that, if it survived its solar orbit, it could shine brighter than Venus in the early morning sky. It was, of course, a rare opportunity to observe with the naked eye the comet that had been travelling for over a million years from its origins in the Oort Cloud, way, way out on the very edge of our solar system. Since its discovery in September 2012, astronomers and scientists had been talking about this Comet ISON. If it had survived, it would have created an amazing arch of light in its passage across our night sky, but unfortunately this was not to be. On 28 November, the icy comet burnt up at perihelion (its closest proximity to the sun) and our hope of seeing it survive and remerge on the other side evaporated.

Losing an opportunity to catch a glimpse of such a rare visitor is unfortunate, especially when we realise that these massive boulders of ice are the DNA of our early solar system. In fact, when we look out at the sea and our lakes and rivers, it is incredible to think that all the water we have on our planet today may be the result of the impacts of comets such as ISON smashing into the primordial earth billions of years ago, when the planet was still in its infancy.

When observing the stars in Glendalough, I cannot help but wonder about those monks who once lived here, and whether they ever looked up to see a comet tail in their night sky. If they did, I wonder what they made of such a sight. It is fascinating to think that these solitary religious men who built the rocket-shaped tower of Glendalough, and who dedicated their lives to meticulous study in pursuit of religious truth, are the ancestors of the men and women who now build similarly shaped objects that allow us to see past our own world in the pursuit of scientific truth. Despite the massive gulf between their lives and ours, there is a solid bridge between the Neolithic builders, the early Christian monks and the astronauts, cosmonauts and scientists of today. All are pioneers of their time, in search of a deeper understanding of our existence.

Whether comets are responsible for our water-covered planet or not, one sure thing is that water is here. As late December approaches, torrential heavy rain is not unusual. Mornings exhale in an icy chill and, by afternoon, stormclouds cast menacing shadows over a misty landscape. Bloated rivers burst their banks and the sea rises once again like a hungry bear awoken from its slumber. Such a day as this is the perfect time to visit the spectacular Powerscourt Waterfall.

Nestled in a valley that has Djouce Mountain on one side and the Great Sugar Loaf on the other, this waterfall stands at an impressive 121 metres high, making it the highest waterfall in Ireland. Like Glendalough, it is one of the most popular destinations in all of Wicklow in the summer months, with families flocking here to enjoy their barbecues and picnics by the foot of the falls. But, if you want to see the waterfall at its most impressive, winter is the optimum season to arrive. The narrow road leading to the falls is lined with bare beech, oak and larch trees, but the giant redwoods still display their finery, standing tall and erect like attentive silver-service waiters. As soon as you enter the gate and before you even park the car you can you hear the waterfall's

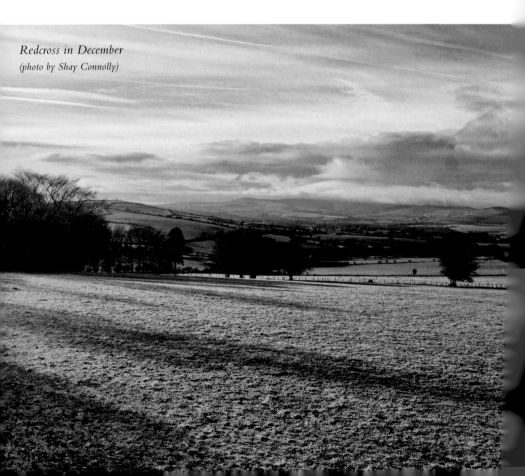

Redcross in December
(photo by Shay Connolly)

bellow from the other side of the hill. At this time of year, any snow that has melted on the peaks of the mountaintops flows into the Dargle River, creating an overspill of violent thunder that echoes throughout the valley. During the dry days of summer, the fall is little more than a faint whimper, seeping out timidly between rock and stone, but when winter's voice roars it spills and thrills in a froth of milky soup. This is the type of waterfall that King George IV is supposed to have approved of when he visited here in 1821. It is reported that the fifth Viscount Powerscourt, Richard Wingfield, had the waterfall blocked and a bridge built, so that when the king came he could admire the full majestic power of the falls from below. Luckily for the king, he never arrived. Having a reputation for quite an indulgent lifestyle, he was probably more interested in the flowing liquor of Powerscourt House than the natural wildness of the waterfall. So, with the king opting to remain indoors, the disappointed viscount had the waterfall undammed. The force of the water was so great that it thundered down on the bridge where the king was supposed to stand, sweeping it away in a violent torrent. On such small chances is history carved.

A few days before the Christmas holidays arrive, I often read Patrick Kavanagh's poem 'A Christmas childhood' to my English class. We discuss how Kavanagh's memories of a Christmas in Monaghan in the early twentieth century differ from their own memories of Christmas morning in Wicklow as children of the twenty-first century. There is general agreement that much has obviously changed since the Ireland of 1910, when Kavanagh was a boy. Instead of making the music of milking in the cow-house by the light of a stable-lamp, milk is now bought in a well-lit supermarket that pipes automated Christmas songs through loudspeakers in the ceiling. And a gift of a penknife to a child of six years of age might prompt a visit from social services, rather than the Lennons or Callans. But what has remained the same? The crunch of feet breaking the 'wafer-ice' of the potholes and the first frost dusting the potato drills? Or Cassiopeia, which may still be seen sitting over 'Cassidy's hanging hill'? Most definitely. We all agree that, even if the details have shifted, the wonder of Christmas remains. As I listen to the choir singing their selection of carols before teachers and students wish each other a happy Christmas, I am reminded of the famous ceasefire on the Western Front in 1914, when the Germans and British soldiers sang 'Silent night' to each other over no-man's land. With the arrival of January and a new term beginning, normal service will resume, but for now, for this brief moment, there is a real sense of happiness as all thoughts turn homeward.

As the year ends, we naturally look back on what has changed in the past 12 months and ponder what is to come. This reflection is fused with life's joys and hardships. Some families celebrate a new arrival, while others face into a Christmas with heart-heavy absence. For such grieving families, this time of year can feel desperately cruel.

The Scottish songwriter Dave Goulder's haunting song 'The January man' captures this sense of time passing, but it also celebrates the rejuvenation of the year beginning over. Goulder lives in the Highlands, where he is, amongst other things, a dry-stone-wall builder. I cannot help but think that the rhythmic act of piling stone upon stone is as good a way as any to mirror nature's eternal wall-building, stacking month upon year across the landscape of time.

> The January man is here
> for starting each and every year
> Along the way forever.

Now, as I return to walk the coast along the Murrough, I look out once again on all the familiar sights I love to return to. Down by the shore, the statuesque grey heron still waits perfectly patiently for a shadow in the ripples, while out on the wetlands the grazing geese fatten up for their epic journey across the seas. Up in the high Wicklow streams, the salmon and trout are succumbing to the urge to leave their spawning grounds and make their own journey downriver, winding their way through budding trees engrained with the ring of another passing year.

As I come to the end of my book, I look back on my own year in Wicklow and reflect on the changes that have taken place. Like the wildlife all around us, we also continue on our own great wayward and homeward journeys and, like the January man, I wonder what next year will bring. All I know is that, no matter which way I take, I will always be bound to the wonders of Wicklow. Stopping to reflect on the past year gives us a brief moment of respite in the journey of our lives, before we set off again on yet-untravelled paths. Our lives also mirror the journey of the four seasons coming to an end, only to begin again with the rebirth of spring. What better way to feel part of this great journey than to observe the majestic winter light touching ancient stone? Or to walk through an old passage of yew trees that have stood witness to hundreds of past winters, secure in their mature confidence that spring will always return? Or to look up at an ancient round tower and feel its cold stones, piled one on top of another by forgotten hands? If we do this, we will not

simply be celebrating this winter, or the end of this year; we will be celebrating the cycle of nature and life on a much grander scale. Janus-like, we look both backward and forward. We reach downwards into the roots of our ancient past, but also upwards, towards the buds of our distant future. By bearing witness to these timeless progressions, we are truly taking our place in the unending cycle of life.

Kilmacurragh Gardens
(photo by Seán Ó Súilleabháin)

Appendix I

Suggested itinerary: a five-day tour of east and south Wicklow

Day one
9.00 a.m.	Bray Promenade
9.30 a.m.	Bray–Greystones cliff walk
11.00 a.m.	explore Greystones town (options to eat)
1.00 p.m.	Powerscourt Gardens* (options to eat)
3.00 p.m.	Powerscourt Waterfall*
5.00 p.m.	explore Enniskerry village (options to eat)
7.30 p.m.	live theatre performance in Killruddery Gardens* or live music in the Harbour Bar, Bray

Day two
9.30 a.m.	Glendalough Monastery and Lakes (optional 3-hour Spink walk)
1.30 p.m.	lunch in Roundwood followed by walk by Vartry Reservoir
3.30 p.m.	Victor's Way Indian Sculpture Park
4.30 p.m.	drive to Sally Gap (views of Lough Dan and Lough Tay)
6.30 p.m.	Castle Inn, Newcastle (options to eat)
8.30 p.m.	evening stroll to the fen in BirdWatch Ireland's East Coast Nature Reserve, Newcastle

Day three
9.00 a.m.	Devil's Glen Waterfall walk
11.30 a.m.	Mount Usher Gardens* (options to eat)
2.00 p.m.	Brittas Bay and/or Magheramore Beach
5.00 p.m.	Wicklow Brewery tour, Redcross,* followed by dinner in Wicklow Brewery Bistro restaurant

Day four

9.00 a.m.	Clara Vale looped walks
11.30 a.m.	Avondale House and Gardens
1.00 p.m.	Meeting of the Waters: Avoca
1.30 p.m.	lunch and walk in Avoca village
3.00 p.m.	1–2 hour coastal sightseeing tour from Wicklow Harbour*
5.00 p.m.	explore Wicklow town; Wicklow Gaol tour* and dinner in Jailer's Rest restaurant

Day five

9.00 a.m.	Kilmacurragh Gardens
12.00 p.m.	explore Aughrim village (options to eat)
2.00 p.m.	Tomnafinnoge Wood looped walks
5.00 p.m.	evening stroll to the Breaches, Kilcoole
6.30 p.m.	dinner in Greystones town

** fee required*

The Sally Gap (photo by Shay Connolly)

Appendix II

Suggested itinerary: a family day out using public transport (Bray, Greystones and Kilcoole)

10.00 a.m. **National Sea Life, Bray**
Tickets: adult: €12; child: €9
Opening hours: 10 a.m.–6 p.m. daily with last admission one hour prior to closing
Telephone: +353 (0)1 2866939
Website: www.visitsealife.com

11.30 a.m. **Bray–Greystones cliff walk**
Time: approximately 90 minutes; up to two hours with younger children (option to return to Bray by DART from Greystones Train Station)
Distance: approximately 7 kilometres
Terrain: well-maintained path with occasional steps and slopes, but not suitable for buggies

Alternatively, it is possible to get the DART from Bray to Greystones.

1.00 p.m. **Greystones town and beach**
Options for eating include La Crêperie Pierre Grise, the Beach House, the Happy Pear and the Baker's Table.

2.30 p.m. **Glenroe Farm, Kilcoole**

Arriving from Greystones, take a left at Lott Lane before entering Kilcoole village and follow the signposts for Glenroe Farm.

Tickets: adult: €7; child: €7; child under two: free; family (two adults and two children): €25

Opening hours: March and April (weekends only): 10 a.m.–5 p.m; May–August: daily 10 a.m.–5 p.m; September and October (weekends only): 10 a.m.–5 p.m; November–February: closed

Telephone: +353 (0)1 2872288

Website: www.glenroefarm.com

or

Killruddery House and Gardens, Southern Cross, Bray

Tickets: adult: €7.50 (€16 for guided house tour and garden admission); child under 12: €2; child under 4: free

Opening hours: April (weekends only): 9.30 a.m.–6 p.m.; May–September: daily 9.30 a.m.–6 p.m.; October (weekends only): 9.30 a.m.–6 p.m.; November–March: closed

Telephone: +353 (0)1 2863405

Website: www.killruddery.com

Public transport

Regular DART services run from Dublin city to Bray and Greystones.

The 84A bus runs from outside Greystones Train Station to Glenroe Farm in Kilcoole.

The 184 bus runs to Killruddery House and Gardens from outside Bray Train Station (alight at Southern Cross)

See www.dublinbus.ie and www.irishrail.ie for timetables.

Note

The information listed here regarding opening hours and fees is correct at the time of publication, but may be subject to change. Please check details in advance of your visit.

Appendix III

Selected walks and places of interest

COASTAL WALKS

Bray to Greystones cliff walk

Follow the seafront promenade that leads up to the start of the Bray Head walk. Remain on the lower path that winds its way around the cliff face. This path brings you all the way to Greystones Harbour and town. You can return to Bray by DART from Greystones Train Station. The distance is 7 kilometres and the walk is a level footpath with occasional step and rises.

Approximate time: 1.5 hours (one way)

Grade: Easy

Bray Head

From Bray seafront, follow the promenade to the start of the Bray Head Walk. At the car park, arrows indicate the trail that leads to the Bray Head Cross. The climb is steep and can be difficult underfoot after heavy rain, so good footwear and a reasonable level of fitness is recommended. After reaching the cross, descend by the same trail.

Approximate time: 1 hour

Grade: Moderate

Cliff walk and Bray Head

Beginning at the Beach House opposite Greystones Harbour, follow the path northwards towards the marina. Keep left and continue along this path, passing the newly built houses to your left. The path cuts across a field, before it rises up towards Bray Head, with stunning views of the sea to your right.

Railway line from the Bray–Greystones cliff walk
(photo by Seán Ó Súilleabháin)

Once you reach Bray, do not descend to the seafront, but turn left and follow the trail that leads to the top of Bray Head. This is a steep incline of 200 metres and it will take approximately 30 minutes to reach the cross. From the top you will have views of Dublin Bay to the north, the Wicklow coast to the south and the Wicklow Mountains to the west. From here, follow the southern track that winds its way above the cliff walk and railway line, before descending the western side of Bray Head. You will arrive at Lower Windgates Road. Take a left here and follow the R761 Bray to Greystones Road. Turn left again and remain on the footpath, which will bring you back into Greystones. Good footwear and a reasonable level of fitness is required for this walk.

Approximate time: 3–3.5 hours
Grade: Moderate

The Murrough: from Greystones to Wicklow town

This is a 15 kilometre-linear coastal walk that begins at Greystones's south beach and runs parallel with the rail line, passing Kilcoole, the Breaches, Newcastle Aerodrome, BirdWatch Ireland's East Coast Nature Reserve, Five Mile Point, Killoughter and Broad Lough Estuary before arriving at Wicklow town. Crossing the Vartry River at Bridge Street will lead you into Wicklow town. Rail and bus services are available from there back to Bray and Greystones.

Approximate time: 3–3.5 hours (one way)
Grade: Easy

The Secret Fen: BirdWatch Ireland's East Coast Nature Reserve, Blackditch Woods, Newcastle

Once you arrive in Newcastle, take the Sea Road (opposite the Castle Inn), heading towards the coast. Past the Newcastle Aerodrome you will see the gate of the East Coast Nature Reserve on the right, where there is room for a few cars to park. After passing through the gate and crossing over a wooden bridge, follow the gravel path down towards the sea. Where the path verges onto a grassy trail, you may detour to the right and visit the wooden birdwatching hides that overlook the wetlands, with the fen visible to the south. Once back on the grassy trail, continue seaward. The trail runs around the outside of a field, with the rail line on the left, before veering right and entering the fen by a wooden boardwalk. Follow a bramble-lined grassy path for 200 metres before taking a right onto another wooden boardwalk, which will bring you into the heart of the fen. A third wooden birdwatching hide is at the end of the boardwalk, looking north. Return along the boardwalk, turn right and follow the trail through the fen, before turning left around the perimeter of a private field. Passing through a wooden gate, follow the walk to the left and head back down to the coast. At the Five Mile Point rail crossing, turn left and walk back along the beach before turning left again at the Newcastle rail crossing. Follow the road back to the gate of the nature reserve, where you began.

Approximate time: 1.5 hours
Grade: Easy

Kilcoole: the Breaches and the Strawberry Path

Entering Kilcoole village from Greystones, take a right down Sea Road and park at Kilcoole Station car park. Cross over the railway line and turn right down the coast. Follow the grassy trail for about a kilometre until you reach the Breaches. From May until the end of July you will see the colony of little terns nesting on the beach. Return the same way. To extend your walk, take a left turn at the top of the car park and continue down the path until you see a small clearing among the trees with a wooden plank crossing a stream. This is a small wooden trail known locally as the Strawberry Path, which cuts across farmland. It is especially enjoyable on a summer or autumn evening. Return to the car park the same way.

Approximate time: 1 hour (allow an extra 40 minutes for the Strawberry Path)
Grade: Easy

Broad Lough and coastal walk to Killoughter

Driving south towards Wicklow town, take the Industrial Road on your left before entering Wicklow town. Follow the road to the end of the industrial estate. Park there and walk north until you reach scrubland, then turn left, which leads you down to the lough. If you cross the railway line and turn right, it leads you onto the coastal walk. After 3 kilometres you will reach the old railway station of Killoughter. Return the same way.

Approximate time: 2–2.5 hours

Grade: Easy

Wicklow Head

Wicklow Head used to be accessed by cliffs around Bride's Head, just beyond Wicklow Golf Club, north of Wicklow town, but this walk is now closed because of coastal erosion and, at the time of publication, it is not accessible. To reach Wicklow Head and the Octagonal Lighthouse, park in the car park just beyond the Wicklow Golf Club car park and walk along the path, before taking a left towards the coast. This small coastal road winds its way down to the lighthouse, with stunning views from Wicklow Head. Return the same way.

Approximate time: 1 hour

Grade: Easy

BEACHES

Silver Strand Caravan Park
This beach is located 3 kilometres south of Wicklow town, off the R750 Wicklow coast road. Payment is necessary to access the private beach and caves for day visitors. www.silverstrandcaravanpark.ie

Magheramore Beach
Magheramore is located 6 kilometres from Wicklow town on the Wicklow coast road (R750). Public access to this beach is through a large gate on your left and down a small farm path, about a ten-minute walk. There is no public access to the larger Magherabeg Beach, which is beyond the cliff promontory to the south.

Brittas Bay
This 4-kilometre beach is situated on the R750, about 15 minutes' drive south from Wicklow town. If travelling on the M11, take junction 19, signposted 'Brittas Bay'. Follow the road until you reach the T-junction. Take a left; the car park is immediately on your right. There is an alternative car park further up on the right.

MOUNTAIN AND LAKE WALKS

Seefin and Seefingan Neolithic tombs
From Dublin, take the N81 in the direction of Blessington, then take a left onto the R759 in the direction of Manor Kilbride. Take another left before you enter the village of Manor Kilbride and follow the R759 as far as Kippure Estate. Take the small back-road on your left, with Kippure Estate just beyond on the right. If arriving from Wicklow, take the Sally Gap road. The slip road will be on your right, just beyond Kippure Estate on your left. Follow this road until you reach the edge of Kippure Forest on your right, where you will see signs for Kippure Rifle Range. Park in the lay-by or further down the road.
Begin your walk by following the worn track that runs along the edge of the Kippure Rifle Range. Keeping the forest on your right, continue to climb for about half an hour, until you see a fence where the trail turns left out of the trees and up across the mountain bog. As the trail rises, expansive views of Dublin and Wicklow can be admired from either side. Eventually, the Neolithic tomb of Seefin will appear on top of the hill. Rest and explore

the site. The cairn on Seefingan Hill will be visible to the north-east and can be reached by crossing the col. If the ground is boggy, it is best to walk around the edge of the col. From here you may continue on over Corrig Mountain and Seahan to the north and descend by Seahan Forest, before arriving at a tarmac road. Take a left and follow the road down, back to your car. Alternatively, you can turn back at Seefingan Hill and descend along the Kippure Forest trail.

Approximate time: Seefin and Seefingan Neolithic tombs: 2.5 hours; entire looped Seefingan walk: 4 hours

Grade: Difficult

Spink

Arriving at Glendalough, park at the Lower Lake car park and explore the monastic site. From there, cross the wooden bridge and turn right towards the Upper Lake. Once you reach the information centre, take the path on your left that leads up the hillside, signposted 'Pollanass Waterfall'. Follow the path up along the waterfall. Beyond, you will arrive at a sign to the right indicating the Spink walk. Leave the path at this point and begin the climb up the steep wooden steps, through the trees. Eventually you will emerge from the trees and a spectacular view of the Upper Lake will be to your right. Continue along the trail, crossing wooden sleepers over the mountain bog, with stunning views of the Glendalough Valley below. You will cross a wooden footbridge before turning right and descending into the valley once more, with the Glenealo River tumbling to your right. Once you arrive at the bottom, cross the deserted mining village and follow the path around the Upper Lake, by which you will return to the upper and lower car parks.

Approximate time: 3.5–4 hours

Grade: Moderate

Djouce

Just north of Roundwood village, take the R759, signposted 'Sally Gap'. Continue straight up this road, passing a small junction. Continue straight on, passing the Luggala gate entrance on your left and a small parking area on your right. Further up on your right you will see a car park, where you begin the walk. On the other side of the barrier, the path passes some forest, before turning left at the clearing and leading up towards the summit. This boardwalk trail is part of the Wicklow Way and, as you rise, you see wonderful views of Lough Tay and Luggala to your left, with Lough Dan emerging in the

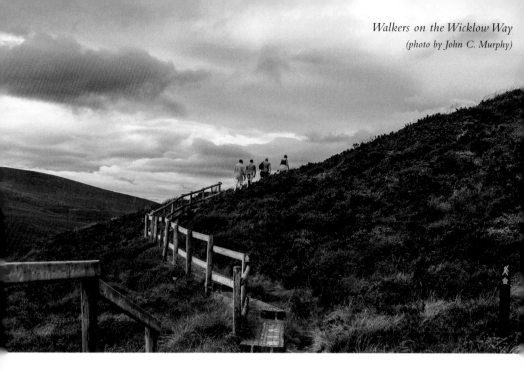

south-west and the coast becoming visible to the east. Along the trail you will also pass the J.B. Malone memorial plaque, dedicated to the founder of the Wicklow Way. Continue up the boardwalk over White Hill and the boardwalk will eventually veer right and the trail veer left. Leave the boardwalk and make your way up to the summit of Djouce, standing at 725 metres high, with panoramic views of the county and beyond. Descend the same way.

Approximate time: 3.5 hours

Grade: Moderate

Lough Tay to Lough Dan

Just north of Roundwood village, take the R759, signposted 'Sally Gap'. Continue straight up this road, passing a small junction. Once you reach the top of the hill, you will see black gates to your left and a small parking area on the right. Begin the walk here. Passing through the side gate, follow the tarmacadam path that leads down into Luggala Valley, with views of Lough Tay and Luggala Mountain straight in front. Once in the valley, cross a wooden bridge with the Cloghoge Brook running underneath, then traverse a wooden walking stile before arriving at a clearing where the Luggala sika deer may be seen on the left. Follow the grassy trail and you will eventually arrive at Lough Dan, with Ballinrush Estate to your left. Rest here, before returning the same way.

Approximate time: 2.5 hours

Grade: Moderate

Luggala

Follow the same directions as the Lough Tay to Lough Dan walk, but before you reach the bridge you will see a clear trail running up the side of the mountain to your right. Follow this trail up through the ferns, with Lough Tay on your right. Once you reach the top, remain on the worn trail that brings you right above Lough Tay. Looking east, you will have spectacular views of the valley, Vartry Reservoir and the coast in the distance. To your left, the Wicklow Way trail can be seen leading up towards Djouce. On a clear day you will see the coast of Wales and some of the peaks of Snowdonia National Park. Do not wander too close to the edge, however, as the cliff face can appear unexpectedly, especially in bad weather. Continuing north, you will have views of Luggala Lodge and the private beach, where film and television production sets can often be seen. From here, you can return back the way you came, or continue down the other side of the mountain, bringing you out onto the Sally Gap road. Turn right and walk back towards the gates.

Approximate time: 3.5–4 hours
Grade: Difficult

Lough Dan, famine village and Kanturk summit

Entering Roundwood village, look for the signpost for Lough Dan directly opposite the Coach Inn. Follow this road around, keeping right until you reach a T-junction. Take a left and then the next right, passing the Scout Den on your right-hand side. Further up on your right you will see a small lay-by where you can park. Commencing your walk here, continue straight up the hill and along the small road, with the southern half of Lough Dan emerging below on your right. Crossing a bridge, turn left and continue up the road for about 50 metres, before turning right at a wooden gate with a walking trail clearly marking the route to Kanturk. Continuing up the grassy trail, you will find yourself standing directly above Lough Dan, with some lovely views of the surrounding mountainous landscape. Following the trail around the bend, the northern half of Lough Dan comes into view, with Luggala Estate and Valley to the north-east. Once you pass through a small wooden gate, you arrive at a gravel track. Here you can choose to follow the track down to the old famine village, about 3 kilometres north, with views of Lough Dan and its beach and the Inchavore River meandering by on your right as you descend down into the valley. Alternatively, if you wish to reach Kanturk, cross over the gravel track and climb up the wooden steps and over a wooden stile and up a

heather-flanked trail that leads all the way to the summit of Kanturk, standing at 523 metres, with views of Scarr Mountain to the south and the Wicklow coast to the east. Descend the same way.

Approximate time: 2.5 hours (Lough Dan and famine village); 3–3.5 hours (Lough Dan and Kanturk)
Grade: Moderate

Lower Vartry Reservoir

Parking in a small car park outside the Vartry Water Treatment Plant, south of Roundwood village, cross over a stone wall on your left, which will bring you onto a grassy trail that leads around the Lower Reservoir. Once you reach the bridge, you have the option of either crossing the road and continuing up through a wooden trail that leads up to the Upper Reservoir, or turning right and crossing the bridge, before passing through a gap in a stone wall on your right, which will bring you back around the eastern side of the Lower Reservoir. You will eventually return onto a small road, where you can continue straight on for about a kilometre and a half, with the reservoir visible to your right. At the crossroads, take a right again and cross over the southern bridge, with the reservoir on your right and the water-treatment plant to your left, before arriving back at the small car park.

Approximate time: 2.5 hours (allow another 40 minutes for the Upper Reservoir)
Grade: Easy

WOODLAND WALKS

Vale of Clara

The Vale of Clara is on the R755, halfway between Laragh and Rathdrum. Take a minor road signposted 'Clara Vale Church', which leads you down a hill and across a stone bridge. Continue up the hill on the other side, passing the church on your left, until you see a small parking area on your right, signposted 'Vale of Clara Nature Reserve'. There are three colour-coded looped walks to choose from. The blue route is 9.5 kilometres long, the green route is 5.6 kilometres long and the red route is 2 kilometres long. All routes are clearly signposted and easy to follow, taking you back to the car park.

Approximate time: 2.5 hours (blue route); 1.5 hours (green route); 40 minutes (red route)
Grade: Easy

Woodland walk, Tomnafinnoge (photo by Seán Ó Súilleabháin)

Tomnafinnoge, Tinahely

If arriving from west Wicklow, take the R749 between Shillelagh and Tinahely. About halfway down this road, take the only right turn onto a minor road. Follow the road and, just before you come to the stone bridge, turn right into the Tomnafinnoge car park. If arriving from east Wicklow, take the R748 towards Tinahely. Do not enter Tinahely village, but take the immediate left just after Lugduff Service Station. The Railway Walk that connects to the Tomnafinnoge looped walk will be on your left if you wish to begin there. Alternatively, you can continue driving for about two kilometres until you arrive at the first right. Follow this small road, which crosses over a stone bridge. The Tomnafinnoge car park will be on your left, immediately after the bridge. This is the starting point for a group of colour-coded walks. The distance for each walk is indicated. The River Walk is 2 kilometres long, but

you must return by the same path. The Oak Walk is 3.2 kilometres long and the Hazel Walk is 1.3 kilometres long. Both are looped walks.
Approximate time: 1–1.5 hours
Grade: Easy

Devil's Glen Waterfall

In Ashford village, take the turn onto the R764, then onto the R763. Follow the road as it rises up into the hills for about 4 kilometres. After a steep incline, you will see a sharp turn on your right that leads you into Devil's Glen. Follow this small road through the forest. You will eventually arrive at the car park. Note that the closing time for the car park is 5 p.m. The walk begins at the corner of the car park, which leads you into a woodland pathway. You will soon arrive at a place from where you can follow the trail towards the Vartry River through the coniferous woods, before turning left and walking along its bank until you reach the waterfall. Alternatively, remain on the path that runs diagonally along the river from above. If you do stay on the top trail, keep right when the path splits before it descends towards the waterfall. Return by the steep path and keep left at the junction, following the path all the way back to the car park.
Approximate time: 1.5 hours
Grade: Easy

PLACES TO VISIT IN WICKLOW

Avoca Handweavers and Mill
Avoca village
County Wicklow
www.avoca.com

Baltinglass Abbey
Church Lane
Baltinglass
County Wicklow
www.visitwicklow.ie

Black Castle
Wicklow town
County Wicklow
www.visitwicklow.ie

Dwyer McAllister Cottage
Derrynamuck
Knockanarrigan
County Wicklow
www.heritageireland.ie

German War Cemetery
Glencree
Enniskerry
County Wicklow

Glencree Centre for Peace and Reconciliation
Glencree
Enniskerry
County Wicklow
www.glencree.ie

Glendalough Monastic Site
Glendalough
County Wicklow
www.glendalough.ie

Kilpatrick House
Redcross
County Wicklow
www.kilpatrickhouse.ie

Victor's Way Indian Sculpture Park
Old Enniskerry Road
Roundwood
County Wicklow
www.victorsway.eu

Wicklow Abbey
Wicklow town
County Wicklow

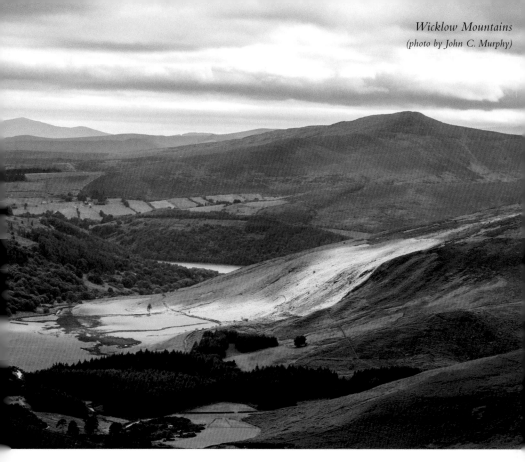

Wicklow Mountains
(photo by John C. Murphy)

Wicklow Brewery
Main Street
Redcross
County Wicklow
www.wicklowbrewery.ie

Wicklow Head Lighthouse
Wicklow town
County Wicklow
www.irishlandmark.com

Wicklow's Historic Gaol
Kilmantin Hill
Wicklow town
County Wicklow
www.wicklowshistoricgaol.com

HOUSES AND GARDENS OF WICKLOW

Avondale House and Forest Park
Rathdrum
County Wicklow
www.heritageisland.com

Killruddery House and Gardens
Southern Cross
Bray
County Wicklow
www.killruddery.com

Mount Usher Gardens
Ashford
County Wicklow
www.mountushergardens.ie

National Botanic Gardens, Kilmacurragh
Kilbride
County Wicklow
www.botanicgardens.ie

Powerscourt Estate
Enniskerry
County Wicklow
www.powerscourt.com

Russborough House and Gardens
Russborough
Blessington
County Wicklow
www.russborough.ie

Bibliography

Andrews, Elmer (ed.), *The poetry of Seamus Heaney* (New York: Columbia University Press, 1998)

Annaidh, Séamus Mac, *Irish history* (Bath: Parragon, 2002)

ap Nicholas, Islwyn, *Iolo Morganwg, bard of liberty* (London: Foyle's Welsh Press, 1945)

Beckett, Samuel (James Knowlson and Elizabeth Knowlson, eds), *Beckett remembering, remembering Beckett: a centenary celebration* (New York: Arcade Publishing, 2006)

Beckett, Samuel (James Knowlson, ed.), *Krapp's last tape: with a revised text* (London: Faber and Faber, 1992)

Bladen, F.M. (ed.), *Historical records of New South Wales* (7 vols, Mona Vale, New South Wales: Lansdown Slattery, 1892–1901), iv

Boland, Eavan, *In a time of violence* (New York: Norton, 1994)

Brennan, Deirdre, *Teanga bheo* (Baile Átha Cliath: Comhar na Múinteoirí, 1999)

Bruchac, Joseph, and Anna Vojtech, *The first strawberries: a Cherokee story* (New York: Dial Book for Young Readers, 1993)

Collinge, Déaglán, *Gléasnótaí Gaeilge ardleibhéal 2016* (Dublin: Mentor, 2014)

Conrad, Joseph (Paul O'Prey, ed.), *Heart of darkness* (London: Penguin, 1989)

Cousins, Mark, *The story of film* (New York: Thunder's Mouth, 2004)

Cróinín, Dáibhí Ó, *Early medieval Ireland, 400–1200* (London: Longman, 1995)

Dawkins, Richard, *The God delusion* (London: Bantam, 2006)

Dickens, Charles (Richard Maxwell, ed.), *A tale of two cities* (New York: Penguin, 2003)

Dickinson, Emily, *The complete poems of Emily Dickinson* (London: Faber and Faber, 1977)

Don, Monty, *Extraordinary gardens of the world* (London: Weidenfeld and Nicolson, 2009)

Duffy, Seán, *Atlas of Irish history* (2nd ed., New York: Macmillan, 2000)

Emerson, Ralph Waldo (Jaroslav Pelikan, ed.), *Nature* (Boston: Beacon, 1985)

Fhrighil, Ríóna Ní (ed.), *Filíocht chomhaimseartha na Gaeilge* (Baile Átha Cliath: Cois Life, 2010)

Fitter, Alastair and David More, *Trees* (Glasgow: HarperCollins, 2004)

Flegg, Jim and David Hosking, *Birds of Britain and Europe* (London: New Holland, 2002)

Frost, Robert, *Complete poems of Robert Frost* (New York: Holt, Rinehart and Winston, 1967)

Gogh, Vincent van (Ronald de Leeuw, ed.), *The letters of Vincent van Gogh* (London: Allen Lane, Penguin, 1996)

Groom, Nick, *The seasons: an elegy for the passing of the year* (London: Atlantic, 2013)

Hardy, Thomas (Ronald Blythe, ed.), *Far from the madding crowd* (Harmondsworth: Penguin, 1978)

Hardy, Thomas (Tony Slade, ed.), *The return of the native* (London: Penguin, 1999)

Hawthorne, Nathaniel (Sophia Hawthorne, ed.), *Passages from the American notebooks of Nathaniel Hawthorne* (Boston: Houghton, Mifflin & Co., 1868)

Heaney, Seamus, *Opened ground* (London: Faber and Faber, 1998)

Heaney, Seamus, *Eleven poems* (Belfast: Queen's University of Belfast, 1965)

Heraclitus of Ephesus (John Grover, ed.), *Heraclitus* (Bergen: J. Grover, 1999)

Hopkins, Gerard Manley, and John Pick, *The windhover* (Columbus, Ohio: C.E. Merrill, 1969)

Hughes, Ted, *Season songs* (New York: Viking, 1975)

Jennings, Robert, *Kilcoole, County Wicklow: history and folklore, historical walks and drives* (Kilcoole: Kilcoole Millennium and Residents' Association, 1998)

Joyce, James, *Ulysses* (New York: Modern Library, 1992)

Kavanagh, Patrick (Antoinette Quinn, ed.), *Collected poems* (London and New York: Allen Lane, 1994)

Keats, John, *The poetry of John Keats* (n.p.: Monarch Notes, 1966)

Kiberd, Declan, *Inventing Ireland: the literature of the modern nation* (Cambridge, Massachusetts: Harvard University Press, 1996)

Knowlson, James, and John Haynes, *Images of Beckett* (Cambridge University Press, 2003)

Larkin, Philip, and Anthony Thwaite, *Collected poems* (New York: Farrar, Straus and Giroux, 2004)

MacGill-Callahan, Sheila, and Gennady Spirin, *The children of Lir* (New York: Dial, 1993)

McGuire, Matthew J., *Irish poems* (New York: Alfred A. Knopf, 2011)

Melville, Herman, *Moby-Dick* (New York: Macmillan, 1962)

Moore, Thomas, *The last rose of summer* (Lowell, Massachusetts: I.H. Welton, c. 1849)

Moore, Thomas, *Twine weel the plaiden; Beadle of the parish; O Jeanie there's naething to fear ye; The Irish fisherman; Meeting of the Waters; The deer hunter; Native land* (Glasgow: the Ellers, 1820)

O'Brien, Eugene, *Seamus Heaney: creating Irelands of the mind* (Dublin: Liffey, 2002)

O'Casey, Sean, *The plough and the stars: a tragedy in four acts* (New York: Macmillan, 1926)

Ó Direáin, Máirtín, *Dánta 1939–1979* (Báile Átha Cliath: An Clóchomar, 1980)

O'Donohue, John, and John Quinn, *Walking on the pastures of wonder* (Dublin: Veritas, 2015)

O'Flaherty, Liam (A.A. Kelly, ed.) *The collected stories* (3 vols, New York: St Martin's Press, 1999)

Palgrave, Francis Turner, and W.T. Brewster, *The golden treasury: selected from the best songs and lyrical poems in the English language* (New York: Macmillan, 1956)

Plunkett, James, *Strumpet city: a novel* (London: World Books, 1970)

Russell, Bertrand (Nicholas Griffin, ed.), *The selected letters of Bertrand Russell: the private years 1884–1914* (Boston: Houghton Mifflin, 1992)

Shakespeare, William, *Henry VIII* (Minneapolis: Filiquarian Publishing, 2007)

Shakespeare, William, *Hamlet* (New York: Dover Publications, 1992)

Shakespeare, William (G.K. Hunter, ed.), *King Lear* (Harmondsworth: Penguin, 1972)

Shakespeare, William (Stephen Orgel, ed.), *Macbeth* (New York: Penguin, 2000)

Shakespeare, William (Kenneth Muir, ed.), *Othello* (Harmondsworth: Penguin, 1968)

Solnit, Rebecca, *Wanderlust: a history of walking* (New York: Viking, 2000)

Sterry, Paul (Derek Mooney, intro.), *Complete Irish wildlife* (London: HarperCollins, 2004)

Stevenson, Robert Louis, *Bed in summer* (Mankato, Minnesota: Child's World, 2012)

Stewart, Lyn, *Blood revenge: murder on the Hawkesbury, 1799* (Kenthurst, New South Wales: Rosenberg Publishing, 2015)

Swagger, E.A. James, *The Newgrange Sirius mystery: linking passage grave cosmology with Dogon symbology* (Guildford: Grosvenor House Publishing, 2012)

Synge, J.M. (Robin Skelton, ed.), *The collected works of J.M. Synge* (Gerrards Cross: Colin Smythe, 1982)

Thoreau, Henry David, *A week on the Concord and Merrimack Rivers* (Mineola, New York: Dover Publications, 2001)

Tolstoy, Leo (Richard Pevear and Larissa Volokhonsky, trans.), *Anna Karenina: a novel in eight parts* (New York: Penguin, 2002)

Tusser, Thomas, *Five hundred points of good husbandry* (Oxford University Press, 1984)

Wilde, Oscar (Susan Gallagher, ed.), *The selfish giant* (New York: Putnam, 1995)

Wittgenstein: a wonderful life, BBC television programme (1989)

Woolf, Virginia, *To the lighthouse* (New York: Harcourt, Brace, 1927)

Wordsworth, William, *Collected works of William Wordsworth: poems in two volumes* (Charleston, South Carolina: Bibliobazaar, 2007)

Wright, G.N., *A guide to the county of Wicklow: illustrated by engravings, after the designs of George Petrie, Esq., and a large map of the county, from an original survey* (London: Baldwin, Cradock, and Joy, 1827)

Yeats, W.B. *The collected poems of W.B. Yeats* (New York: Macmillan, 1956)

Index

1798 Rebellion 52, 125, 143, 173

1913 Lockout 186

Abbey Grounds 168

Acton family 55, 56

Acton, Captain Charles Annesley 55

Acton, Janet 55

Acton, Reginald Thomas-Ball 56

Acton, Thomas II 55

Acton, William 55

Adam and Eve 104

Aegean Sea 27

Africa 44, 63, 127, 134 135, 175

African and Asian countries 103

African coast 133

African Sahel 63

Aghavanna 124

Aghavanna Bridge 124

Ahab, Captain 51

Alaska 175

Alex Ferguson 4

Aliens Registration Office of Dublin
 Castle, 108

Altaclarensis 55

Alte Nationalgalerie, Berlin 25

Alzheimer's disease 10

Amerigo Vespucci 14

Amuigh faoin spéir 14

Angela's ashes 136

Anglo-Normans 168, 174, 175

Anna Karenina 19, 117

Anna Livia Plurabelle 59

Apus apus 64

Arandora Star 107

Arctic 22

Arctic Canada 44

Arctic char 91

Arctic fox 6

Argentina 14, 133

Aristotle 22

Arklow 115, 143

Art's Lough 124

Asgard 125

Ashford 31, 88, 135, 211, 214

Athlone 108

Athlone Prison 108

Atlantic 133, 154

Atlantic salmon 153

Aughavannagh 144

Aughrim River 91, 92, 166

Australia 145, 171, 173

Austro-Hungarian army 57

Avoca 130, 137, 138, 139, 198, 211

 Avoca Valley 138

 hand-weaving 138

mill 139
Avondale 126, 127, 198, 214
Avonmore River 29, 30
azalea 54, 55, 135
badger 3, 24, 64, 65, 66, 67, 75, 127, 165
Baffin Island 5
Ballycorus 189
Ballyguille 170
Ballykissangel 138
Ballymanus 173
Baltinglass Hill 182
Banquo 13
bar-tailed godwit 21
Bardsey Island 126
barley 102
barnacle goose 5, 6
Bartlett, W.H. 139
bat 28, 64
Beach House 38
Beatles 122
Beckett, Samuel 3, 25
'Bed in summer' 99
bee 112, 129
Beech Hedge Pond 136
beech tree 202
Berlin 25, 105, 108
berries: blackberry 131, 132, 136
 elder 136
 haw 136
 rowan 136
 strawberry 102, 103, 104
Betts, Luckyn 173
Bewick's swan 10
Billy the Kid 81
bindweed 128
birch 30, 141
BirdWatch Ireland 8, 16, 61, 64, 70, 80,
 111, 197, 202, 203
Black Castle 168, 170
black-backed gull 36, 81

black-tailed godwit 44
blackberry-picking 131–2
blackbird 14, 31, 70, 79, 95, 127, 151, 152
blackcap 30
Blackditch Wood 61, 116
blackthorn 81, 128
Blessington Lakes 58, 167, 205
Bloody Foreland 107
Bloom, Leopold 58, 96
Bloom, Molly 33, 97
Bloomsday 95, 96
bluebell 64, 72, 73, 86, 135
Bodleian Library 185
bog 61, 144, 205
'Bogland' 71
bog pony 79
Boland, Eavan 129
Bolt, Usain 89
Book of Glendalough, The 185
Botanic Gardens, Dublin 57
Boylan, Blazes 97
Boyne River 107, 180
Boyne Valley 180, 181
Brabazon, Sir William 136
bramble 92, 128, 140, 176
Brandy's Hole 41
Brandywell Viaduct 41
Bray 4, 9, 38, 39, 42, 63, 109, 132, 135,
 151, 171, 197, 199, 201
Bray Air Display 64
Bray Harbour 134
Bray Head 34, 38, 42, 53, 60, 80, 81,
 110, 116
Brazil 14, 133
Breaches 5, 12, 13, 14, 15, 21, 27, 57,
 63, 80, 95, 112, 128, 129, 157, 202,
 203
Brehon Laws 126
Brennus 5
Bridge Street 170

Bridge Tavern 170
Britain 47, 141, 143
British 189, 193, 203
British Army 143
British Isles 141
British military barracks 144
Briton 170
Brittas Bay 99, 100, 101, 175, 197, 205
Broad Lough 46, 202, 204
Broad Walk 55
bronze age 27
brown trout 45
Browne, Tara 122
Brunel, Isambard Kingdom 171
'Brunel's folly' 40
Buckroney Fen 101
Buddha 106
buddleia 128
Bull Island 44
bullfinch 87
butterfly, 112–13
 orange tip 72, 74, 128
 painted lady 79, 128, 134
 peacock 79, 112, 128
 tortoiseshell 79
Byrne, Captain William Billy 173
Caledonian orogeny 60
Callinan, Chris 96
Cambrian Period 40
Cambridge 57, 72
Camillus, Marcus Furius 5
Canada 5, 44, 107, 127, 166, 170, 171
Capitoline Hill 5
Captain Boyle 66
Cardinal Wolsey 168
Carlow 118, 121
Carrickgollogan Hill 189
Carriggower Hill 119
Cassiopeia 66, 193, 203
Castle Forbes 76

Castle Inn 61, 197, 203
caterpillar 73, 112, 135
Celtic 117, 118, 159, 175
chaffinch 14
Charles VI 141
Cherokee 104
cherry blossom 54
cherry laurel 56
Chichén Itzá 48
Chieftains, The 122
'Children of Lir' 12
Chile 56
China 56, 150
Chomsky, Noam 77
Chotah 126
Christian 76, 139, 159, 182, 191, 194, 201
Christianity 48, 117
Christmas 156, 160, 179, 181, 186, 188, 189, 191, 193, 194
'Christmas childhood, A' 203
'Church going' 92
Cill Mhantáin 48
Cinnabar moth 79
'Circe' episode 58
'Clann Lir' 10
Clara 30, 73, 149, 198
Claudius (Hamlet) 185
Claudius Caesar 141
Cloghoge River 86, 120, 122, 206
Clonegal 118
Clonycavan Man 71
cockerel 137
Cohle, Rust 167
collared dove 64
Collins, Michael 93
columbine 86
comet 119, 191, 192
Comet ISON 191
common frog 22, 23

common lizard 46
Congo 127
Connemara 20
Coote, Sir Charles 169
Cork 29, 175
cormorant 8, 9, 41, 110
corncrake 43
Cornwall 171
Corrib, Lough 167
County Wexford 60
County Wicklow Partnership 72
Crane, Walter 51
Cries of London 142
Cromwell, Oliver 55
Crone Wood 123
crow 13, 95, 115
Croydon 142
Crystal Palace 136
Cualainn 118
cuckoo 126, 127
cuckooflower 73
Cunningham's white 55
curlew 15, 21, 46, 56, 57, 59
Dairbhreach, Loch 10
damselfly 112, 135
Dan, Lough 85, 86, 88, 90, 92, 120, 121, 197
Dann's Bar 85
Dargle River 54, 118, 203
Davitt, Michael 122, 123
Davy Byrne's pub 96
Dawkins, Richard 42
de Brún, Garech 122
de Buitléir, Éamon 14, 15
De Valera, Éamon 92, 126
Dean's Grange Cemetery 108
Death Valley 189
Dedalus, Stephen 4, 96
Deirdre Brennan 8
Delgany Wood 64, 144, 163

Demeter 139
Derry River 72
Derrynamuck 144, 202
Devil's Glen 31, 46, 112
Devil's Glen Waterfall 32, 46, 197, 201
Dickens, Charles 129
Dickinson, Emily 164, 168
dipper 30, 32
Djouce Mountain 117, 118, 119, 192, 206, 208
dog whelk 101
dolphin 128, 175
Don, Monty 135
Donegal, County 44, 107
Douglas fir 54
Dover 42
Dowth 180
dragonfly 80, 112
druid 184
Dublin 45, 48, 57, 58, 71, 72, 91, 93, 96, 108, 116, 118, 124, 144, 174, 186, 189
Dublin Bay 117, 189, 202
Dublin Castle 108
Dublin Mountains 118, 144–5
Dunbur Head 51
Dunlavin 143
Dunlavin Massacre 143
dunlin 21
Dunne, Éamonn 93
Dwyer-McAllister Cottage 144
Dwyer, John 143
Dwyer, Michael 143–5
East Coast Nature Reserve 61, 70, 197, 203
Egypt 26
Egyptian frescoes 116
Egyptian hieroglyphics 27
Einstein 25
elderflower 81

Eliot, T.S. 71
Emerson, Ralph Waldo 165
Emmet, Robert 145
Enchanted Wood 106
England 89, 101, 137
English 169, 175, 186
Enniskerry 97, 117, 214
ESB 58
Estragon 25
Europe 74, 75, 89, 121, 170, 171, 180, 186
European Union Habitats Directive 30, 101
Evans, Nicholas 141
'Explosion, The' 16
Far and away 136
Far from the madding crowd 7, 143
'Fear lásta lampaí' 84, 85
Featherbed Mountains 95, 96
fen 61, 79, 87, 132, 140, 141
Fertile Crescent 27
Fiannaíocht 104
fin whale 175
Finnegans wake 182
Fishamble Street 90
Fitzgerald, Baron Maurice 169
Five hundred points of good husbandry 69
Five Mile Point 62, 202
Flanders 30
fly-fishing 91
four-spotted chaser 80
fox 6, 65, 127, 165
Fox Rock 189
foxglove 68, 79
France 87, 101, 127
Fraughan Rock 124
'Free as a bird' 9
French invasion 175
Friedrich, Casper David 25, 29
fuchsia 148, 176

fulmar 42, 110, 111
gabhlán gaoithe 63
Galway 20, 84
Ganesh 105
gannet 42, 133
Garden of Eden 47
Gaul 5, 48
George IV 193
George VI 138
Georgian 63, 126
German 107, 109, 125, 126, 193, 212
German Military Cemetary 106
Germany 108
Glanmore 33
Glanmore Castle 88
Glen of Imaal, 124, 144, 145
Glen of the Downs 60, 65, 81, 116, 149
Glencree 24, 96, 108–09, 121
Glencree Cemetery 108
Glencree Reconciliation Centre 109, 144
Glencree Reformatory 96
Glencree River 107
Glendalough 143, 184–92, 197, 206, 212
Glendalough Mining Company 188
Glendasan River 146
Glenealo Valley 189
Glenmalure 124, 143
Glenmalure Valley 125
God delusion, The 42
goldfinch 87, 120, 127
Görtz, Hermann 107–08
Goulder, Dave 179, 194
great black-backed gull 90, 110
Great Britain 47
Great Eastern 171
'Great Oak of Avondale' 126
great spotted woodpecker 75
Great Sugar Loaf 60, 65, 66, 116, 192
Greece 117

Greek myth 104, 139

green-veined white 79

Greenland 5, 21, 22, 153

grey heron 15, 44, 62, 166

grey squirrel 76, 77, 127

grey tit 14

grey wagtail 31, 32, 153

greylag goose 5, 58, 149

Greystones 5, 7, 13, 36, 38, 39, 41, 48,
 63, 81, 84, 88, 109, 128, 132, 153, 207
 cliff walk 109

Greystones Harbour 4, 85, 128

Greystones–Bray cliff railway 171

Groom, Nick 132

Guide to the county of Wicklow, A 58, 90,
 151

guillemot 42, 110

Guinness 6, 51, 105, 118, 122

gull 81, 111

Hadeon eon 26

Halpin, Captain Robert Charles 170,
 171, 172, 173

Hamlet 185

harbour porpoise 175

Hardy, Thomas 6, 37, 143

hare 89, 90

harvest 115, 131

Hatch, Niall 8

hawthorn 81, 162

Hawthorne, Nathaniel 147

Hayes, Samuel 126

HBO 167

Heaney, Seamus 3, 24, 32, 71, 131, 132

heath speedwell 86

hedgehog 24

Henry VIII 136, 168, 169, 183

Heraclitus 38, 83, 94

Hercules 174

'He reproves the curlew' 21

hermit crab 100

heron 23

herring gull 110

Heytesbury Street 10

Highlands of Scotland 42

Himalayas 56

Hindu 105

'His first flight' 111

Hobart, Lord 174, 175

holly 128

Holt, Joseph 143

Hook Head 52, 175

Hopkins, Gerard Manley 41

Horse whisperer, The 141

Horus 7

house martin 63

Howth gun-running 125

Howth Head 52, 117, 126

Hughes, Ted 35

hummingbird 79

hummingbird hawkmoth 79

humpback whale 175

Hunter's Lodge 46

Huston, John 122

Iago 1, 2, 3

Iceland 5, 9, 22, 44, 57

'If I were a rich man' 11

'I hear you calling me' 11

Inchavore River 86, 91

India 105, 171

International Dawn Chorus Day 69

IRA 107

Ireland 6, 14, 22, 28, 47, 54, 61, 75, 79,
 91, 126, 128, 135, 137, 142, 169

Irish bardic poetry 116

Irish Guards 31

Irish intelligence service G2 107

Irish Raptor Study Group 138

Irish Sea 46, 102, 122, 126, 175

Irrus Domnann 10

Ishmael 14, 171, 172

Jack's Hole 102
jackdaw 79
Jackson, Michael 122
'January man, The' 179, 194
Janus 2, 3, 10, 194
Japan 54, 75
Japanese Garden, Powerscourt 54
jay 30, 86, 115
Jesus 139
Johnson, Samuel 30
Jones, Etta 12
Joxer 66
Joyce, James 4, 46, 59, 96, 182
Julius Caesar 2
Juneau 175
Juno 5
Kaikura 175
Kairouan 26
Kanturk 86
Kavanagh, Patrick 193
Keadeen 144
Keats 129
Kelpie 126
Kent 107
Keogh, Niall 80
Kerry bog ponies 62
Kerry, County 117, 171, 175
kestrel 19, 39, 40, 41
Kevin, Saint 184–7
Kilcoole 4, 36, 44, 45, 115, 129
Kilcoole Beach 3, 4, 12, 16, 21, 22, 45, 64, 72, 111, 125, 126
Kilcoole gun-running 125, 126
Kilcoole wetlands 21
Kildare 181
Killakee 144
Killarney 184
Killarney National Park 30
killer whale 175
Killiney 4

Killorglin 117
Killruddery Estate 137
Killruddery Gardens 135, 136
Killruddery House 42, 136, 197, 200
Kilmacurragh 54, 55, 183
Kilmacurragh Gardens 56, 57, 183, 196
Kilmacurragh House 55
Kilmartin Hill 173
Kilmore Quay 60
Kilpatrick House 57, 212
Kilpedder 119
Kilternan 189
King, Governor 174
King's Castle 169
King's College, Cambridge 72
kingfisher 30, 72
Kippure Estate 181, 205
Kippure Forest 181
kittiwake 42, 110
Knocknacloghoge 85
Knocksink Woods 112
knot 21
Knowlson, James 25
Knowth 180
Krapp's last tape 40
Kukulkan, Temple of 48
labrador 15
Lake Louise 166
Langheld, Victor 105
lapwing 12, 19, 20, 101
Laragh 29, 85, 107
larch 192
Larkin, Philip 16, 92
'Last rose of summer, The' 139
Late spring 54
lazy beds 91
le Nôtre, André 136
Lear, King 37
Leaving Certificate 72
Lebar Glinne Dá Locha 185

Leinster 124, 136
Lenehan, Matt 96, 97
Lennon, John 9
lesser stitchwort 85
Lia Fáil 118
Liffey 58, 155
limpet 101
little egret 12, 44
little tern 16, 44, 95, 111, 129
Liverpool 107
locust 167
London 136, 142
long-tailed tit 14
Longford, County 76
Lord Meath's Lodge 42
Loughcrew Cairns 181
Louisiana 167
Luftwaffe 107
Luggala 122
Luggala Estate 120, 121
Luggala Mountain 118, 122, 123
Lugh (Lú) 117
Lugnaquilla 124, 144
lugworm 44
Lúnasa 117
Mac Cumhaill, Fionn 182
Macbeth 13
Machu Picchu 190
Magherabeg Beach 176
Magheramore Beach 176, 205
Mahabalipuram 105
Malahide 48
Malcolm, Norman 57
Mantán 48
Manx shearwater 42, 43, 111
'March morning unlike others' 35
Marilyn 60
Marlay Park 118
Martello towers 4, 175
Mathews 186

Mayans 48
Mayo 10, 44
McAllister, Sam 145
McCormack, Count John 12
meadow pipit 61
Meán Fómhair 131
Meath 107, 170, 180
Meath, Lord 42
Mediterranean 27, 81
Meegan, Christopher 30
Meeting of the Waters, The 130, 139
Megalithic 180, 181, 182
Melancholy Lane 170
Melville, Herman 51
Mexico 26, 48
Michaelmas Day 142
Military Road 95, 97, 144
Mining Company of Ireland 189
minke whale 175
Mizen Head 101
Moby-Dick 51, 171
Mochorog, Saint 183
molluscs 100
Monaghan 193
Monet, Claude 8
montbretia 176
Moore, David 55
Moore, Thomas 139
Morganwg, Iolo (Edward Williams) 22
Morocco 127, 135
Mount Usher 46, 135, 136
Mouritsen, Henrik 28
Muckross Abbey 184
Munro 60
murmuration 167
Murray, William 30
Murrough 4, 14, 15, 19, 45, 78, 194
mushrooms: death cap 141
 fly agaric 141
 wild 140–2

My left foot 136
Myles, Sir Thomas 126
N11 65, 102, 151
Nairn, Richard 38
Napoleonic wars 175
National Botanic Gardens,
 Kilmacurragh 54, 56
National History Museum, Dublin 71
National Parks and Wildlife Service 58,
 121
Native American 104
'Nature' 165
Navel of the Sea 58
Neolithic 181, 182, 184, 191, 205
Neptune's horses 51
New Ross 143
New South Wales 145
New York 110
Newcastle 16, 44, 60, 129, 140, 193
Newcastle Aerodrome 64, 202
Newcastle Fen 60, 112, 115–16
Newgrange 26, 180, 191
Nighttown 58
Norman Black Castle 168
Norman conquest of Ireland 169
Normans 170
North Sea 10
Norway 58
Nun's Cross Bridge 46
O'Brien, Seamus 183
O'Byrnes 169
O'Casey, Sean 66
O'Dea, Bill 142
Ó Direáin, Mairtín 84
O'Donohue, John 118, 119
O'Flaherty, Liam 111
O'Tooles 169
oak 30, 74, 82, 152, 192
Obama, Malia 182
Obama, Michelle 182

Obama, Sasha 182
Old Croghan Man 71
Old Massey's Estate 144
Oldenburg, University of 28
Oort Cloud 191
Orion's belt 66
'Oró sé do bheatha 'bhaile' 10
osprey 89, 90
ossifragus 89
Othello 1, 2
otters 15
Ow River 124
Oxford 185
oystercatcher 111
Ozu, Yasujiro 54
Paddyganesh 105
pagans 48, 117, 175
Pakistan 106
pansy 128
panta rhei 94
Paris 59, 136
Parnell, Charles Stewart 126
Parnell, John 126
passage tomb 180
Patrick, Saint 47, 175
Perseid meteor shower 119
Persephone 139
Peru 26, 190, 191
Petrie, Ronnie 88
pheasant 127
Philosophical investigations 57
Phoenicians 27
pigeon, homing 28
pine marten 76, 77
Plough and the stars, The 66
Plunkett, James 186
'Poc ar buile, An' 10
Polaris 27
Polish 109
Pollaphuca Reservoir 58, 149

Pollaphuca Waterfall 58, 149

Powerscourt Estate 54, 214

Powerscourt Gardens 55

Powerscourt House 203

Powerscourt, Lord 121

Powerscourt Waterfall, 118, 192

Powerscourt, Viscount 54, 203

Pratt, Donald 139

Pratt, Hillary 139

'Prelude' 87

Prendergast, Jeremiah 174

Prince Charles 138

Puck Fair 117

Quiet man, The 29

RAF Manston Air Base 107

ragworm 44

Raleigh 29

Ram's Scalp Bridge 41

Rathdrum 29, 126, 199

Rathfarnham 88, 144

Rathwood 138

razorbill 42

Red Arrows 64

red fox 6

red kite 89, 137, 138

red squirrel 76, 77, 152

Redcross 57, 87, 180, 192, 213

Redmond, John 92

redshank 21

redwood 192

reindeer 179

Return of the native, The 37

Rhododendron ponticum 56

Rhododendron x superponticum 56

rhododendron 55, 56

ringed plover 111

ringfort 182

Rio de Janeiro 14

Risso's dolphin 128

Robertson, Daniel 54

robin 28, 29, 70, 95, 127, 166

Robinson, William 135

rockpooling 100

Roman emperor 141

Rome 5

rook 13, 19

rookery 128

Roundwood 45, 85, 105, 117, 207

Roundwood Reservoir 118

Royal Botanic Gardens, Glasnevin 55

ruffs 129

Ruraíocht 104

Russell, Bertrand 122

Russia 21, 22

Russian 116

Sahara 127, 128, 134

Saint Brigid's Day 20

Saint John's, Newfoundland 171

Saint Kevin's Lead and Zinc Mines 189

Saint Patrick's and Saint Killian's Church 29

Saint Patrick's Day 13, 48

Sally Gap 45, 122, 143, 145, 198

salmon 14, 45

Samhain 159, 181

sand martin 63

sanderling 21, 129

Sandymount 4

Santa 179

Scandanavia 21, 90

Scarr Mountain 85

Scotland 10, 57, 89, 137

sea anemone 100

seal 36

Seasons, The 132

sedge 61

Seefin 182

Seefin Hill 181, 182

Seefin passage tomb 181

Seefingan 182

'Selfish giant, The' 56
Sellers, Peter 107
shag 8, 9
Shakespeare, William 1, 2, 168
Shankill 189
Shannon Estuary 44
shell 101
Shillelagh 72, 138
shrimp 100, 170
Sí an Bhrú 180
Siberia 10, 90
Siddartha 106
sika deer 121, 207
'Silent night' 193
Silver Strand 101, 175, 205
Silver, Long John 102
Sitka spruce 127
Slí Cualann Nua 118
smooth newt 46, 47
Socrates 57
soldier beetle 80
Solnit, Rebecca 38, 39
solstice 117, 180, 183, 184
song thrush 70, 127
South Island, New Zealand 175
'Spailpín fánach, An' 143
Spain 127, 137, 175
spruce 85
Sruth na Maoile (Sea of Moyle) 10
starling 14, 167
Stevenson, Robert Louis 99
stonechat 61, 120
Stonehenge 26
Strongbow 169
Strumpet city 186
Stuart, Francis 107
Stuart, Iseult 107
sub-Saharan Africa 44
Sudanian Savannahs 63
'supermoon' 95

Supreme Court 108
Svalbard 5
swallow 22, 27, 63, 128
Sweden 137
swift 64, 128
sycamore 56
Synge, John Millington 87, 88
Table Mountain 144
Tallaght 10, 20
Tandy, James Napper 173
Tay, Lough 114, 118, 120, 122, 207
Temple Bar 96
tern 110, 111
Tevye 12
Theia 26
'This moment' 129
Thoreau, Henry David 188
Tinakilly House 171
Tinahely 72, 160, 210
To the lighthouse 52
Tokyo story 54
Tolstoy, Leo 19, 35, 117
'Tollund Man, The' 3
Tomnafinnoge 64
Tomnafinnoge Wood 74, 76, 77
Tone, Wolfe 145
Tractatus logico-philosophicus 57
Treasure Island 102
Trinity College, Dublin 72
trout 14, 45, 153
True detective 167
Tudors, The 136
Tunisia 26
Turlough Hill 185
Tusser, Thomas 69
Two men contemplating the moon 25
Ulster 10
Ulysses 4, 46, 58, 59, 96
United Irishmen 52, 125, 143, 173
United States 127

Valentia Island 171
Van Diemen's Land 190
van Gogh, Theo 87
van Gogh, Vincent 87
Vartry Reservoir 45
Vartry River 31, 32, 45, 46, 48, 135
Venus 136
Versailles 136
Victor's Way Indian Sculpture Park
 104–06
Viking settlement 168
Viking ships 175
Vikings 101, 170
Vikings 122, 138
Vladimir 25
wagtail 30
Waiting for Godot 25
Wales 89, 122, 137
Wanderlust 38
War of Independence 173
water rail 80
Weaver, Thomas 188
Webster's Caravan and Camping Park
 102
Welsh 184
Welsh Kite Trust 138
Wentworth Place 168
Westmeath, County 10
Westminster Abbey 72
Wexford 102, 103, 143, 175
wheat 102
whimbrel 129
White, Jack 101
whooper swan 9
Wicklow 3, 14, 23, 24, 30, 44, 48, 53,
 59, 60, 67, 75, 84, 85, 88, 91, 92, 99,

102, 116, 118, 124, 137, 141, 143–4,
 169, 191, 192, 194, 199, 203, 204
coast 116
Hills 115, 119, 122, 144, 169
Mountains 23, 60, 95, 105, 107, 117,
 166, 190, 191
Wicklow Gaol 173, 175
Wicklow Harbour 46, 134
Wicklow Head 4, 13, 81, 84, 88, 175
Wicklow Lighthouse 51
Wicklow National Park 184
Wicklow Pier 171
Wicklow town 7, 31, 168, 170, 175
Wicklow Way 117, 118
Wilde, Oscar 56
wildflowers 69, 103
willowherb 79, 128
Wingfield, Richard 193
Wittgenstein, Ludwig 57
wood pigeon 62
Woodenbridge 72, 91
woodland 112
Woodlands Falconry 138
Woolf, Virginia 52, 149
Wordsworth, William 129
World War I 30, 56, 57, 92, 107, 199
wren 120, 127, 129
Wright, G.N. 58, 59, 90, 91, 151
Wynne family 189
Wynne, J.B. 189
Yearling 186, 188
Yeats, W.B. 21, 88, 129
'Yes, sir, that's my baby' 11
yew 55, 58, 150, 183
Ypres 56
Zurich 59